£ 9.99

KT-838-209

HARROW COLLEGE

047531

Andy Warhol

Eric Shanes

Grange
BOOKS

Text: Eric Shanes
Designed by: Baseline Co Ltd
19-25 Nguyen Hue
Bitexco Building, Floor 11
District 1, Ho Chi Minh City
Vietnam

Published in 2005 by Grange Books
an imprint of Grange Books Plc
The Grange, Kingsnorth Industrial Estate
Hoo, nr Rochester
Kent ME3 9ND
www.grangebooks.co.uk

ISBN 1-84013-782-7

Printed in Singapore

Contents

5 His Life

56 His Work

154 Biography

157 Selected Bibliography

158 List of Plates

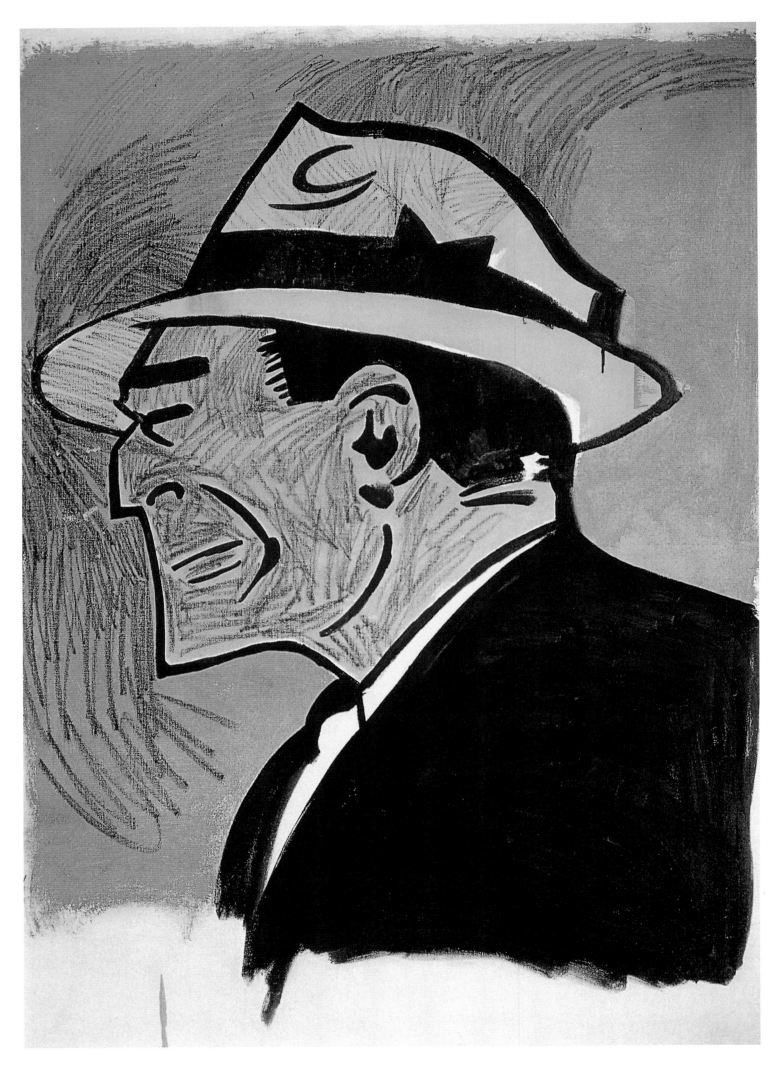

4.

The Life

All art ultimately illumines the culture in which it is created, even if that culture usually serves merely as a backdrop to the projection of some more ideal or alternative reality by the artist. But with so-called Pop Art, the very backdrop of mass-culture became the foreground subject of art itself. By magnifying the lack of taste and extreme vulgarity or kitsch that are inevitable by-products of an increasingly globalised mass-culture, artists have not only ironically drawn attention to that debasement of taste, but equally stressed their own detachment from it, as though to assert that they themselves are privileged beings who stand outside society and remain untainted by its corruptions. For the most part these artists simply celebrated pop-culture but one of them – the subject of this book – went much further. Through pioneering a variety of techniques, but principally by means of the visual isolation of imagery, its repetition and enforced similarity to printed images, and the use of garish colour to denote the visual garishness that is often encountered in mass culture, Andy Warhol threw much direct or indirect light upon modern *anomie* or world-weariness, nihilism, materialism, political manipulation, economic exploitation, conspicuous consumption, media hero-worship, and the creation of artificially-induced needs and aspirations.

Warhol's images might initially appear to be rather simple. Yet because of that very simplicity they enjoy a high degree of immediate visual impact. For example, the visual repetitiousness that Warhol employed within a great many of his images was intended associatively to parallel the vast repetitiousness of images that is employed in a mass-culture in order to sell goods and services – including vehicles of communication such as movies and TV programmes – whilst by incorporating into his images the very techniques of mass production that are central to a modern industrial society, Warhol directly mirrored larger cultural uses and abuses, while emphasizing to the point of absurdity the complete detachment from emotional commitment that he saw everywhere around him. Moreover, as well as relating to the Pop Art movement which employed imagery derived from popular culture in order to offer a critique of contemporary society, Warhol also carried forward the assaults on art and bourgeois values that the Dadaists had earlier pioneered, so that by manipulating images and the public persona of the artist he became able to throw back in our faces the contradictions and superficialities of contemporary art and culture. And ultimately it is the trenchancy of his cultural critique, as well as the vivaciousness with which he imbued it, that will surely lend his works their continuing relevance long after the particular objects he represented – such as Campbell's soup cans and Coca-Cola bottles – have perhaps become technologically outmoded, or the outstanding people he depicted, such as Marilyn Monroe, Elvis Presley and Mao Tse-Tung, have come to be regarded merely as the superstars of yesteryear.

Andy Warhol was born Andrew Warhola on 6 August 1928 in Pittsburgh, Pennsylvania, the third son of Ondrej and Julia Warhola.* Both his parents were immigrants from a small Carpatho-Rusyn village in the Presov region of Slovakia. Warhol's father had first emigrated to the United States in 1907 and married Julia Zavacky in 1909 on one of his return trips to Slovakia.

1. *Dick Tracy*, 1960.
Casein and pencil on canvas,
121.9 x 83.9 cm,
The Brant Foundation,
Greenwich.

* *Andy Warhol did not abbreviate his surname from Warhola until 1949, but we shall employ the shortened surname hereafter in order to differentiate the painter from his father.*

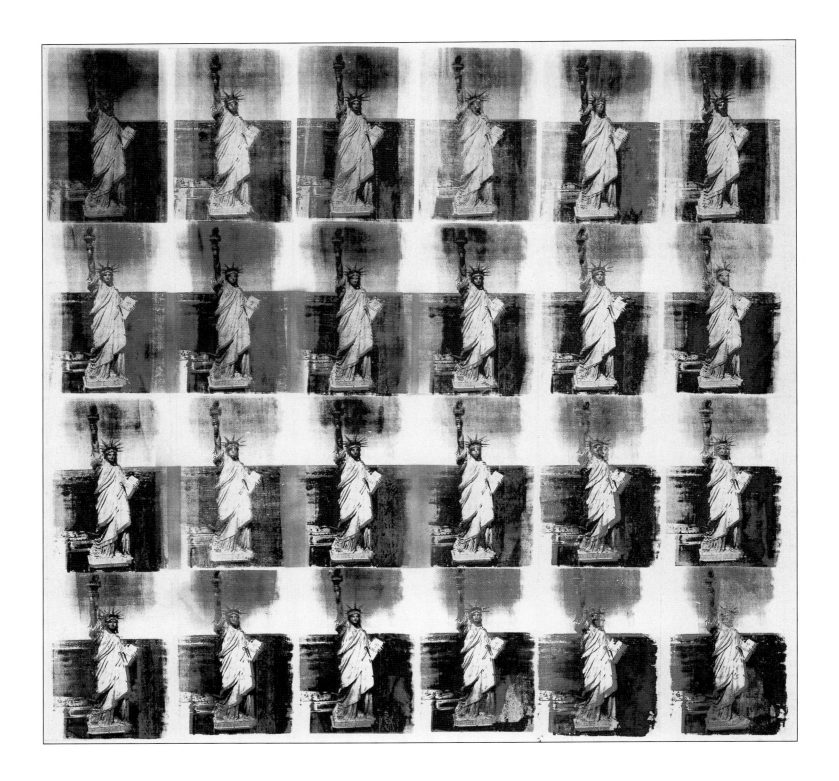

2. *Statue of Liberty*, 1963.
 Silkscreen ink and acrylic paint
 on canvas, Daros collection,
 Zurich.

3. Jasper Johns, *Flag on Orange
 Field II*, 1958.
 Encaustic on canvas,
 92.7 x 37.2 cm,
 Private collection.

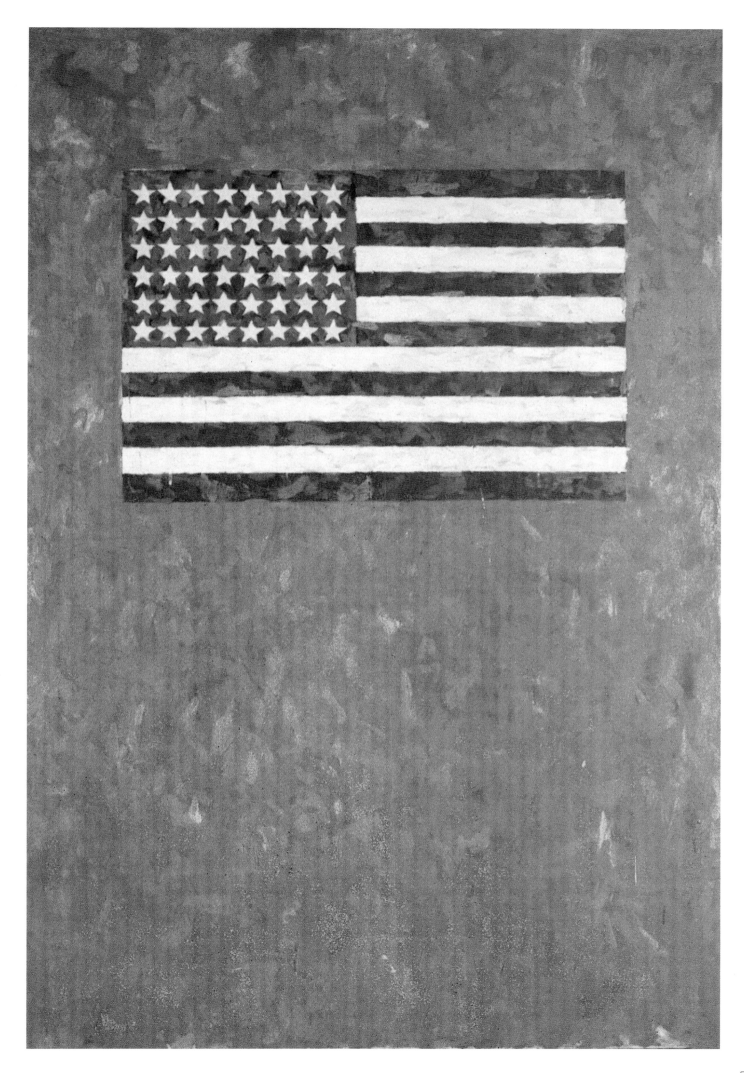

7.

In 1912 he re-emigrated to America when threatened with conscription into the Austro-Hungarian army, although it was not until 1921 that Julia Warhola was able to join him there.

Although Pittsburgh was, and remains one of the most dynamic industrial cities in America, the Depression severely affected its economy shortly after Warhol was born, and his father was amongst the many tens of thousands thrown out of work by the slump. However, Ondrej Warhola's resourcefulness ensured that his family did not suffer unduly. By 1934 his finances had sufficiently recovered to permit him to move his family to a more salubrious part of Pittsburgh, and shortly afterwards his youngest son entered Holmes Elementary School where the boy's artistic talent soon became apparent.

In 1936 Warhol developed rheumatic fever, which worsened into a mild attack of chorea or St Vitus's dance, and this illness somewhat disrupted his schooling for the next few years. In September 1941 Warhol entered Schenley High School, Pittsburgh, where his artistic talents were further encouraged. But these years were overshadowed by the increasing illness, and finally the death of Warhol's father in May 1942. With the death of Warhola senior, the second son, John, assumed the role of head of the family, and the paternal loss forged a further close bond between Andy and his mother, a bond that would last almost up to her death.

Warhol graduated from Schenley High School in 1945 and obtained a place at the Carnegie Institute of Technology (now the Carnegie-Mellon University) in Pittsburgh, majoring in Pictorial Design. He also suffered from the need to establish his artistic personality. Very frequently the timid, malleable boy would produce work that was obviously designed to appeal to his teachers rather than express his own view of things. Consequently, at the end of his first year Warhol was threatened with exclusion from the course. This had an electrifying effect on him and during the subsequent vacation he worked exceptionally hard at making drawings of daily life. By the time college reconvened in the autumn Warhol possessed an excellent body of work that not only regained him a place on the Pictorial Design course and obtained him a show in the art department. To the end of his life Warhol had a fear of failure, and it is easy to pinpoint the youthful event that gave rise to it.

Warhol benefited from an excellently rounded art education at the Carnegie Institute of Technology. Here, Warhol was greatly influenced by German *Bauhaus. The New Vision* by Moholy-Nagy, for example, celebrated the creation of works of art by wholly mechanistic and emotionally detached means, and such recommendations could well have had a subsequent bearing on Warhol's mature practice as an artist.

Indirectly, another erstwhile Bauhaus teacher certainly had an immediate effect upon Warhol's stylistic development. This was the Swiss painter Paul Klee whose *Pedagogical Sketchbook* was set reading for the students at Carnegie Tech. Many of Warhol's magazine illustrations throughout the late 1940s and 1950s look stylistically very like drawings by Shahn, for although they contain a much greater whimsicality than is ever apparent in Shahn's work, it was surely from Shahn's broken-line technique that Warhol developed his similar looking but more vivid blotted-line technique that he used throughout his career as a commercial illustrator. This method gave Warhol's drawings an instantaneous visual quirkiness, as well as providing him with the first of his many means of reproducing images *en masse*.

Other artists whose output Warhol is known to have encountered at Carnegie Tech in the late 1940s were Marcel Duchamp and Salvador Dalí. In time, Warhol would actually own works by Duchamp, and in his cultural attitudes and artistic iconoclasm he certainly would prove himself to be the Frenchman's worthy successor at deflating cultural pretensions and subverting creative expectations.

4. *Dance Diagram (Fox Trot)*, 1962.
Casein and pencil on canvas,
177.8 x 137.2 cm,
Onnash collection.

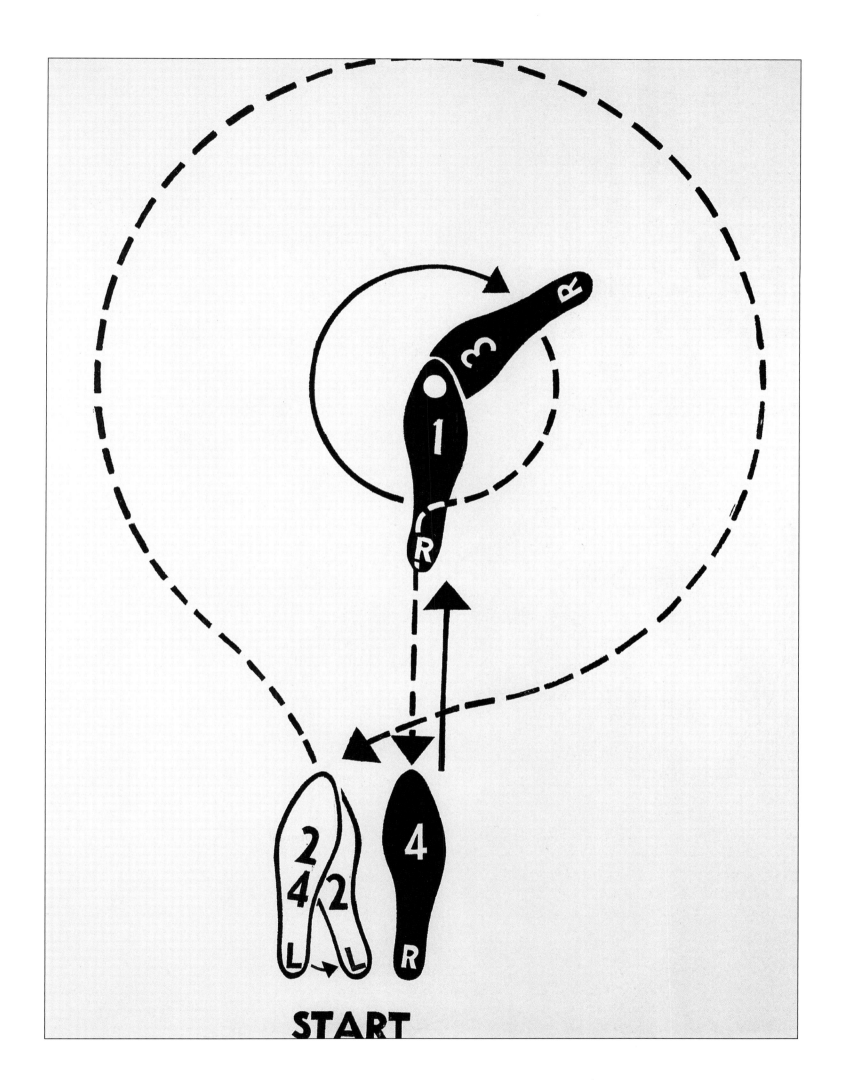

START

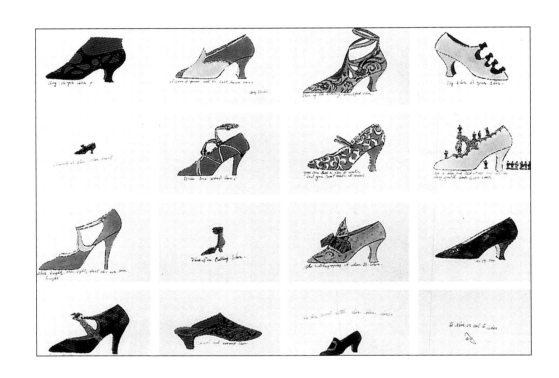

5. *A la Recherche du Shoe Perdu*,
 1955. Lithograph watercolour,
 each 24.5 x 34.5 cm,
 The Andy Warhol Foundation for
 the Visual Arts, Inc., New York.

6. *Shoe Advertisement for I.Miller*,
 1958. The Andy Warhol
 Foundation for the Visual Arts,
 Inc., New York.

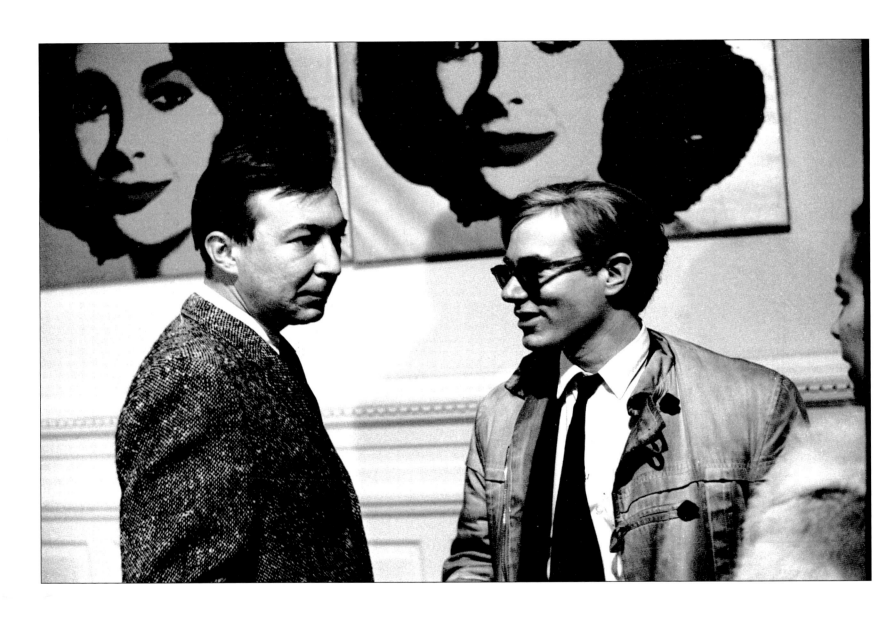

7. *Photo of Andy Warhol with Jasper Johns*, c. 1964.

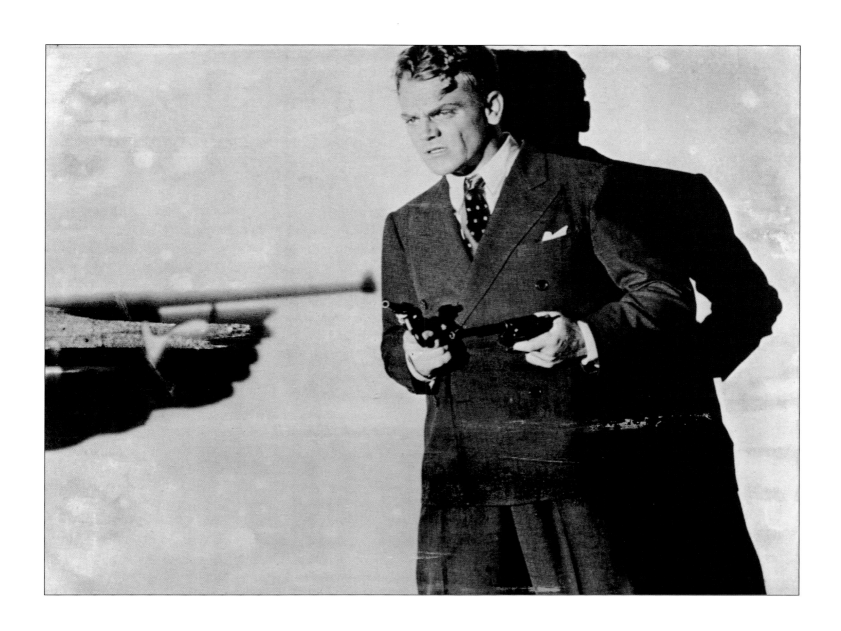

8. *Cagney*, 1962. Silkscreen ink on
 paper, 76.2 x 101.6 cm,
 Mugrabi collection.

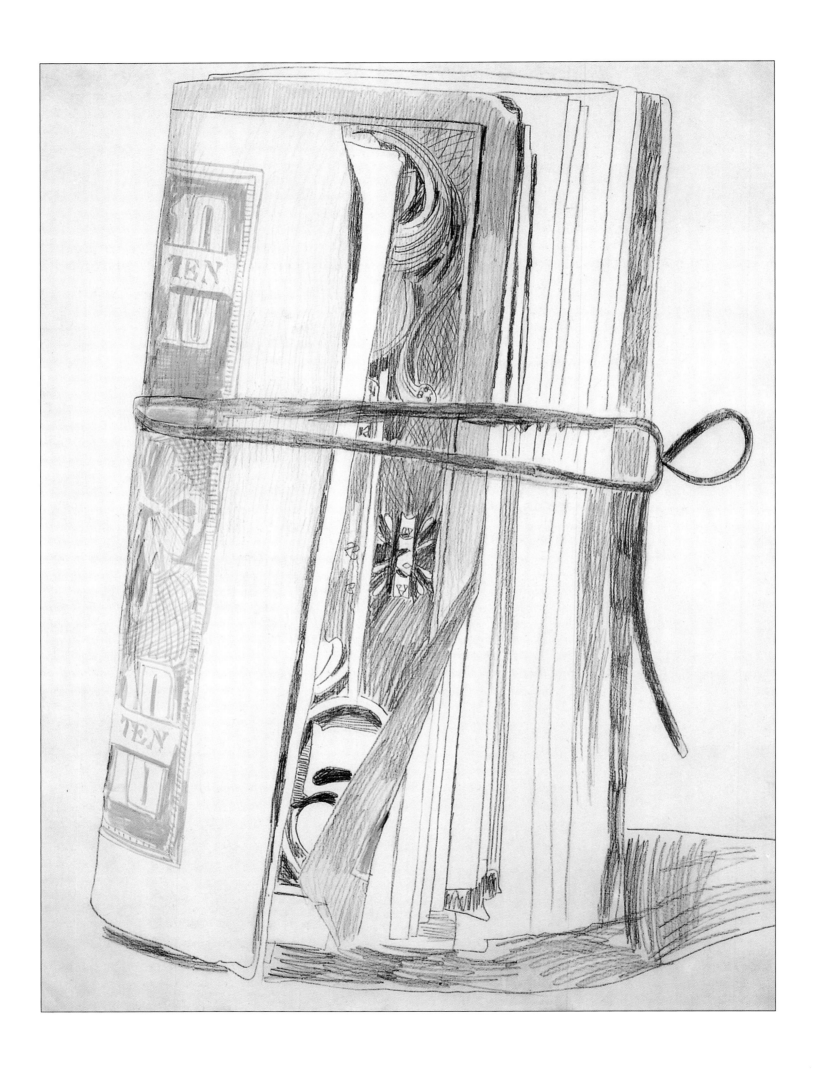

14.

In June 1949 Warhol graduated from the Carnegie Institute of Technology with a Batchelor of Fine Arts degree. The following month he moved to New York, along with his fellow student Philip Pearlstein. On a previous trip to New York in September 1948, Warhol had made the acquaintance of Tina Fredericks, the art editor of *Glamour* fashion magazine, and now he looked her up again in order to solicit work; she responded by buying one of Warhol's drawings and commissioning a suite of shoe illustrations, shoes being a subject that Warhol would soon make his speciality. When these illustrations appeared in the magazine in September 1949, the 'a' in Warhol's surname was dropped from the credit byline (possibly by accident) and the artist adopted that spelling thereafter.

Warhol was determined to succeed in New York and he haunted the offices of art directors in search of work, even cultivating a down-and-out, 'raggedy Andy' look in order to gain the sympathy of potential clients. One successful commission soon led to another, and within a relatively short time Warhol was much in demand for his highly characterful illustrations, both within the Condé Nast organisation (to which *Glamour* magazine belonged) and beyond it. Later, as a mature fine artist, Warhol would react against any impartation of 'feeling' to images made by his somewhat industrialised processes, and he would thereby achieve a much greater congruity between cause and effect.

Throughout 1950 Warhol's career was on the up and up, and by the following year he was creating his first drawings for television. In September 1951 one of his drawings was reproduced as a full page advertisement in the *New York Times* to advertise a forthcoming radio programme on crime, this greatly boosted his professional reputation; two years later the design would win him his first Art Director's Club Gold Medal.

In June 1952 the artist held his first exhibition. This was mounted at the Hugo Gallery on East 55th Street and comprised a suite of fifteen drawings based on the writings of Truman Capote. The Capote drawings exhibition gained one or two reviews but Warhol sold nothing. However, by now his commercial career was really taking off. Within a short time Warhol had become the most sought-after fashion illustrator in New York. He also became very active as a book illustrator, producing privately published books of drawings with whimsical titles such as, *Love is a Pink Cake*, upon which he collaborated with one of his boyfriends, Ralph Ward.

Warhol had first discovered his latent homosexuality when he was still a student in Pittsburgh but naturally, within such a relatively narrow-minded and intolerant provincial environment, he had been very guarded about his sexual preferences; in the more open surroundings of New York he felt less inhibited and initially indulged his proclivities to the full, although after the first shock of freedom had worn off he was not particularly promiscuous.

Indeed, Warhol thereafter formed a number of fairly committed relationships, such as the friendship he enjoyed with Charles Lisanby whom he met in the autumn of 1954 and to whom he closely related for about ten years. In time Warhol would form other relationships and frequently become infatuated, but for the most part he downplayed his sexual persona, and often he sublimated his sexuality into a highly manipulative voyeurism.

In 1955 Warhol took his biggest step as an illustrator by obtaining the commission to make a series of designs to appear almost weekly in the *New York Times* Sunday editions for the highly fashionable I. Miller shoe store. Warhol's shoe illustrations created an enormous impact. Nathan Gluck, his new studio assistant, who would go on working for him until 1964, had good contacts in the retail trade and he arranged for Warhol to design window displays for the Bonwit Teller department. This commission also led Warhol to design window displays for the Tiffany's and I. Miller stores.

9. *Roll of Bills*, 1962. Pencil, felt-tipped pen and crayon on paper, 101.6 x 76.4 cm, Museum of Modern Art, New York.

10. *Double Self-Portraits*, 1966-
1967. Silkscreen ink on two
panels, each 55.9 x 55.9 cm,
The Brant Foundation,
Greenwich.

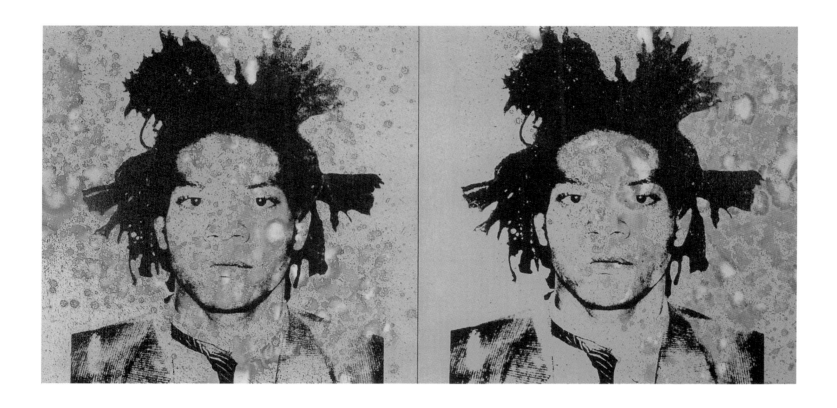

11. *Jean-Michel Basquiat*, ca. 1984.
Synthetic polymer paint and
silkscreen, 101.6 x 101.6 cm,
The Andy Warhol Museum,
Pittsburgh.

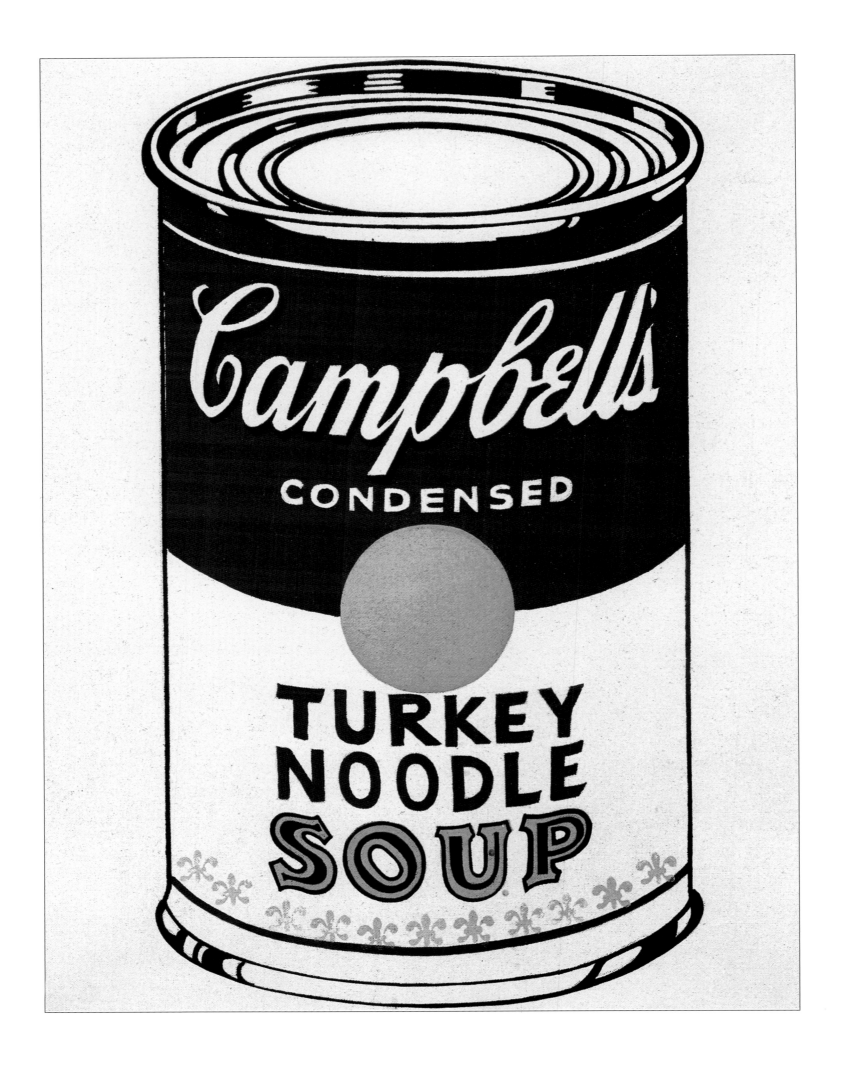

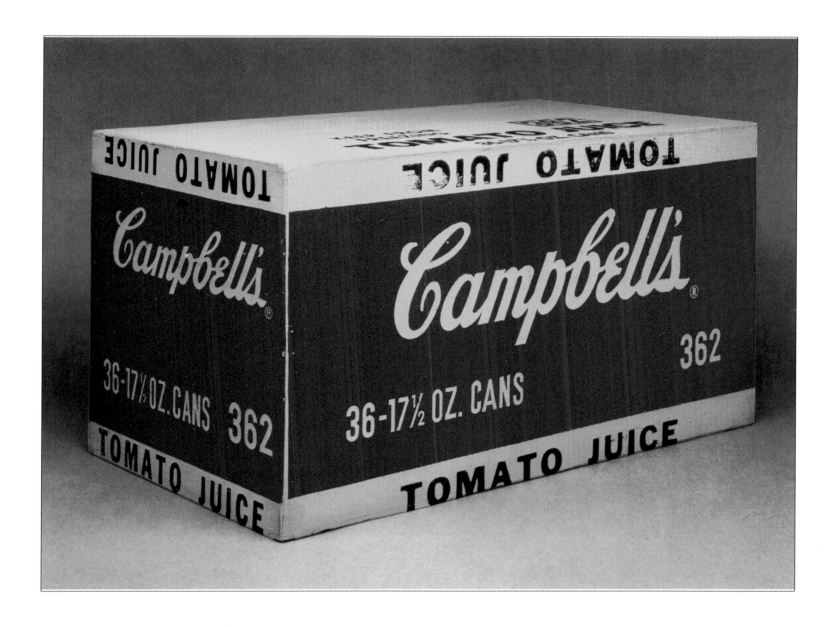

12. *Campbell's Soup Can
(Turkey Noodle)*, 1962. Silkscreen
ink on canvas, 51 x 40.6 cm,
Sonnabend collection.

13. *Campbell's Tomato Juice*, 1964.
Oil on wood, 25.4 x 48.2 x 24.1 cm,
Paul Warhol collection.

Warhol sold many of the original I. Miller shoe advertisement drawings through the Serendipity shop, and subsequently he produced a book of highly whimsical drawings of shoes entitled *A la Recherche du Shoe Perdu*, shoes being objects to which he was sexually attracted; in time he would collect hundreds of pairs of them and would enjoy kissing the shod feet of his boyfriends when making love to them. He was also highly voyeuristic, creating an ongoing series of drawings of sexual organs for a proposed book of 'cock' drawings, as well as a portfolio of studies of beautiful young males and their beribboned private parts which he published under the title of *Drawings for a Boy Book*.

In February 1956 Warhol held an exhibition of the *Boy Book* designs, as well as the books themselves, at the Bodley Gallery. That year Warhol was also awarded the 35th Annual Art Directors Club Award for Distinctive Merit for his I. Miller shoe advertisements.

In January 1958, an exhibition opened at the Leo Castelli Gallery in New York that would ultimately change Warhol's entire life. This was the first largescale showing of Jasper Johns's paintings of the American flag, and of targets and numbers. The challenge such images offered to the prevailing aesthetic trend of the day was consolidated a mere two months later by an exhibition of works by Robert Rauschenberg. Between them, these two artists brought about a radical break with the direction that recent American art had been taking.

Throughout the late 1940s and the 1950s, American artists such as Jackson Pollock, Arshile Gorky, Willem de Kooning, Franz Kline, Clyfford Still, Mark Rothko and Barnett Newman had been giving American art the aesthetic lead over art everywhere else by exploring the psychological, expressive or colouristic basics of the painterly process in ways that carried to fulfilment the implications of surrealism, expressionism or colour abstraction, whilst usually ditching representationalism altogether. In the face of such elevated aspirations, the throwaway, neo-Dada gestures of Johns and Rauschenberg, which also occasionally looked to the familiar imagery of contemporary mass culture, seemed wholly subversive. Thus in works like his American flag pictures, Johns redeployed the familiar quasi-expressionistic brushwork of the previous artistic generation in ways that paradoxically and ironically enjoyed no expressive intention whatsoever. Neither Johns nor Rauschenberg can be considered to be pop artists, for they were not primarily interested in the mass culture around them. But undoubtedly the occasional appropriation by Johns and Rauschenberg of imagery from mass culture rubbed off on Warhol and, like them, in time he too would call into question the very nature of a work of art itself.

The Johns and Rauschenberg shows of 1958 gave Warhol an intense desire to break with 'commercial' art and instead become a fine artist. In 1959 he received the Certificate of Excellence from the American Institute of Graphic Arts for his previous year's output. That autumn he published a joke cookbook, *Wild Raspberries* and in December 1959 he held an exhibition of the book designs at the Bodley Gallery. However, New York taste was moving away from Warhol's fey imagery. Faced with this marginalisation, and by the growing acclaim that was being accorded to artists such as Johns and Rauschenberg, Warhol felt increasingly desperate about the creative *cul de sac* into which he was heading.

As with the threat of dismissal that had confronted him in his first year at art school some fifteen years earlier, the possibility of failure galvanised Warhol into action. In 1960 he even made works in the neo-Dada vein that Rauschenberg had previously explored, by urinating on some white canvases as an anti-art gesture. He also resorted to placing some blank canvases on the pavement outside the house on Lexington Avenue so that the footmarks left on them by passing pedestrians would constitute a random 'artistic' statement. However, he soon realised that such gestures would not lead anywhere.

14. *Do It Yourself (Sailboats)*, 1962. Acrylic paint and pencil on canvas, 183 x 254 cm, Daros collection, Zurich.

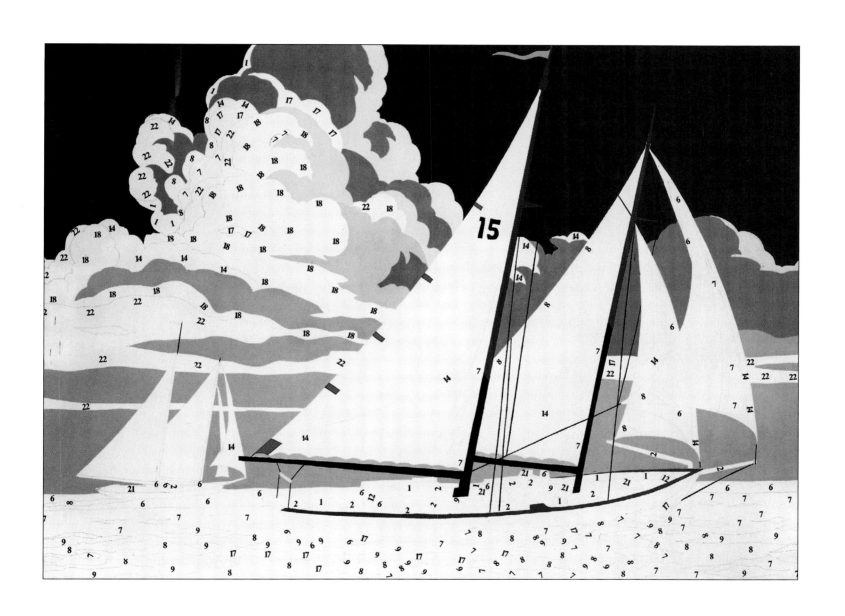

capricorn

Moe Whiskey Fizz

Juice of ½ lemon, 1 teaspoon sugar, 1 jigger whiskey. Shake with ice, strain into highball glass. Fill with soda and ice cubes.

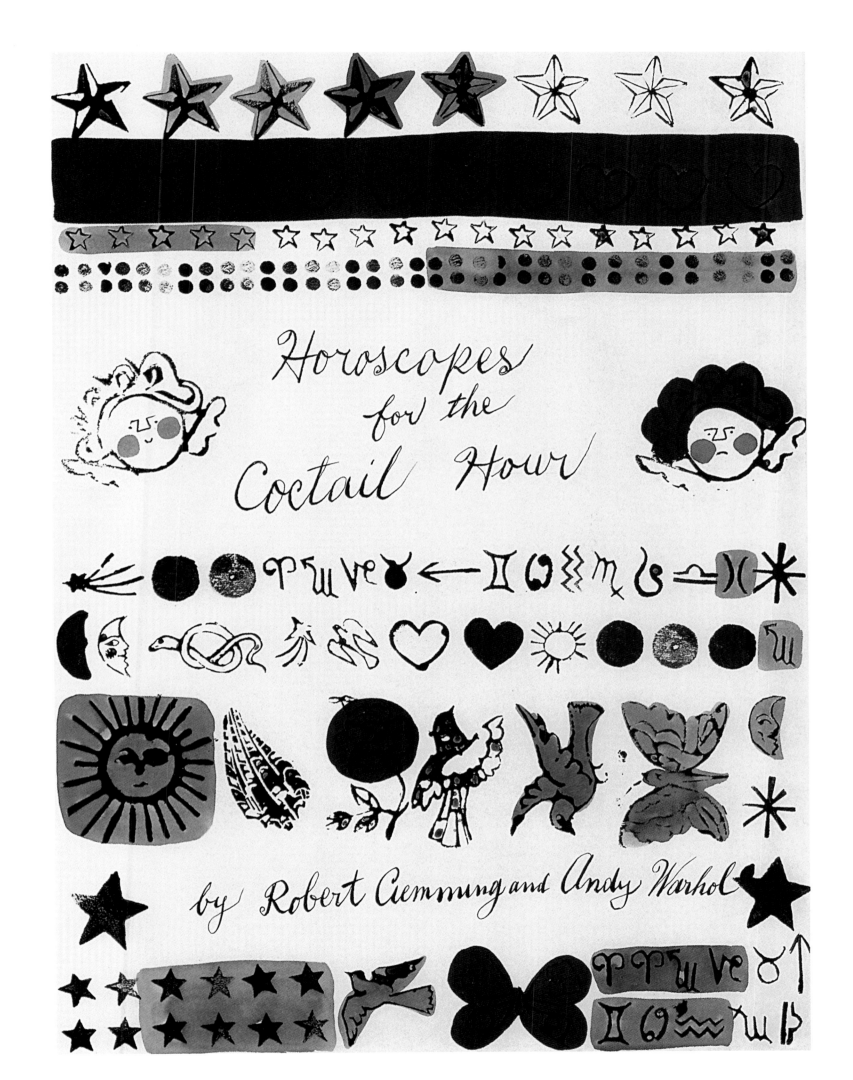

Horoscopes for the Coctail Hour

by Robert Clemming and Andy Warhol

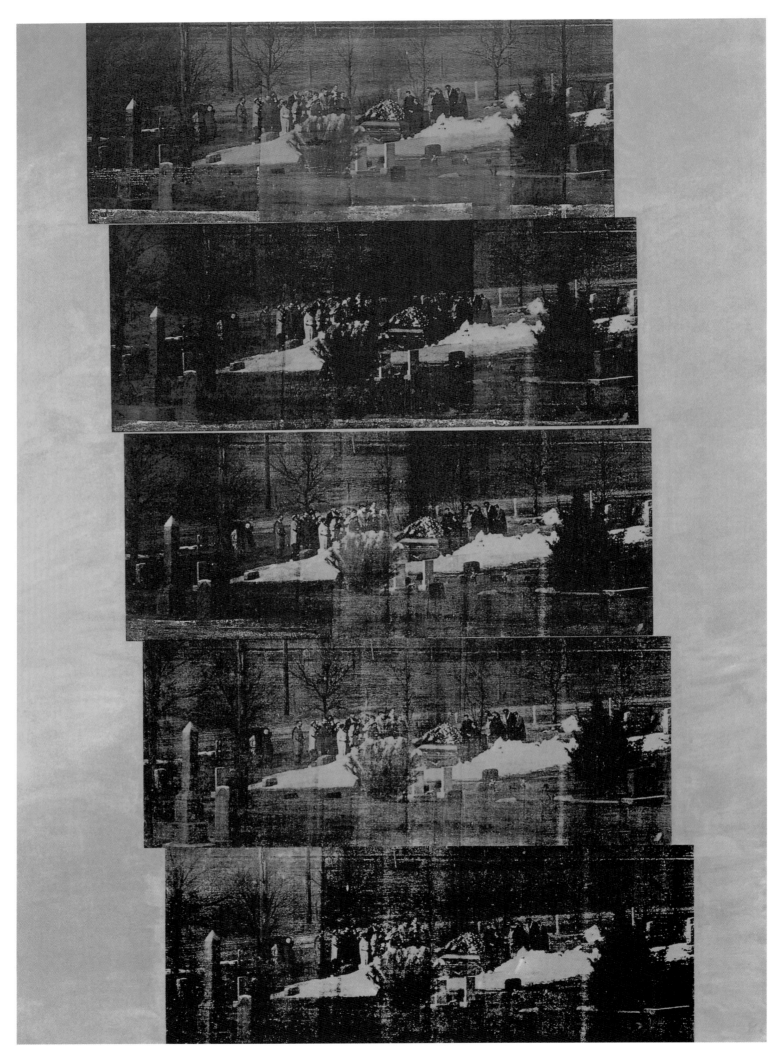

24.

Instead, he began painting mass-culture objects such as Coca-Cola bottles, refrigerators and television sets, and he also appropriated imagery from cheap advertisements and comic strips. And when he showed two of the resulting efforts to his friend, the filmmaker Emile de Antonio, he was left in no doubt that he was on the right track; as the painter later recalled:

> *After I'd done my first canvases, De [Antonio] was the first person I wanted to show them to. He could always see the value of something right off... One of them was a Coke bottle with Abstract Expressionist hash marks halfway up the side. The second one was just a stark, outlined Coke bottle in black and white. I didn't say a thing to De. I didn't have to – he knew what I wanted to know.*
>
> *"Well, look, Andy," he said after staring at them for a couple of minutes. "One of these is a piece of shit, simply a little bit of everything. The other is remarkable – it's our society, it's who we are, it's absolutely beautiful and naked, and you ought to destroy the first one and show the other".*

Faced with such encouragement, Warhol began to put out feelers for a gallery to show his work, although he encountered strong resistance, due mainly to his prevailing image as a 'commercial artist'. But one person who did take Warhol seriously was Leo Castelli's assistant, Ivan Karp. Unfortunately Castelli didn't like the pictures at first. This was due to the fact that although Warhol had dropped comic strip imagery from his paintings when he learned that another New York artist, Roy Lichtenstein, was also employing such source material, Castelli felt that the imagery of the two painters was over-similar; as he already represented Lichtenstein, he felt he couldn't handle Warhol as well. Nonetheless he still had other ways of putting his pictures before the public: in April 1961 he exhibited several of them in one of the 57th Street windows of the Bonwit Teller department store.

Warhol wanted fame, and to achieve that he required an imagery that would force the world to take him seriously as an artist. Finally the problem resolved itself one evening in December 1961. Warhol got talking to an interior decorator and gallery owner acquaintance, Muriel Latow, who supplied exactly what he needed, albeit at a price; as a mutual friend, Ted Carey, later related:

> *... Andy said,... "I've got to do something that really will have a lot of impact..., that will be very personal, that won't look like I'm doing* exactly *what they're doing... I don't know what to do. So, Muriel, you've got fabulous ideas. Can't you give me an idea?" And Muriel said, "Yes, but it's going to cost you money." So Andy said, "How much?" She said, "Fifty dollars..." He said, "All right, give me a fabulous idea." And so Muriel said, "What do you like more than anything else in the world?" So Andy said, "I don't know. What?" So she said, "Money. The thing that means more to you and that you like more than anything else in the world is money. You should paint pictures of money." And so Andy said, "Oh, that's wonderful". "So then either that or," she said, "you've got to find something that's recognizable to almost everybody... Something like a can of Campbell's soup". So Andy said, "Oh, that sounds fabulous." So, the next day Andy went out to the supermarket, and we came in, and he had a case of... all the soups. So that's how [he obtained] the idea of the* Money *and* Soup *paintings.*

This would not be the last time that Warhol would obtain some of his most important ideas from others. Yet because he received stimulus in this way does not in any way render it invalid, for ultimately it was he who carried the visual, aesthetic and cultural potential of those given ideas through to visual fruition. Warhol himself was very open about the derivation of his works, for as he stated in his book *POPism: The Warhol '60s*:

> *I was never embarrassed about asking someone, literally, "What should I paint?" because Pop comes from the outside, and how is asking someone for ideas any different from looking for them in a magazine?... That kind of thing would go on for weeks whenever I started a new project... I still do it. That's one thing that has never changed...*

18. *Coca-Cola*, 1960.
 Oil and wax crayon on canvas,
 182.9 x 76.2 cm,
 Dia Center for the Arts,
 New York.

19. *Close Cover Before Striking*,
 1962. Acrylic paint on canvas,
 183 x 137.2 cm,
 Louisiana Museum of Modern
 Art, Humlebaek, Denmark.

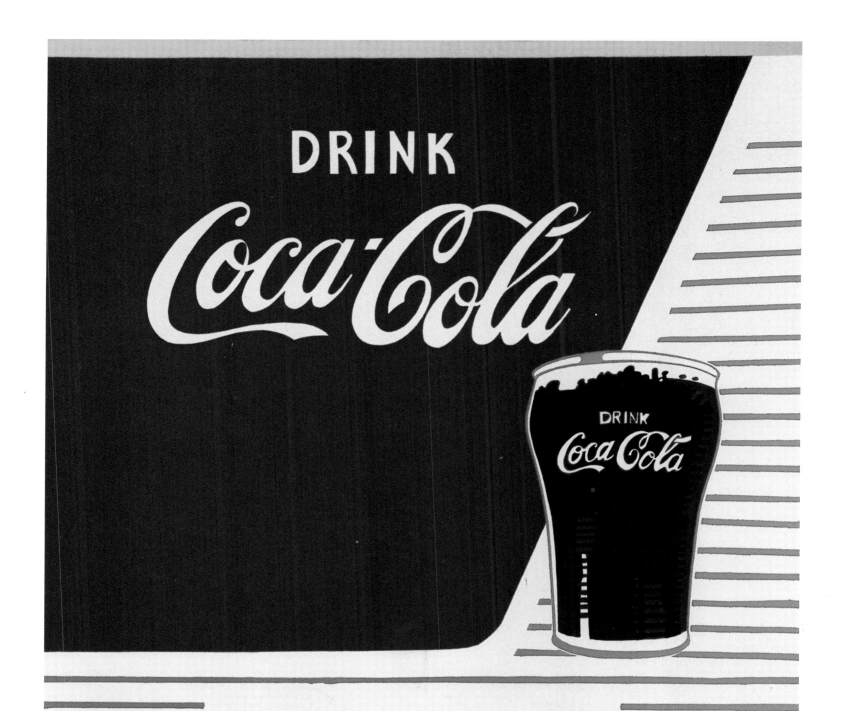

27.

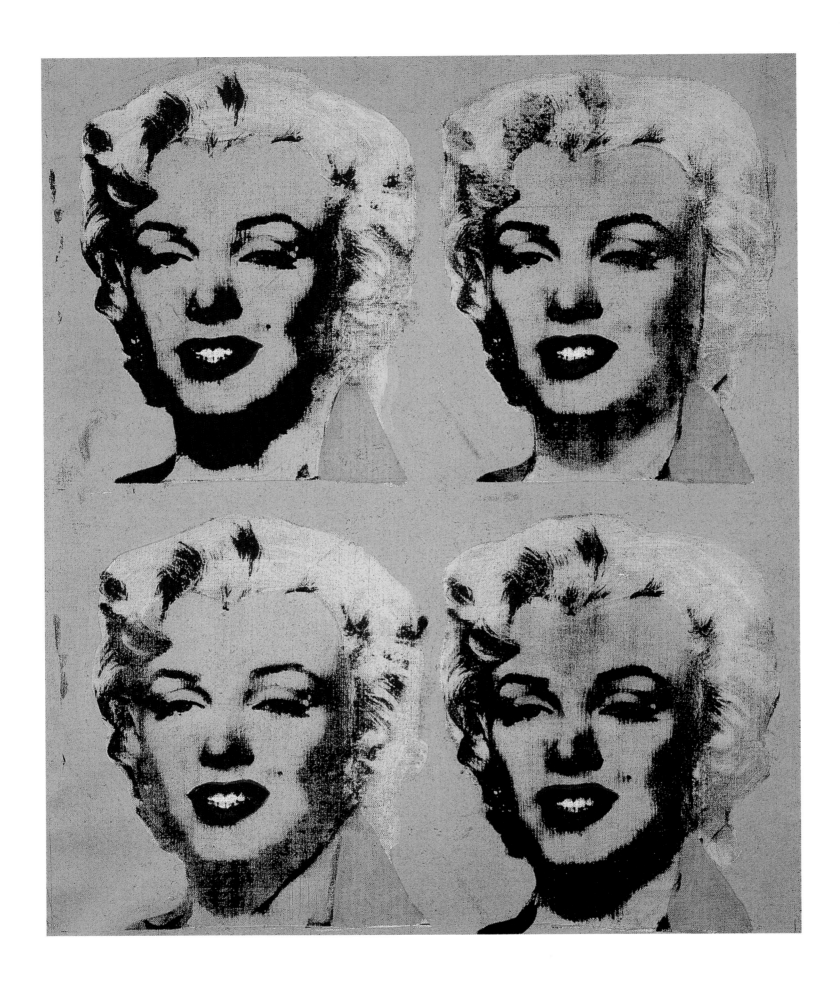

28.

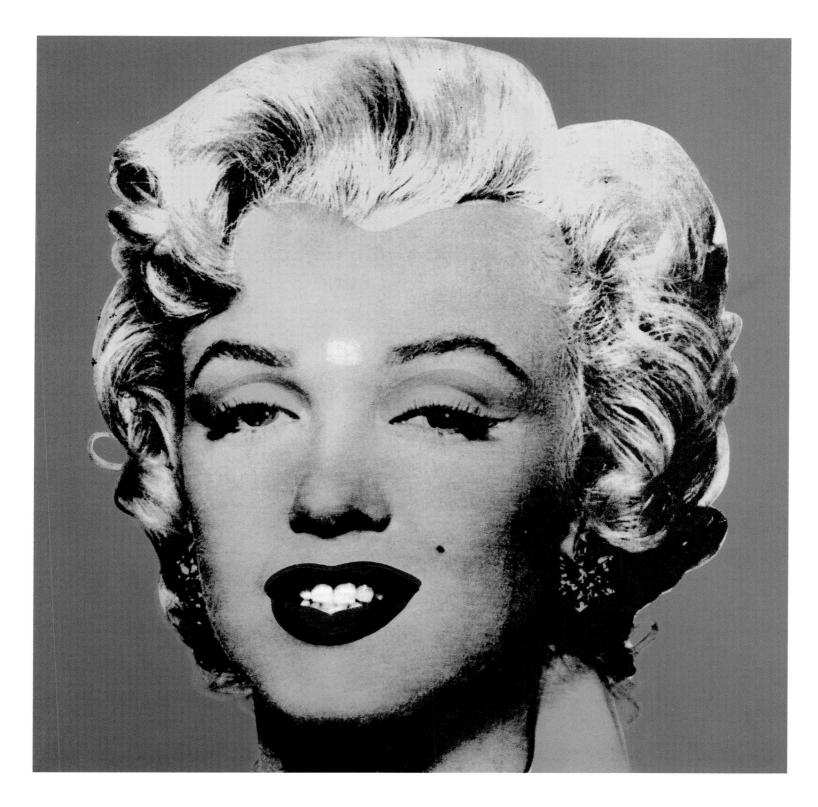

20. *Four Marilyns*, 1962.
 Silkscreen ink on canvas,
 73.6 x 60.9 cm,
 Sonnabend collection.

21. *Shot Blue Marilyn*, 1964.
 Silkscreen ink and synthetic
 polymer paint on canvas,
 101.6 x 101.6 cm,
 The Brant Foundation,
 Greenwich. This is one of the
 four canvases shot by Dorothy
 Podber in 1964, hence its name.

Inspired by the ideas he had purchased from Muriel Latow, Warhol immediately set to work painting pictures of both money and of cans of Campbell's soup.

All through the winter and spring of 1962 Warhol worked on pictures of dollars in various combinations, both as individual bills and in rows, and also upon a set of 32 small canvases that individually featured the 32 different varieties of Campbell's soups, each on a blank background. And this is where Warhol's conceptual and visual genius took over from Muriel Latow's original idea, for the deadpan arrangement of the images enforced a rigid disconnection from emotion, whilst the machine-like appearance of the images was an exact analogue for the industrial processes that had brought the objects they represented into being in the first place. Warhol was making a comment upon the bloodless imagery of the machine age through directly reflecting its mechanistic divorce from emotion by means of his own imagery.

Muriel Latow's ideas had therefore taken root in very fertile soil indeed. And for Warhol, such imagistic mechanisation probably reflected a social mechanisation as well; as he told Gene Swenson in 1963:

> Someone said Brecht wanted everybody to think alike. I want everybody to think alike…
> Everybody looks alike and acts alike, and we're getting more and more that way.
> I think everybody should be a machine… because you do the same thing every time. You do it
> again and again… Some day everybody will think just what they want to think, and then
> everybody will probably be thinking alike; that seems to be what is happening.

But undoubtedly Warhol was making larger points here about the repetitiousness and conformism that underlies much of modern life generally. And from this time onwards Warhol equally began to cultivate a public persona as a machine.

Yet Warhol did not want to be a machine just for its own sake; instead, by means of such an affected stance he could achieve a complete congruence between life and art, for as he told *Time* magazine in May 1963: 'Paintings are too hard. The things I want to show are mechanical. Machines have fewer problems. I'd like to be a machine, wouldn't you?'

To achieve this machine-like end, after 1963 Warhol began to feign an almost robotic emotional and intellectual vacancy that was far removed from the sometimes overwrought and thinking persona he revealed to his friends in private. His machine-like stance was certainly very effective in increasing media interest in him, for the more non-committal he appeared, the more intriguing he became. This was noted by Henry Geldzahler, an assistant curator of twentieth-century American art at the Metropolitan Museum of Art who had been introduced to Warhol by Ivan Karp. Ivan Karp also recorded that when he first visited Warhol 'there was a record playing… at an incredible volume… It was by Dickie Lee, called "I Saw Linda Yesterday". And during the entire time I was there, [Warhol] did not take off the record and it played over and over again… I asked him why he did not change the record since there were other nice things to listen to, and I recommended other groups that might be interesting. He said that he really didn't understand these records until he heard them at least a hundred times.' But there was a serious purpose to this affectation of automatism, as Warhol himself also made clear in *POPism: The Warhol '60s*:

> I still wasn't sure if you could completely remove all the hand gesture from art and become
> noncommittal, anonymous. I knew that I definitely wanted to take away the commentary of the
> gestures – that's why I had this routine of painting with rock and roll blasting the same song.
> The music blasting cleared my head out and left me working on instinct alone… I'd also have
> the radio blasting opera and the TV picture on (but not the sound) – and if all that didn't clear
> enough out of my mind, I'd open a magazine, put it beside me, and half read an article while
> I painted. The works I was most satisfied with were the cold "no comment" paintings.

22. *Self-Portrait with Skull*, 1978.
 Silkscreen ink and acrylic paint
 on canvas, 40.6 x 33 cm,
 Private collection.

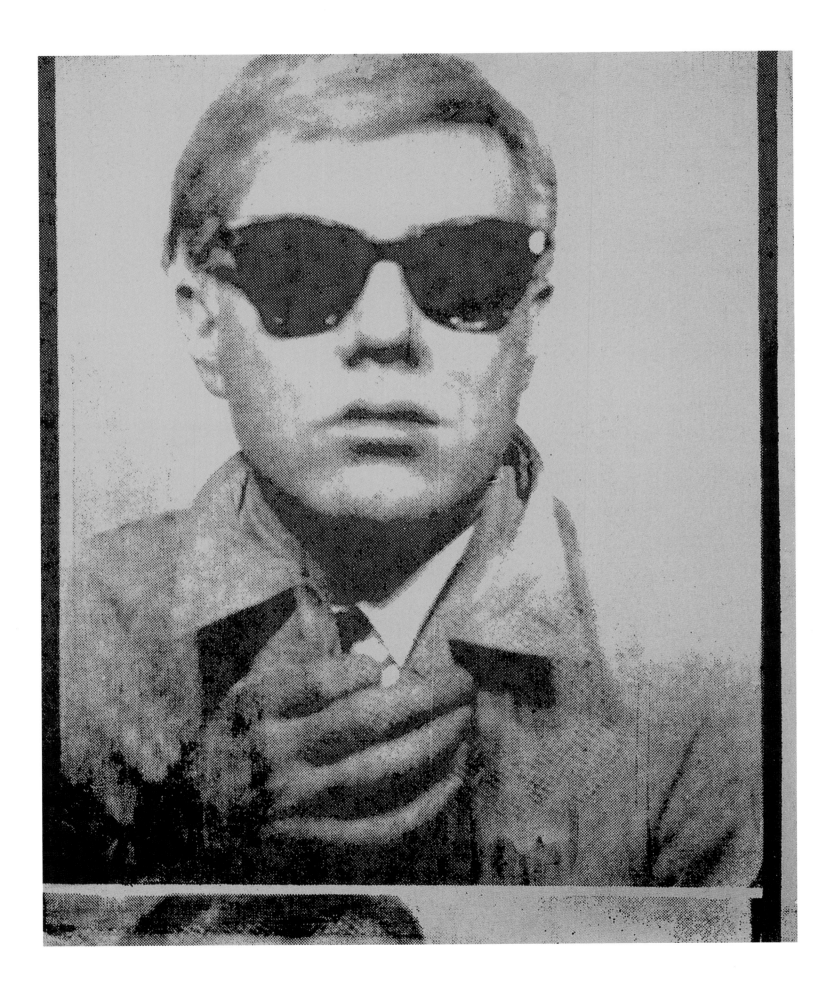

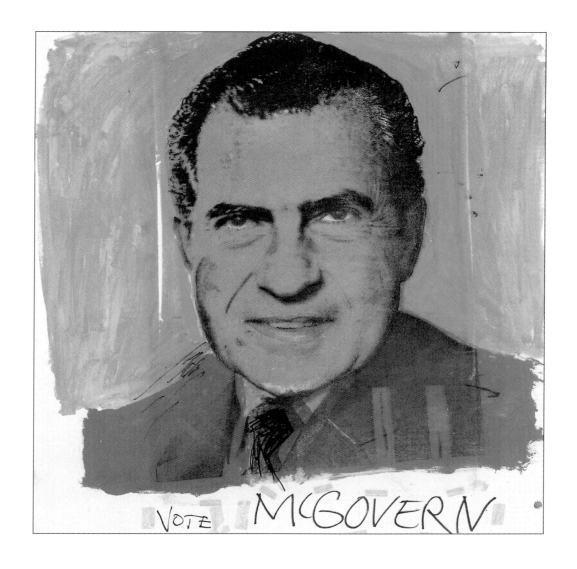

23. *Self-Portrait*, 1964.
 Silkscreen ink and acrylic paint
 on canvas, 183 x 183 cm,
 Froehlich collection, Stuttgart.

24. *Vote McGovern*, 1973.
 Screenprint, 106.7 x 106.7 cm,
 Gemini GEL, Los Angeles.

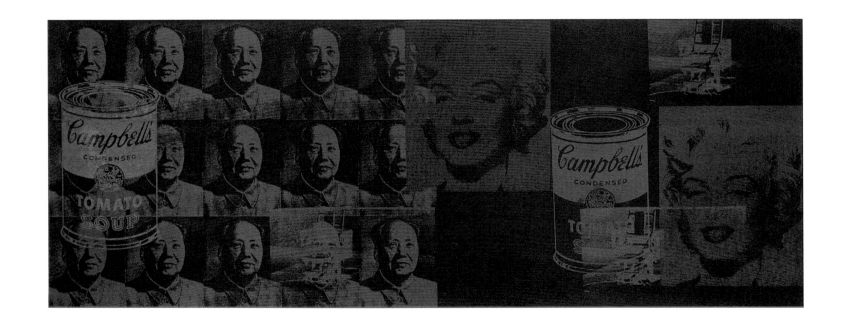

25. *Black on Black Retrospective*,
1979. Synthetic polymer paint
and silkscreen ink,
75.5 x 187.9 cm,
Mugrabi collection.

26. *Ethel Scull Triptych*, 1963.
Silkscreen ink and acrylic paint
on canvas, 50.8 x 40.6 cm,
Mugrabi collection.

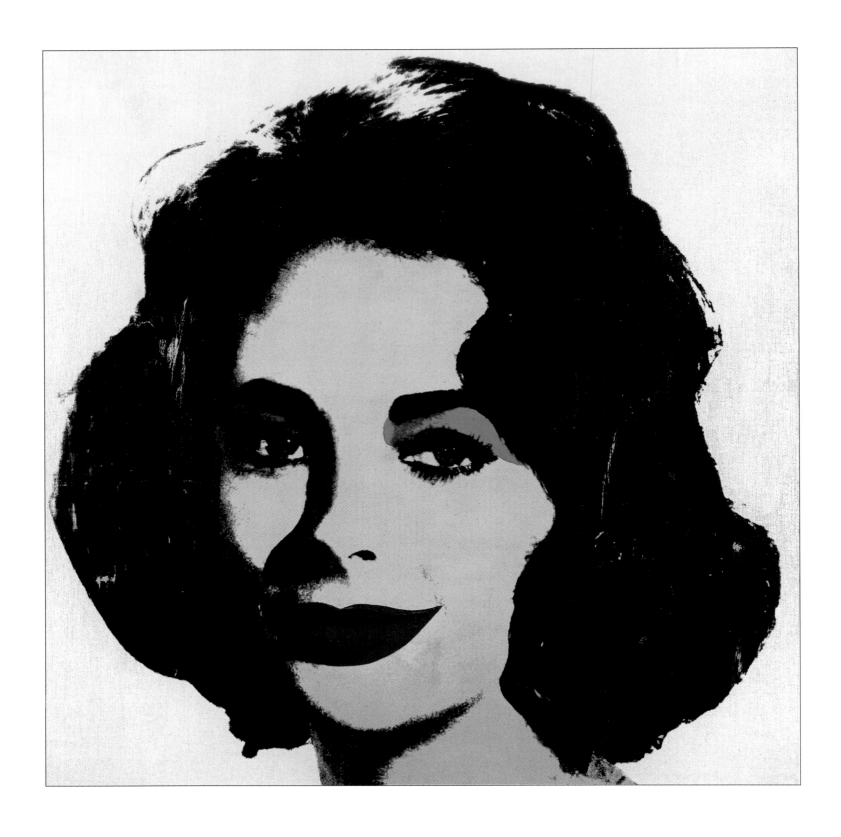

36.

Related to Warhol's affectation of a robotic stance in order to achieve and/or match the objectivity of his visual images, was his affected avoidance of being taken seriously or even of taking himself seriously. One is lead to believe that the artist did not intend to communicate any meanings whatsoever through his works. But it is precisely in Nothingness that his greatest meaning resides, for it testifies to the utter nihilism that Warhol saw in the world around him, a negation that gives his art its acute relevance to the spiritual void in which Western man for the most part resides.

Throughout the late spring and early summer of 1962 Warhol laboured on his canvases, making large pictures of individual soup cans, teach-yourself-to-dance diagrams and paint-by-numbers images. He also further extended his subject-matter by depicting serried ranks of Coca-Cola bottles, S & H Green Stamps, airmail stamps and stickers, and 'Glass – Handle with Care' labels. And simultaneously he moved in a different direction too. On 4 June 1962 Warhol lunched at Serendipity with Henry Geldzahler who told him:

> That's enough affirmation of life... Maybe everything isn't so fabulous in America. It's time for some death. This is what's really happening.

Geldzahler then handed Warhol a copy of that morning's *Daily News* which carried the headline '129 DIE IN JET!' Once again Warhol immediately grasped the underlying cultural implications of such imagery and created the painting of the selfsame front page that is reproduced below. It was to be the first of his many disaster pictures.

129 Die in Jet! was hand-painted and therefore not as mechanistic-looking as its prototype, inevitably it looks subjective. In an attempt to counter this problem, and equally to help streamline the process of reproducing visually complex objects such as dollar bills, Coke bottles, Green Stamps, airmail stickers and the like *en masse*, several of those types of images were initially produced using hand cut stencils or rubber stamps and wood blocks, all devices that Warhol had used in his former life as an illustrator. But the gap between hand-made and machine-made images was truly closed in July 1962 when Nathan Gluck suggested that if Warhol really wanted to cut out the laboriousness of producing repetitive images, he should use the photo-silkscreen printing technique instead.

With this method, a photographic image is transferred to a screen of sensitised silk stretched on a frame. It thereby allowed him to address to the full the 'quantity and repetition' he saw as being the essential content of his art, in addition to achieving the 'assembly line effect' he wanted. Such a process necessarily imparted a mechanical look to the images, although Warhol was careful to guard against that mechanisation becoming too sterile by encouraging variations in inking and printing overlaps. Moreover, the overlaps and extreme tonal ranges of density in the inking add great visual variety, immediacy and movement to the images. By using photo-silkscreen, Warhol the 'machine' came one step closer to achieving full realisation, with the extra advantage that if necessary the artist could utilise the labour of others in order to help him create the images, as well as enable him to work easily on a comparatively vast scale.

July 1962 was also an important month for Warhol for another reason, for it saw him mount his first one-man show as a fine artist. However, this debut took place not in New York but in Los Angeles, where the owner of the Ferus Gallery, Irving Blum, displayed the 32 Campbell's soup paintings as an ensemble. The exhibition only received limited critical coverage. However, Blum soon regretted having sold any of the pictures, for he realised the artistic value of the group if its individual canvases were kept together. To that end he bought back the works he had parted with and then purchased the entire set.

27. *Silver Liz*, 1963. Acrylic paint and silkscreen ink on canvas, 101.6 x 101.6 cm, The Brant Foundation, Greenwich.

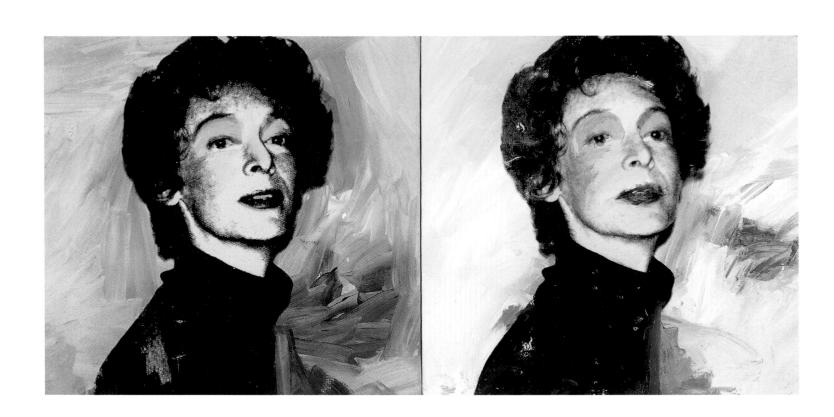

28. *Marella Agnelli*, 1972.
Synthetic polymer paint and
silkscreen ink on canvas,
2 works, 101.6 x 101.6 cm,
The Andy Warhol Museum,
Pittsburgh.

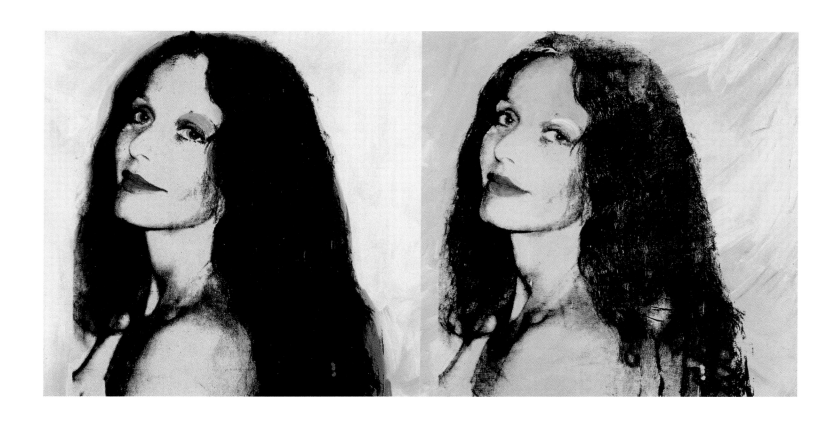

29. *Brooke Hayward*, 1973.
 Acrylic paint and silkscreen
 ink on canvas, 4 panels,
 each 102 x 102 cm,
 The Tate Gallery, London.

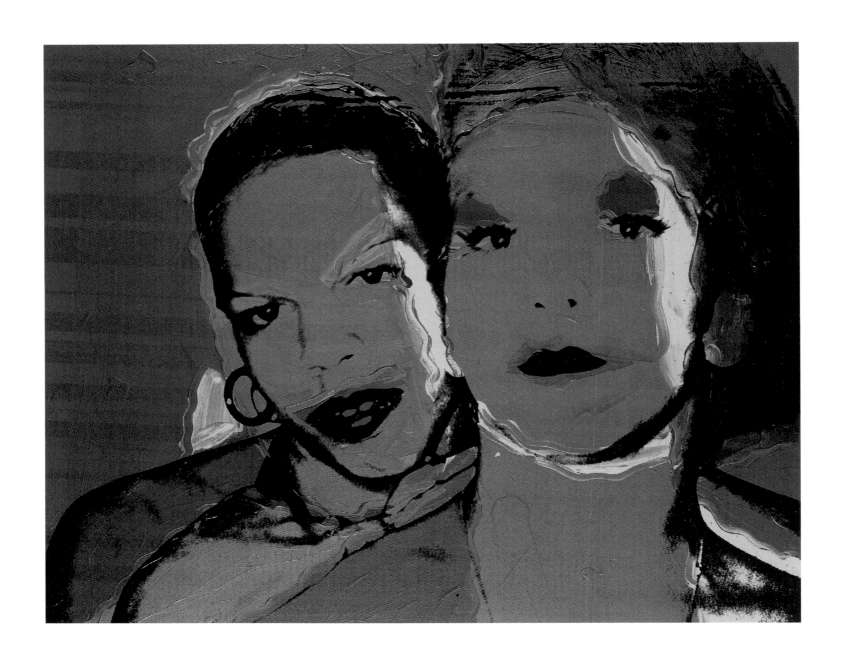

30. *Ladies and Gentlemen*, 1975.
Synthetic polymer paint and
silkscreen ink, 101.6 x 127 cm,
Mugrabi collection.

31. *Ladies and Gentlemen*, 1975.
Synthetic polymer paint and
silkscreen ink, 127 x 101.6 cm,
Mugrabi collection.

Warhol did not travel to Los Angeles for the show, but the very day it ended – 4 August 1962 – Marilyn Monroe committed suicide and so he immediately began a series of silk-screened pictures of her that were destined to become his most famous images. In the Marilyns, Warhol heightened the garishness of the film actress's lipstick, eye shadow and peroxide blonde hairdo, obviously to make points about the garishness of 'glamour' and stardom. Once the Marilyns series was completed, Warhol used the silkscreen technique to create further sets of the soup cans, Coke bottles, coffee cans and dollar bills images he had so laboriously painted earlier that year, as well as embarking upon new sets of images of movie and pop music stars such as Liz Taylor, Marlon Brando and Elvis Presley.

All this hard work soon paid off, for in the summer of 1962 Warhol was at last promised a show in New York, to be held at Elinor Ward's Stable Gallery. A foretaste of what the public would see there came at the end of October when Warhol exhibited some of his works in a group Pop Art show, entitled 'The New Realists': a large painting of a Campbell's soup can; a picture bringing together 200 Campbell's soup cans in ten ranks of twenty cans; a *Do-it-yourself* painting; and one of the *Dance Diagram* pictures which was exhibited under glass on the floor. The exhibition created a sensation, and just a week later, on 6 November 1962, Warhol finally made his New York debut with his Stable Gallery show. On view were eighteen pictures, including the *Gold Marilyn, 129 Die in Jet!*, another *Dance Diagram* painting that was again placed on the floor with an invitation to dance over it, the *Red Elvis*, and several Coca-Cola bottles and soup can pictures. The exhibition was an almost total sell-out, for it generated enthusiastic responses that were worthy of the artist's highest aspirations down the years. Never again would Warhol leave the public eye during his lifetime.

In February 1963 the Metropolitan Museum of Art in New York put Leonardo da Vinci's *Mona Lisa* on display for a month, and Warhol thereupon made some paintings incorporating the image. These pictures not only debunk the cultural status of the Leonardo but equally stress the vast mass-media dissemination of the original image. And in May 1963, when racial tension in the American South was at its height due to the struggle for black civil rights, Warhol developed a series of paintings of police dogs savaging blacks in Birmingham, Alabama, before going on throughout that summer and the rest of the year to explore the related implications of deaths and disasters in a long series of images of suicides, car crashes, gangster funerals, electric chairs, fatalities caused by food poisoning, atomic explosions and, after December 1963, Jackie Kennedy at the presidential funeral of her husband less than a month earlier. As the painter related to Gene Swenson soon after he had embarked upon this series of works:

> *The death series I did was divided in two parts: the first on famous deaths and the second on people nobody ever heard of and I thought that people should think about some time: the girl who jumped off the Empire State Building or the ladies who ate the poisoned tuna fish and people getting killed in car crashes. It's not that I feel sorry for them, it's just that people go by and it doesn't really matter to them that someone unknown was killed so I thought it would be nice for those unknown people to be remembered.*

In almost all of Warhol's Death and Disaster pictures the visual repetition makes cultural points about the way we habitually encounter tragic or horrific imagery through the mass-media, whilst the fact that for most of us such imagery is intriguing throws back in our faces the morbidity, vicariousness or prurience of our interest in unnatural deaths and disasters. The use of colour also importantly contributes to the associations of such imagery, as does the fact that Warhol coupled many of the paintings with a complementary canvas painted blankly with the same background colour. Ostensibly he did so to give purchasers of the works twice as much painting for the same money, but behind this apparently cynical motive it is possible to detect another, more darkly thought-provoking and completely serious rationale: the blankness of each complementary image projects the cosmic meaninglessness of the accidental or manmade tragedies that are represented alongside.

32. *16 Jackies*, 1964.
Silkscreen ink and acrylic
paint on canvas, 16 panels,
each 50.8 x 40.6 cm,
The Brant Foundation,
Greenwich.

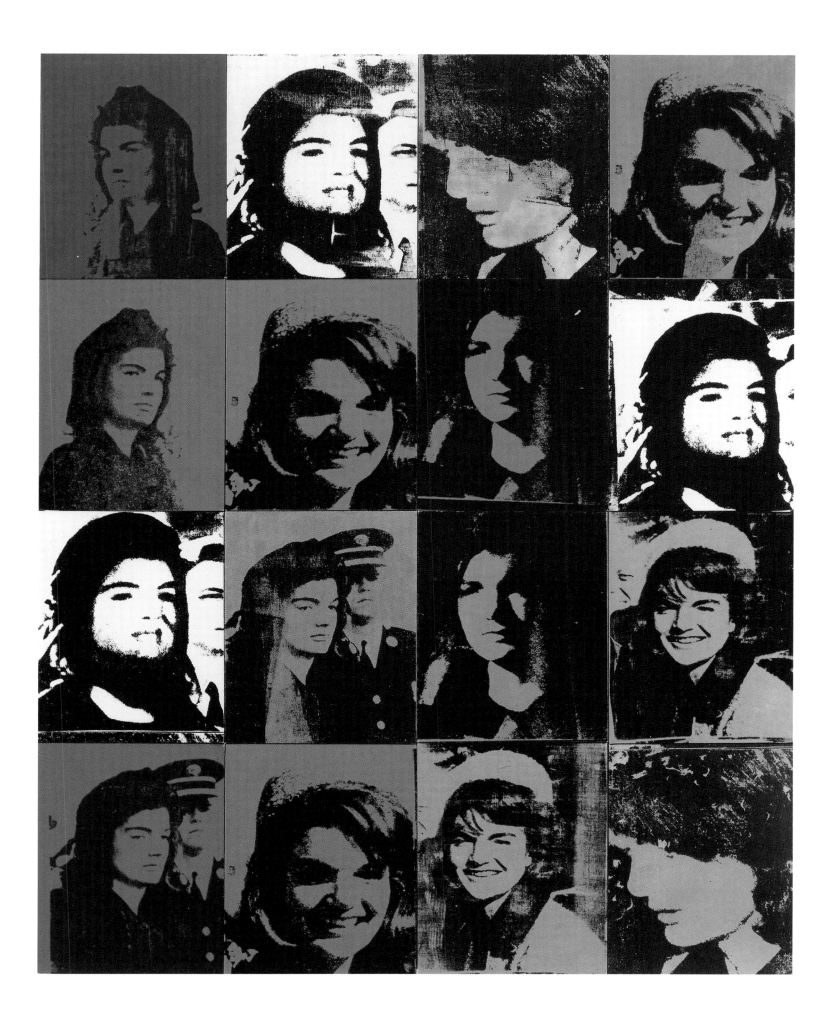

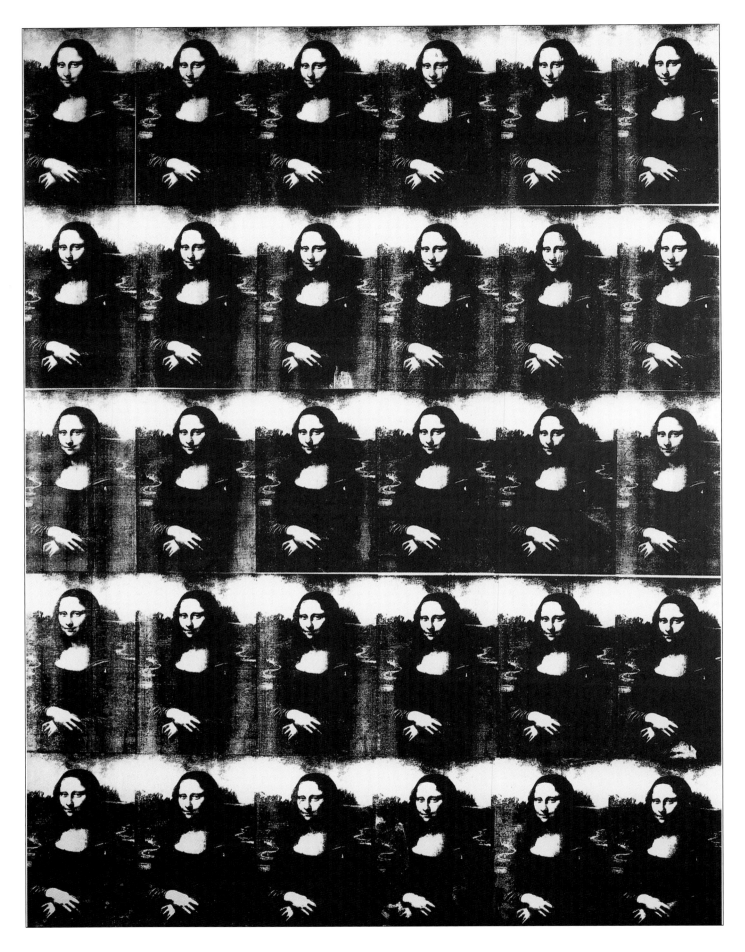

33. *Thirty Are Better Than One*,
1963. Silkscreen ink, acrylic
paint and silver paint on
canvas, 279.4 x 240 cm,
The Brant Foundation, Greenwich.

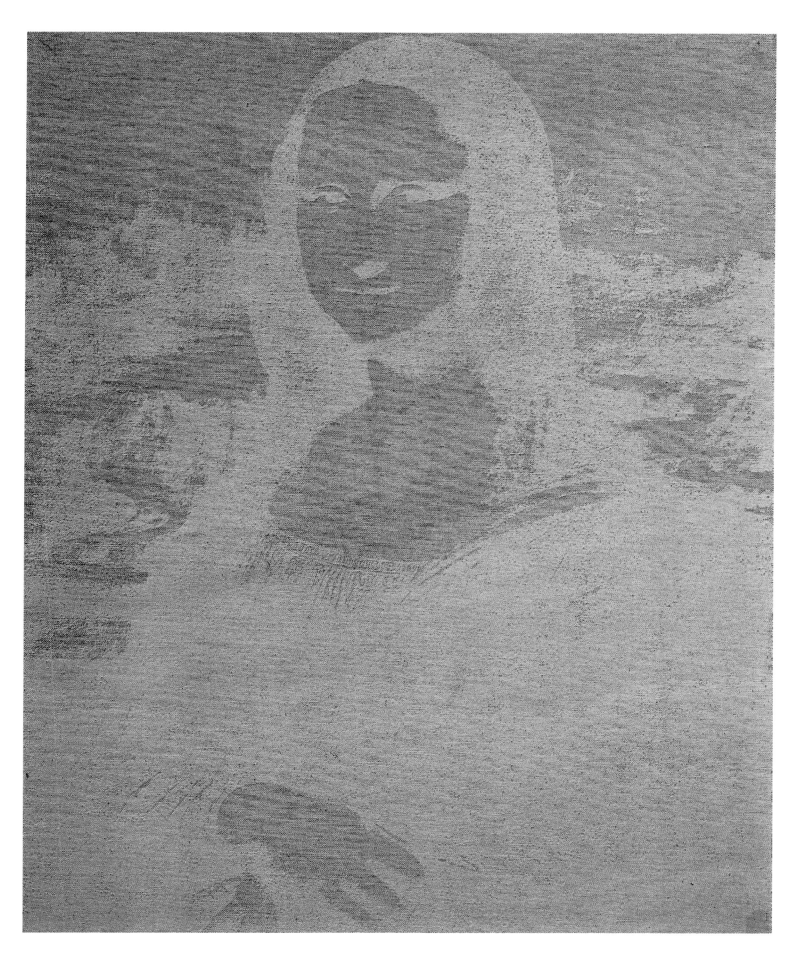

34. *White on White Mona Lisa*,
 1979. Silkscreen ink and acrylic
 paint on canvas, 62.9 x 50.5 cm,
 Bruno Bischofberger Gallery,
 Zurich.

46.

By mid-1963 working conditions in the house on Lexington Avenue had become much too crowded, so in order to create yet more pictures, and on a bigger scale, in June of that year Warhol first rented additional studio space known as 'The Factory' , so called because it had previously been a hat factory. One of his helpers, Billy Name, painted the entire interior with silver paint or decorated it with silver foil, and Warhol welcomed the effect for the associations it triggered with space ships and the silver screens of old Hollywood movies. In order to speed up his work, that summer the painter employed another studio assistant, Gerard Malanga, and because of such help he was soon able to free himself sufficiently to begin making movies.

The artist had not been overly impressed with the underground films that were then beginning to circulate in large numbers, so in July 1963 he made the first of his many movies, *Sleep*. This lasted for six hours and simply showed his current boyfriend, John Giorno, in a deep slumber. Initially Warhol ruined all the footage of *Sleep* through unloading the camera wrongly and so had to shoot the film all over again. In films like *Sleep*, or *Empire* (which shows the outside of the Empire State Building over an eight-hour period from twilight to the early hours of the morning and in which the building is not apparent for the first two reels of the movie due to over-exposure of the film), as well as in his many other movies made in 1963-64, Warhol sought to project a mechanical, emotionally-detached view of things, with as little intervention by himself as possible – indeed, for several of these films he would set up the camera and then make telephone calls elsewhere whilst the filming was taking place. Such films do not necessarily enjoy a one-to-one temporal relationship with the real world, for Warhol often slowed down their projection speeds so as to slow down their action, in order to make it clear that 'When nothing happens, you have the chance to think about everything.' His innovations were certainly hailed by some of his more experimentalist contemporaries, for they awarded him the annual prize of the New York underground movie magazine *Film Culture* at the end of 1964.

In September 1963 Warhol held a second exhibition at the Ferus Gallery in Los Angeles. This time he displayed a series of Elvis Presley and Liz Taylor paintings. Equally tempted by the promise of a Hollywood party to be held in his honour by the actor Dennis Hopper, by the fact that 'Vacant, vacuous Hollywood was everything I ever wanted to mould my life into'. Back in New York Warhol subsequently had trouble with Elinor Ward, for she hated the Disaster pictures and refused to exhibit them. As a result, the painter, who was at the height of his powers, was unable to show his works at all during 1963 in New York. Yet the Disasters were soon acclaimed elsewhere, as happened in Paris in January 1964 when Warhol enjoyed his first European exposure at the Ileana Sonnabend Gallery. There he displayed a group of the Disasters under the title of 'Death in America'.

These objects were six vast sets of reproduction outer packing cartons, of the type that serve to transport commodities from factories to supermarket storerooms. When Warhol exhibited them in April 1964 at the Stable Gallery he filled the space virtually from floor to ceiling with the works, thus making the gallery look exactly like a supermarket storeroom. The packing carton sculptures greatly furthered the statements that Warhol had already made in his paintings about mass-culture and mass-production, as well as advancing the assaults on fine-art values those statements represented. Moreover, within the context of an art gallery – or art storeroom – they equally pointed out the very commercialisation of art itself. Yet although the show received enormous critical coverage and Robert Scull ordered some of the works, sales were generally poor and the exhibition caused a final rupture between Ward and Warhol, who thought the dealer was insufficiently supportive. Thereafter the artist moved to the Leo Castelli Gallery.

35. *Man Ray*, 1974.
Silkscreen ink, and acrylic paint
on canvas, 101 x 101 cm,
Private collection.

By the time the carton sculptures exhibition opened to some controversy, Warhol had anyway stirred up controversy elsewhere in New York by creating a mural for the New York State Pavilion at the World's Fair in Flushing Meadows. This comprised of a series of blown-up police mug-shots of criminals.

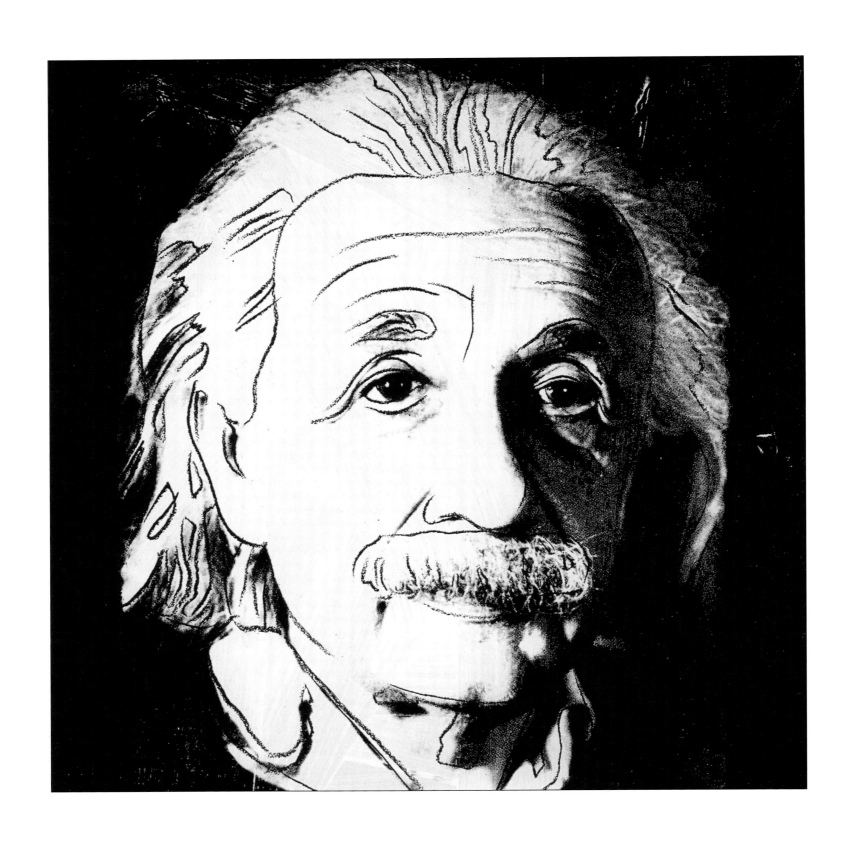

36. *Ten Portraits of Jews of the Twentieth Century (Albert Einstein)*, 1980. Acrylic paint and silkscreen ink on canvas, 101.6 x 101.6 cm, Ronald Feldman Fine Arts, New York.

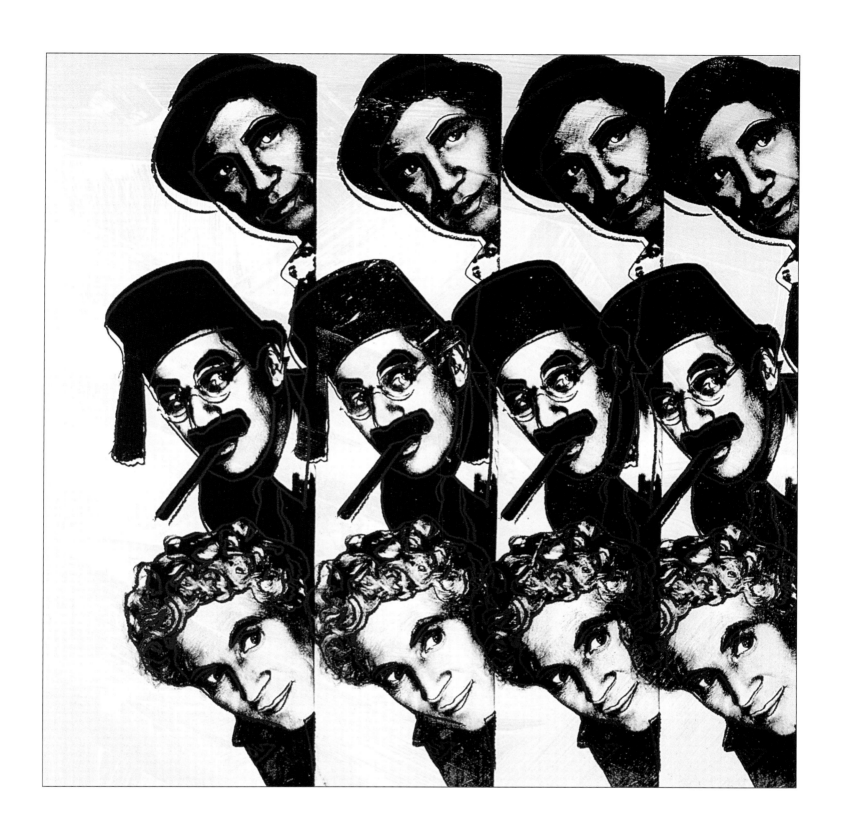

37. *Ten Portraits of Jews of the
 Twentieth Century
 (The Marx Brothers)*, 1980.
 Acrylic paint and silkscreen ink
 on canvas, 101.6 x 101.6 cm,
 Ronald Feldman Fine Arts,
 New York.

However, the work was deemed to be libellous and Warhol was therefore asked to remove it, although rather than do so he simply had it painted over. And Warhol's innate desire to confound expectations surfaced yet again in his next New York exhibition, held at the Leo Castelli Gallery in November 1964. Once more the painter had taken Henry Geldzahler's advice on subject-matter. He felt that Warhol had painted enough gloom-laden pictures and should paint flowers instead. Warhol responded with alacrity to Geldzahler's suggestion because the public might prove to be more financially receptive to pictures of flowers than they had been to images of death and disaster or to reproductions of supermarket artefacts.

As 'Art' became an increasingly glamorous (and financially attractive) activity in New York during the 1960s, and as the word spread regarding Warhol's extreme amenability to employing virtually anyone in his films, so the numbers of helpers and hangers-on at the Factory greatly expanded. Many of these people suffered drug-related emotional or mental problems, but Warhol welcomed such social misfits (or at least did so until he was shot by one of them in 1968), obviously because they were extremely susceptible to manipulation by him as leader of the pack. Indeed, he increasingly derived a peculiar satisfaction from exercising sexual and/or psychological control over his followers. And coupled with Warhol's manipulativeness was his lifelong need for the psychological buttressing that can only be obtained through being exalted by others. Such a compulsion for fame certainly explains the painter's love of partying (or what he called his 'Social Disease'), for even in his early days in New York, Warhol was never happy unless he had a party to go to every night. In time he would move this love onto a more structured plane via his magazine *Interview*, which afforded him access to any party in the land, including presidential parties.

This change was mainly due to the employment of Paul Morrissey who would increasingly prove important to Warhol's filmic activities because of his understanding of the basics of cinematic technique. That October he also enjoyed his first one-man museum retrospective exhibition which took place at the Institute of Contemporary Art in Philadelphia. The opening turned into a near-riot due to the vast numbers of people who turned up simply to catch a glimpse of Warhol himself.

By the end of 1965 Warhol was again beginning to run out of ideas. One day he got into conversation with Ivan Karp:

> Warhol said that he was using up images so fast that he was feeling exhausted of imagination... he said, "I'm running out of things... Ivan, tell me what to paint!" And he would ask everybody that. He asked Henry [Geldzahler] that. He asked, "What shall I paint? What's the subject?" I couldn't think of anything. I said, "The only thing that no one deals with now these days is pastorals... My favourite subject is cows." He said, "Cows... Of course! Cows! New cows! Fresh cows!"

At the artist's behest, Gerard Malanga found a suitable bovine image in an old agricultural magazine. Subsequently this was made up as wallpaper which was used to cover the walls of one of the two rooms in Warhol's next exhibition, held at the Leo Castelli Gallery in April 1966. With its particularly dumb look, the image brings to an absurd end the pastoral tradition in Western art. It also fixes Warhol's negative view of picture-making by 1966, for by then the artist was disillusioned with the creation of fixed images, and the installation undoubtedly projected his view that the only remaining role for wall-hung works of art was as decorative wallpaper; as he stated, when asked whether homes or art galleries provided better settings for his pictures: 'It makes no difference – it's just decoration'.

The other half of the 1966 Castelli Gallery show consisted of a roomful of silver, helium-filled balloons called *Silver Clouds* that floated around aimlessly. Warhol said of these works:

38. *Walking Torso*, 1977. Synthetic polymer paint and silkscreen ink, 127 x 101.9 cm, Mugrabi collection.

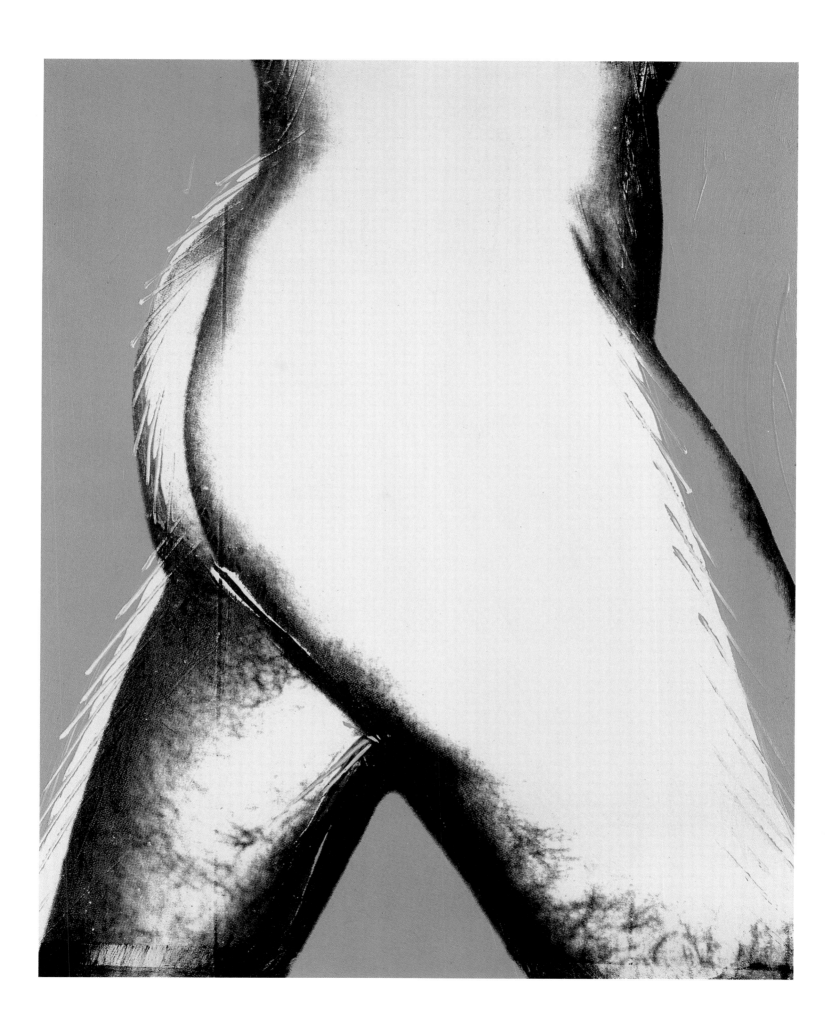

51.

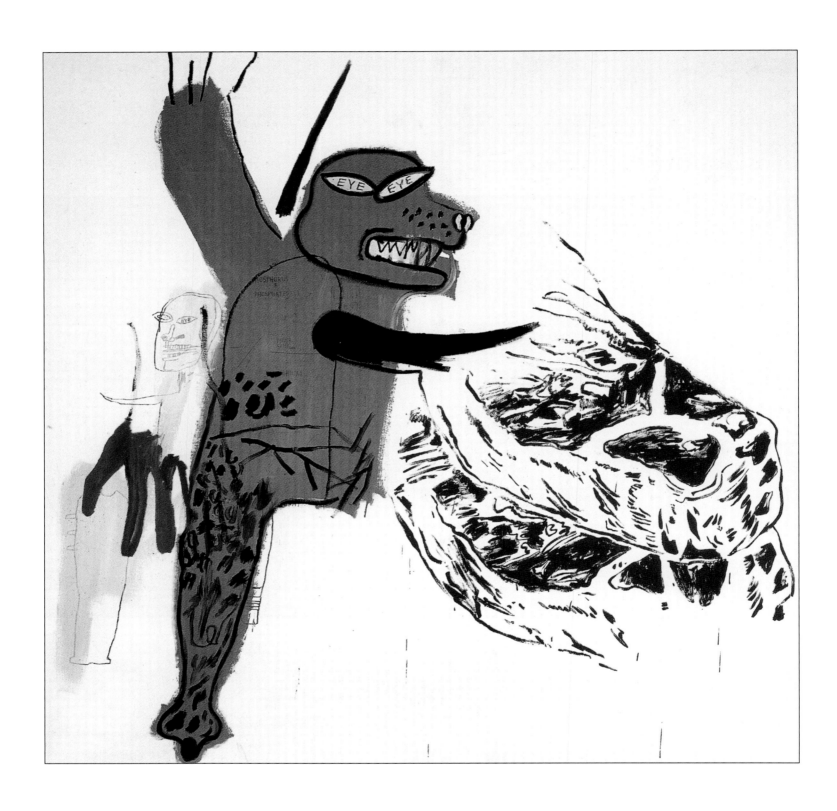

39. Andy Warhol and Jean-Michel
 Basquiat, *Monster Meat*,
 1984-1985. Synthetic polymer
 paint and silkscreen,
 261.6 x 260.4 cm,
 Gagosian Gallery, New York.

40. Andy Warhol, Jean-Michel
 Basquiat, *Stoves*, 1985.
 Acrylic paint on canvas,
 203.2 x 274 cm,
 Bruno Bischofberger Gallery,
 Zurich.

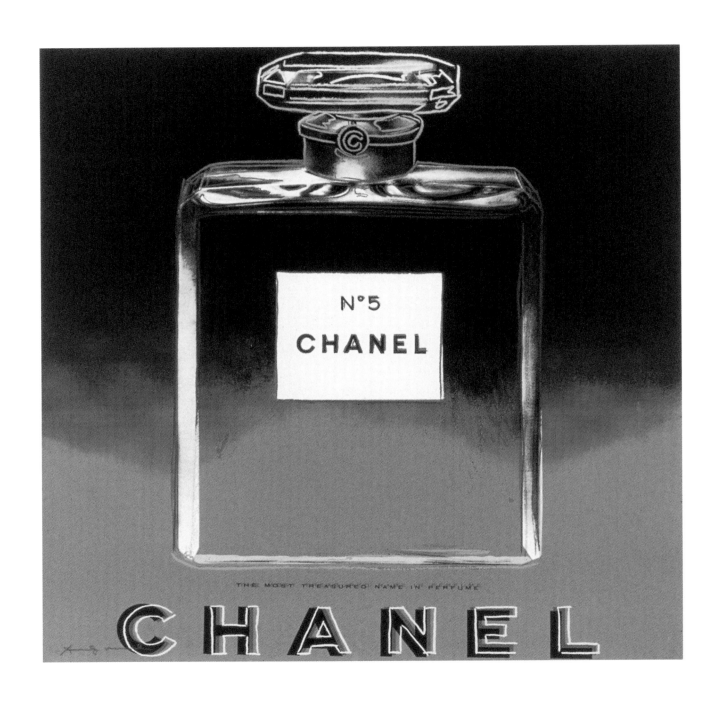

54.

I didn't want to paint any more so I thought that the way to finish off painting for me would be to have a painting that floats, so I invented the floating silver rectangles that you fill up with helium and let out of your windows.

With the exception of the packing carton and *Silver Clouds* sculptures, which obviously related to the anti-art gestures of earlier masters of Dadaism such as Marcel Duchamp, it is possible to divide the majority of works created between 1961 and 1966 into two clear categories. First there are the iconic images. These are the consumer-object works, such as the soup can or Coke bottle pictures and the paintings of movie stars or of 'most wanted men'. In such images Warhol was obviously inspired by the way that Jasper Johns had intensified the iconic qualities of the American flag by isolating it frontally and setting it amid a field of flat colour, for Warhol similarly isolated and set his objects or people so as to project them as solitary or multiplicatory icons, albeit icons of American popular culture. Then there are the situation pictures, such as the paint-by-numbers and the deaths and disasters paintings. Here the original visual material on which the works were based was less well-disposed to such iconic projection simply because it is more visually asymmetric, rather than static or passive ones. Of course, in both categories of works the repetition of the imagery carries cultural implications pertaining to mass-communications. Warhol's increasing disillusion with fixed images by 1966 was therefore probably inevitable, given that he had used up subject-matter 'so fast that he was feeling exhausted of imagination'. Where could he go next?

Faced with this exhaustion, Warhol turned to other forms of cultural expression. In December 1965 he took over the rock music band *The Velvet Underground*, and in April 1966 he made this group the centrepiece of a multimedia music show entitled the *Exploding Plastic Inevitable*. The show was in the vanguard of mid-1960s psychedelic rock-music displays, with the band performing against a backdrop of Warhol films and with strobe lighting adding to the constant visual bombardment. Back in New York, Warhol embarked upon his first commercially successful film, *Chelsea Girls*, and here again he made evident his desire to open up new visual experiences, for several reels of the movie were designed to be simultaneously projected on two adjacent screens, each with a different soundtrack.

Much of Warhol's time during the next year or so was taken up with *The Velvet Underground* and with his filmic activities. In May 1967 he visited Cannes, France, for a planned film festival performance of *Chelsea Girls*, although the movie was not shown in competition. Warhol then visited Paris and London before returning to New York and embarking upon further films, including *Bikeboy* and *I, a Man*. But as far as his fine art activities were involved, by 1967 Warhol's career was further on the wane. Again he sought help from outside, for as Ivan Karp later recalled, Warhol complained that:

"Ivan, there's nothing left for me." He said, "I'm a popular character… but I've got no images." I said, "What's left for you? Do yourself."

The result was a group of self-portraits that, intentionally or not, make the point that Warhol had himself become a cultural icon by 1967. For these portraits, Warhol chose a photo taken when he was much younger, and in them he quite evidently enjoyed exploring highly inventive colour permutations and varieties of paint application.

In 1967 Warhol discovered the creative and commercial potential of large-scale sets of prints. These prints once again demonstrate Warhol's remarkable powers as a colourist and the sets soon sold out, prompting the artist to pursue the creation of many more such portfolios, such as the group of eleven prints entitled *Flash – November 22, 1963* of 1968 which shows images relating to the assassination of President Kennedy, and the two sets of ten prints of Campbell's soups dating from 1968 and 1969 respectively.

41. *Chanel*, 1985.
Silkscreen ink, 96.5 x 96.5 cm,
From the "Ads" Portfolio.

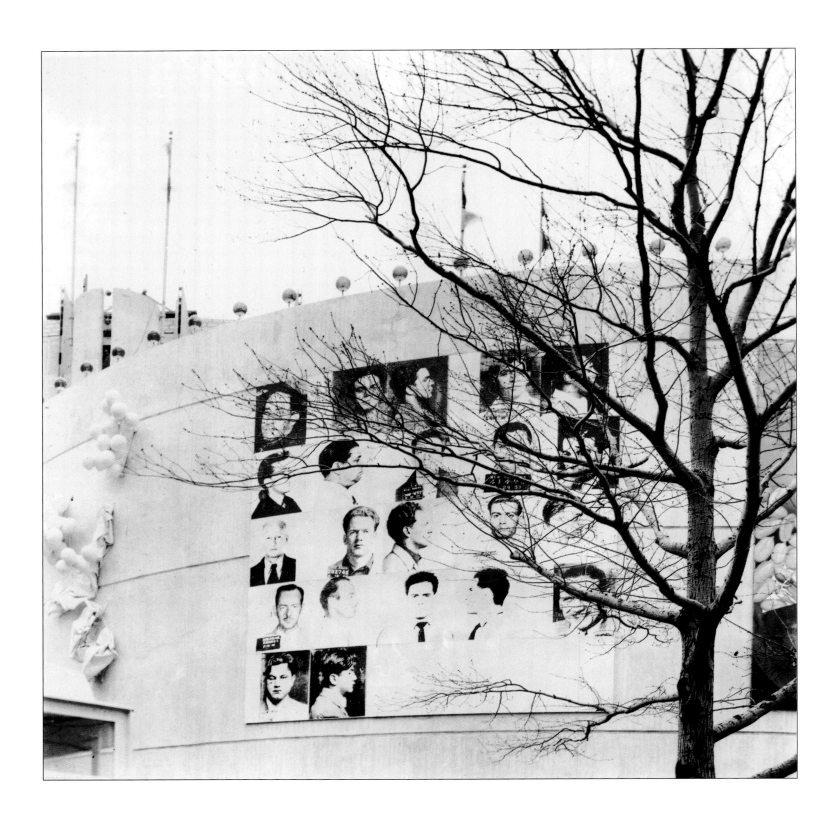

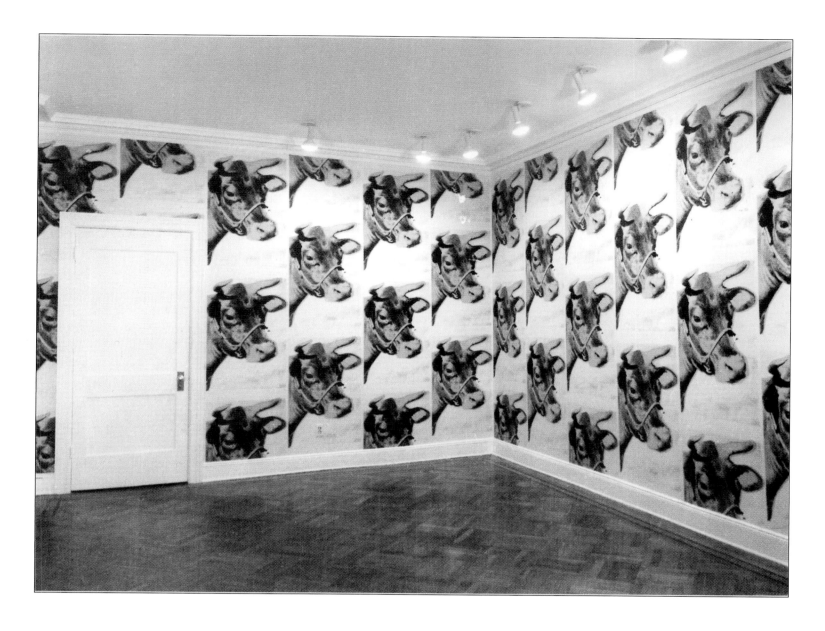

42. Photo of the exterior of the
New York State Pavilion at
New York World's Fair, 1964,
showing Warhol's *Thirteen Most
Wanted Men*.

43. Photo of the installation of *Cow
Wallpaper* at Leo Castelli
Gallery, New York, April 1966.

By now, exhibitions of Warhol's work had burgeoned, as the artist's paintings came to be perceived as being amongst the most essential images of their time. Soon afterwards the painter travelled to Stockholm, Sweden for a retrospective exhibition at the Moderna Museet, the entire outside of which was covered with *Cow Wallpaper* for the occasion; if previously Warhol had used wallpaper to make a cultural point about art in domestic and gallery interiors, how much more effective and witty was that point when the wallpaper shrouded an entire museum.

In May 1968 Warhol travelled with Paul Morrissey to California to speak at further colleges. Whilst in *La Jolla* they started yet another film, *Surfing Movie*, although police harassment and conflicts on the set prevented its completion. Back in New York, life at the Factory continued as hectically as ever, although by now Warhol had been forced to move his working premises. But the change of workplace did little to alter the atmosphere of Warhol's creative surroundings. Certainly the move did nothing to diminish an inherent danger that stemmed from the accessibility of the Factory to people unbalanced by drugs or psychological problems. That incipient danger had certainly been brought home to Warhol on more than one occasion. Thus in 1964 a hanger-on, Dorothy Podber, had fired a gun through four stacked Marilyn canvases (works that were thereafter entitled the *Shot Marilyn* pictures).

Then, late in the afternoon of 3 June 1968, Valerie Solanas, a mentally-ill actress, feminist and founder of a one-woman Society for Cutting Up Men (SCUM), walked into Warhol's studio and shot at the painter three times with a handgun. Warhol was rushed to hospital where he was immediately operated on, and fortunately the operation was successful, although the painter had to undergo further surgery the following year. He remained in hospital until 28 July and spent the rest of the year recuperating. Painting was one of his convalescent activities.

That autumn the artist oversaw the production of his next movie, *Flesh*. This was directed by Paul Morrissey and was intended to be a more sexually explicit version of the John Schlesinger film *Midnight Cowboy* that was then being made in New York. Later that year Warhol also produced *Blue Movie*, which was openly semi-pornographic and exploitative, being a means of generating cash quickly. And in order to make even more and quicker money, in the summer of 1969 Warhol moved yet further into the pornographic film business by mounting a season of hardcore gay porno movies at a Manhattan cinema he rented for the purpose.

Warhol virtually gave up painting between 1969 and 1971, telling Emile de Antonio that 'The critics are the real artists; the dealers are the real artists too. I don't paint any more. Painting is dead.' Instead he increased his other activities, in the autumn of 1969 founding an underground movie magazine, *Andy Warhol's Interview*, and also producing his most commercially successful film, *Trash*. May 1970 saw the opening in Pasadena, California, of a large retrospective exhibition of his paintings; the show later travelled to Chicago, Eindhoven (Netherlands), Paris, London and New York, and for some of the displays Warhol used Cow Wallpaper as the backdrop to the hanging of the paintings. Such a background added greatly to the visual density of the exhibit and again made a witty point about museums as spaces that habitually hang cultural wallpaper. And on 13 May 1970 Warhol had the pleasure of seeing one of his Soup Can paintings fetch the highest price ever yet reached at auction for a work by a living American artist.

Warhol made a welcome return to the visual arts in the winter of 1971-72 by creating over 2,000 paintings of the Chinese communist leader Chairman Mao. It was a masterly piece of irony on his part, for the politician represented everything that is antithetical to the American political, financial and cultural system, whilst the vast proliferation of such images made highly relevant points about the worship of politicians and the proliferation of idolising images of them.

44. *129 Die in Jet (Plane Crash)*, 1962. Acrylic paint on canvas, 254 x 183 cm, Museum Ludwig, Cologne.

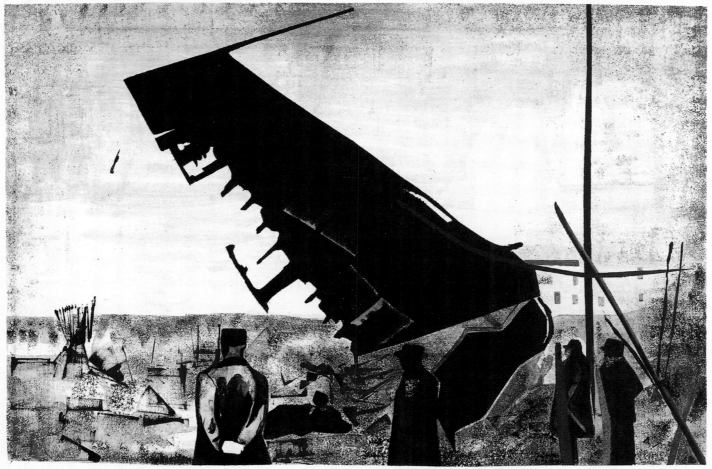

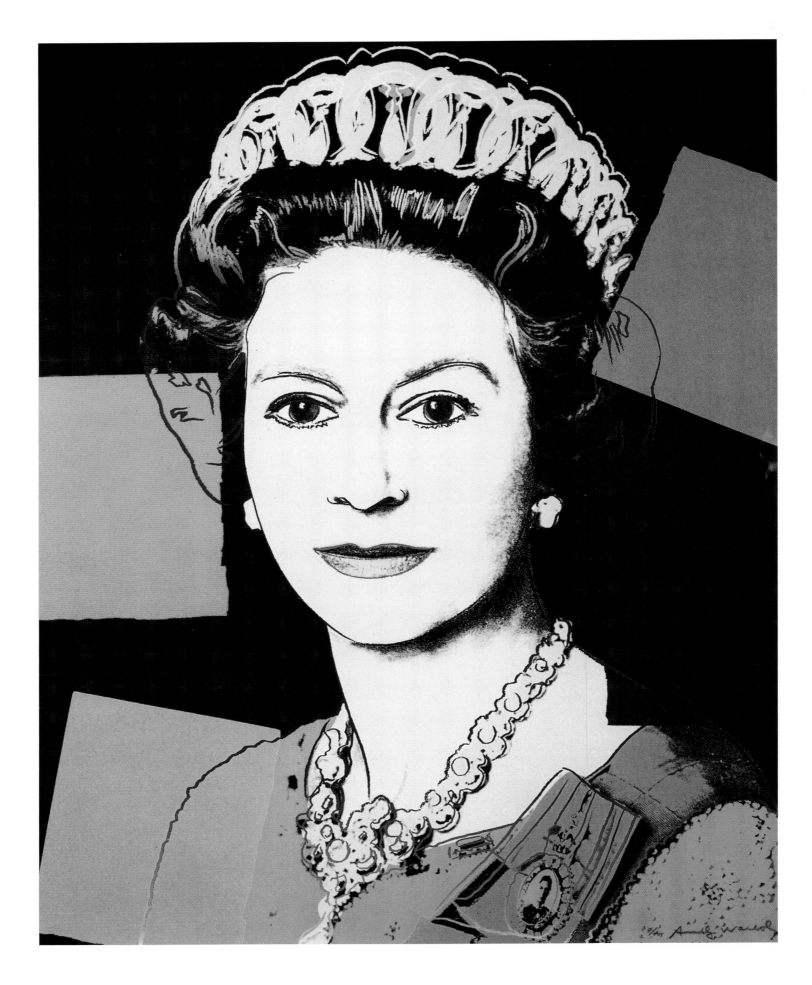

45. *Reigning Queens, Queen Elizabeth II*, 1985. Silkscreen ink on paper, 100 x 79.5 cm, The Tate Gallery, London.

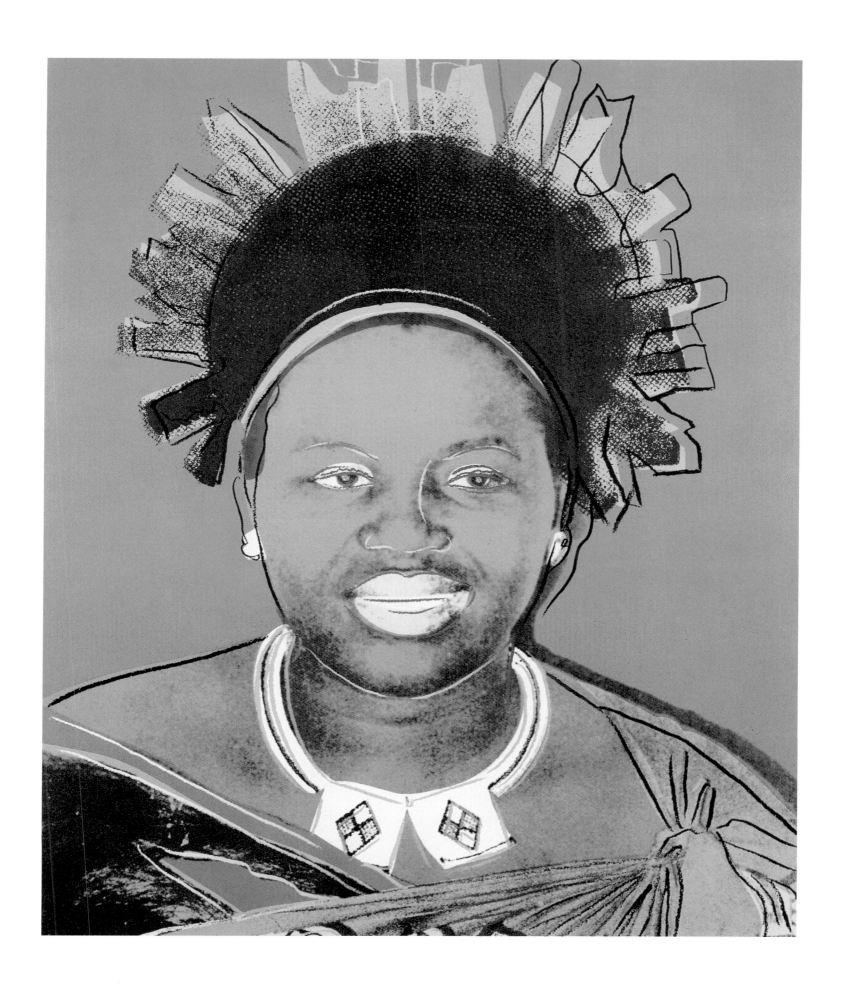

46. *Reigning Queens, Ntombi Twala of
Swaziland*, 1985. Synthetic
polymer paint and silkscreen,
127 x 106.7 cm,
Cardi & Co., Milan.

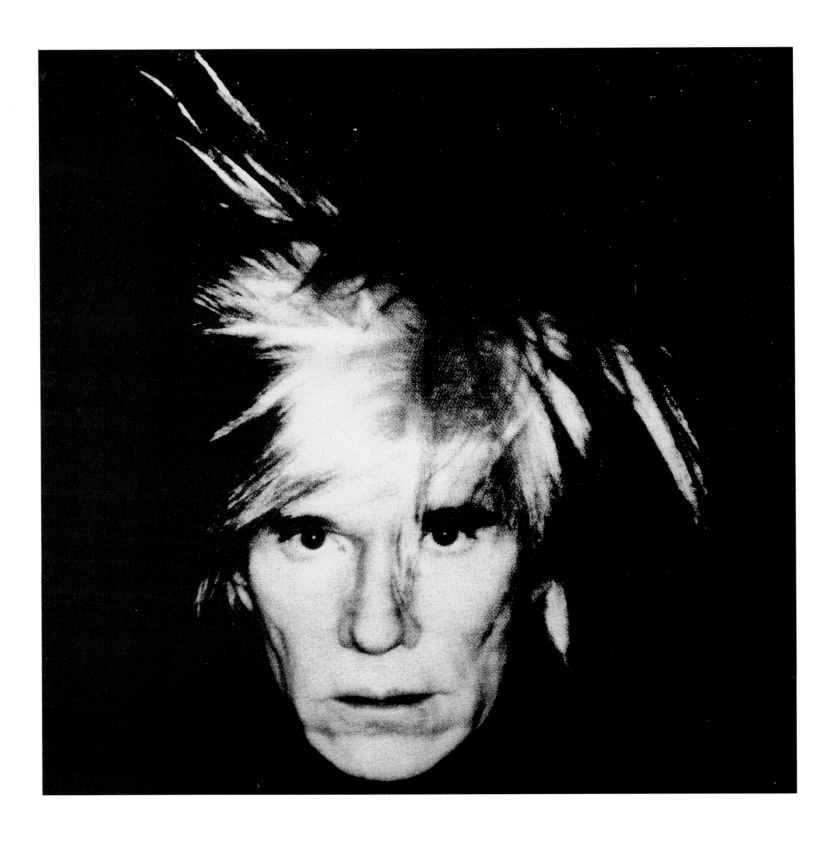

Yet Warhol's true sympathies did not lie in the political arena; instead, he was much more alert to the glamour of politics, as well as the politics of glamour. At the time, increasing affluence was taking the social narcissism and moral turpitude of wealthy New Yorkers to new lows, and Warhol was in the vanguard of that hedonistic, mindless sensibility. The artist frequented the 'in-crowd' discotheque, Studio 54; he cultivated contacts in the pop music world such as Bob Dylan, Mick Jagger and John Lennon; he hung around the White House and hobnobbed with doomed kings and dictators, such as the Shah of Iran and President Marcos of the Phillipines; and money became more and more of a creative incentive to him as his lavish international lifestyle demanded constant refuelling – as he stated in his book *The Philosophy of Andy Warhol*, published in 1975:

> *Business art is the step that comes after Art. I started as a commercial artist, and I want to finish as a business artist. Being good in business is the most fascinating kind of art.*

To that end Warhol now began making huge numbers of commissioned portraits of the wealthy and famous. By the mid-1970s such portraits were earning the painter well over a million dollars a year. Henceforth two main tracks would run parallel in Warhol's visual output: his society portraits, which are usually as vapid as his writings on social matters; and those sadly fewer but by no means negligible numbers of paintings and prints in which Warhol, the master explorer of the artistic and social implications of mass-culture, still shone forth.

In 1975 Warhol made portfolios of Mick Jagger portrait prints and the *Ladies and Gentlemen* series of prints of drag queens, neither of which are of much artistic interest. And in the spring of 1976 he produced a final movie *Bad*. One might bemoan the fact that filmmaking had kept the artist from his canvases for so many years, but given the absence of fresh painterly ideas it is clear that it was a necessary activity for him, and in any case his visual creativity was undoubtedly stimulated by it.

Warhol's major artistic efforts in 1976 were his Hammer and Sickle, and Skulls series of paintings and prints. The Hammer and Sickle images add little if anything to the political and cultural irony of the Chairman Mao series. However, the Skulls did mark a notable addition to Warhol's subject-matter, for they not only introduce associations that Warhol found especially pertinent after his shooting in 1968 (although he had dealt with those implications earlier) but also they relate to a long tradition of *Momento mori* images in Western art.

In 1977 Warhol made the Athletes, Torsos and American Indian pictures, as well as his Oxidation series of paintings. The Athletes were an unashamed attempt to make some quick money with which to recoup the losses on the film *Bad*, and comprised portraits of a number of leading sporting figures such as Muhammed Ali, Pelé, Jack Nicklaus and Chris Evert; none of the images are particularly interesting. Nor are the Torsos, a group of studies of both male and female nudes that work at the interface of representation and abstraction but which are not especially stimulating in either mode. The *American Indian* is simply a portrait of Russell Means who fought for American Indian rights in the 1970s. And the Oxidation paintings perhaps represent the lowest conceptual and visual point that Warhol ever reached in his career, being a rather infantile anti-art gesture, of the type he had already made surreptitiously nearly twenty years earlier. The new pictures were created by coating canvases with copper paint onto which Warhol and his friends then urinated whilst the paint was still wet, so that the chemical interaction of the urine and paint caused the latter to oxidise. Such a process perhaps carries to a logical conclusion the implications of other urinary works of art in recent American art history, such as Marcel Duchamp's pissoir *Fountain* of 1917, or Claes Oldenberg's much more recent *Soft Toilet*, but sadly Warhol's pictures do not enjoy anything of the wit of the latter two works.

47. *Self-Portrait*, 1986.
Silkscreen ink and acrylic paint on canvas, 101.6 x 101.6 cm, Private collection.

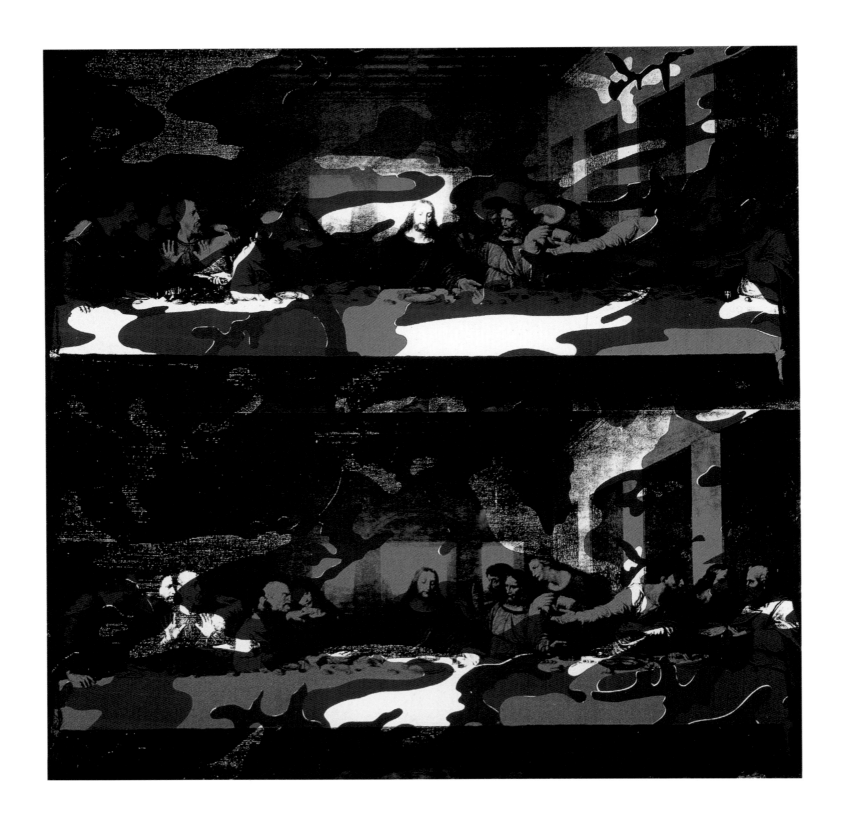

48. *The Last Supper*, 1986.
Synthetic polymer paint and
silkscreen, 198.1 x 777.2 cm,
The Andy Warhol Museum,
Pittsburgh.

49. *Monument for 16 Soldiers*,
1982. Acrylic paint and
silkscreen ink,
330.2 x 177.8 cm,
Bruno Bischofberger Gallery,
Zurich.

65.

In the Reversals series, Warhol simply repeats the images used years before in works such as the Marilyns or the Mona Lisa paintings, except that they are now tonally reversed and look like photographic negatives. The Retrospectives comprise agglomerations of old Warhol images, either in random arrangements or in vertically-orientated series of visual strips. These latter configurations are identical to photo-booth vertical photographic strips, or perhaps they suggest strips of movie celluloid laid side-by-side. In all of these works Warhol characteristically explored new colour and tonal potentialities. The Reversals project a negative view of the painter's own artistic achievements, while the Retrospectives either offer a jumbled view of Warhol's achievements or create associations of memory and processing, as though the art was simply something that had been processed *en masse*, which undoubtedly it had by 1979.

Andy Warhol continued to live in the fast lane during the late 1970s and 1980s. In 1979 he produced his own cable television programme, *Andy Warhol's TV*, and although this was broadcast weekly for about two years it was commercially unsuccessful, for few people ever showed much interest in the artist's self-indulgent and narcissistic televisual approach to the world. He held a 'Portraits of the Seventies' exhibition consisting of depictions of his jet-set friends and clients at the Whitney Museum in New York at the end of 1979; and he launched into the 1980s by making a series of pictures entitled *Ten Portraits of Jews of the Twentieth Century*, images that include portrayals of Freud, Einstein, Gershwin, Martin Buber and the Marx Brothers but which unfortunately look like record album covers. Finaly, Warhol hit a new artistic low in November 1981 when he exhibited at the Los Angeles Institute of Contemporary Art alongside LeRoy Neiman, a kitsch, illustrative painter mostly employed by *Playboy* magazine.

Warhol's next significant group of works dated from 1981 when he made the Dollar Signs, Knives, Guns and Myths series of paintings and prints. The Knives and Guns act as passive reminders of the American glamorization of violence, while the Myths series simply points up, yet again, the essential mythicality and cultural centrality of figures such as Mickey Mouse, Superman, Uncle Sam and even Warhol himself.

New additions to the oeuvre outside such easy works were the German Monuments series, showing a range of buildings, including ones built by the Nazis; the straightforward Goethe pictures which simply recycle Wilhelm Tischbein's famous portrait of the great poet; and the De Chirico Replicas which repetitively point up the Italian painter's own visual repetition. Further art historical recycling took place in 1984 when Warhol reworked images by Edvard Munch. Neither series do anything to improve upon their sources. A further sign of Warhol's loss of daring and imagination by 1984 came in his short-lived artistic collaboration with two much younger but up-and-coming stars of the New York art scene, Francesco Clemente and Jean-Michel Basquiat. Both these artists rose to fame as a result of the 'post-modernist' exploration of graffiti and infantile imagery, and the works that Warhol made in collaboration with them seem a sloppy mishmash of styles, without any visual point or conviction.

In 1986 Warhol made new but tired images of Lenin and of Frederick the Great. Yet in 1986 there was also a return to form, for in his *Last Supper* paintings Warhol did have something to say about the way that great religious art can be turned into cultural kitsch, whilst through using army camouflage patternings in several last self-portraits and other works, he found a way of creating interesting visual maskings that again project negation. This had always been a positive quality of his art, ever since he had first became aware that repetition brings out the inherent abstraction of things.

50. *Dollar Sign*, 1981. Synthetic polymer paint and silkscreen, 228.6 x 177.8 cm, The Andy Warhol Museum, Pittsburgh.

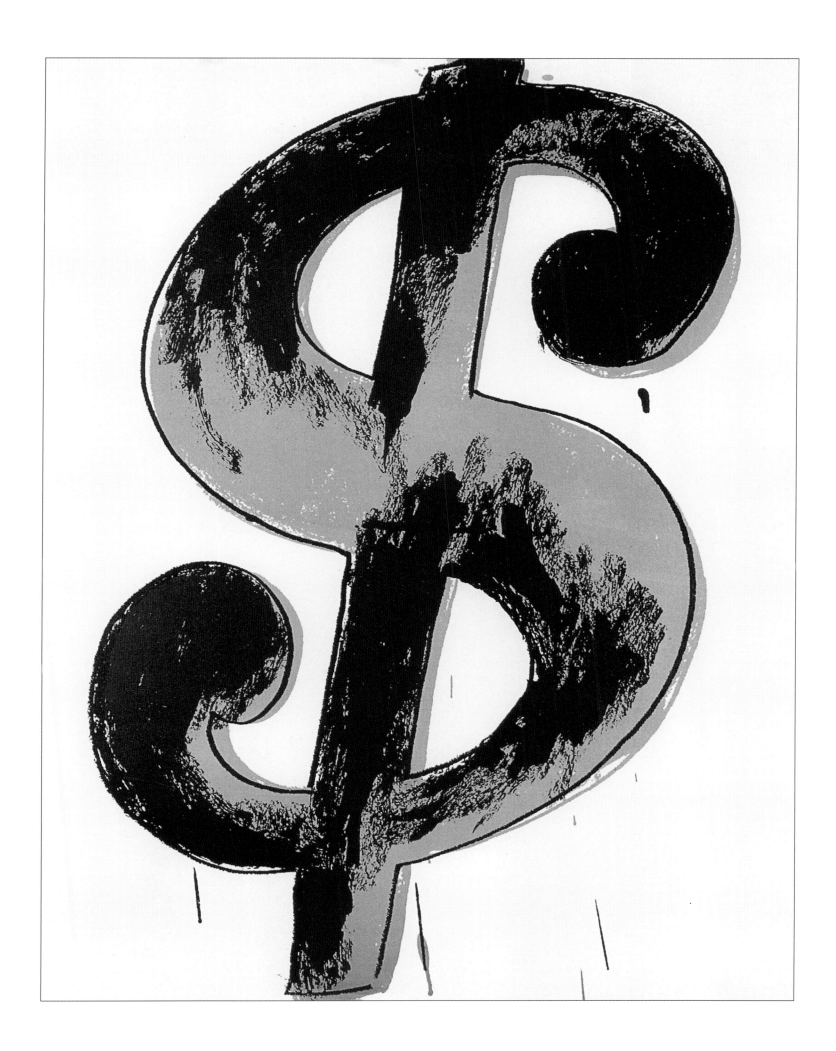

67.

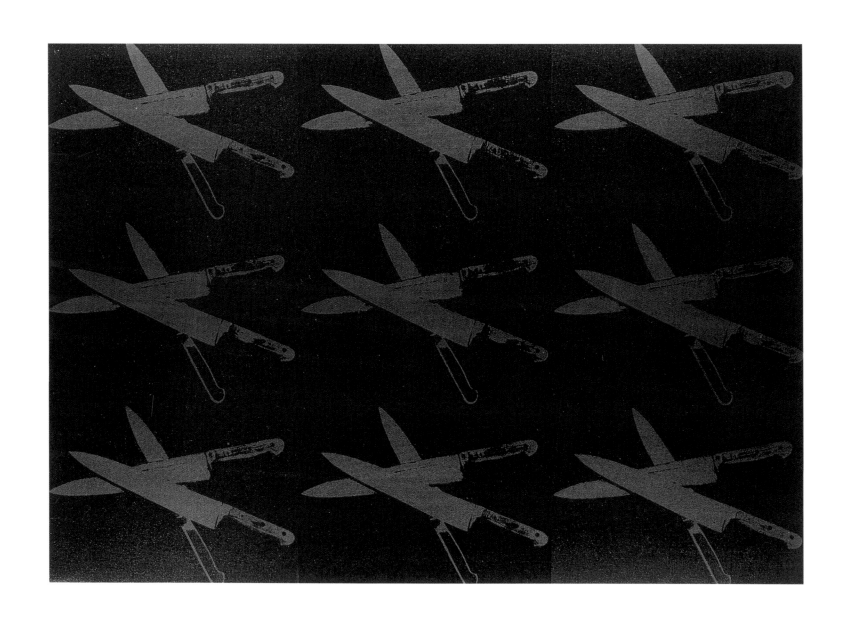

51. *Knives*, 1982. Synthetic
polymer paint and silkscreen,
180 x 132 cm,
Mugrabi collection.

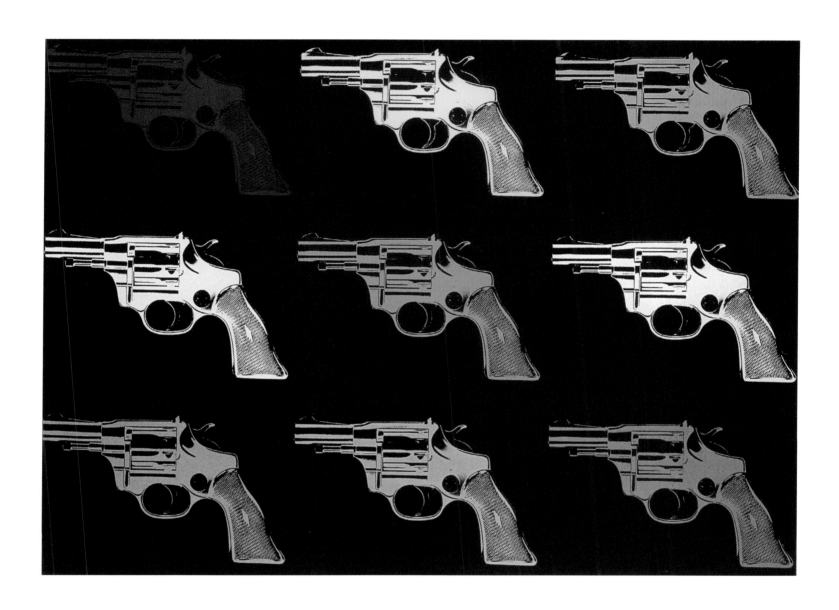

52. *Guns*, 1982. Synthetic polymer
 paint and silkscreen,
 132 x 177.8 cm,
 Mugrabi collection.

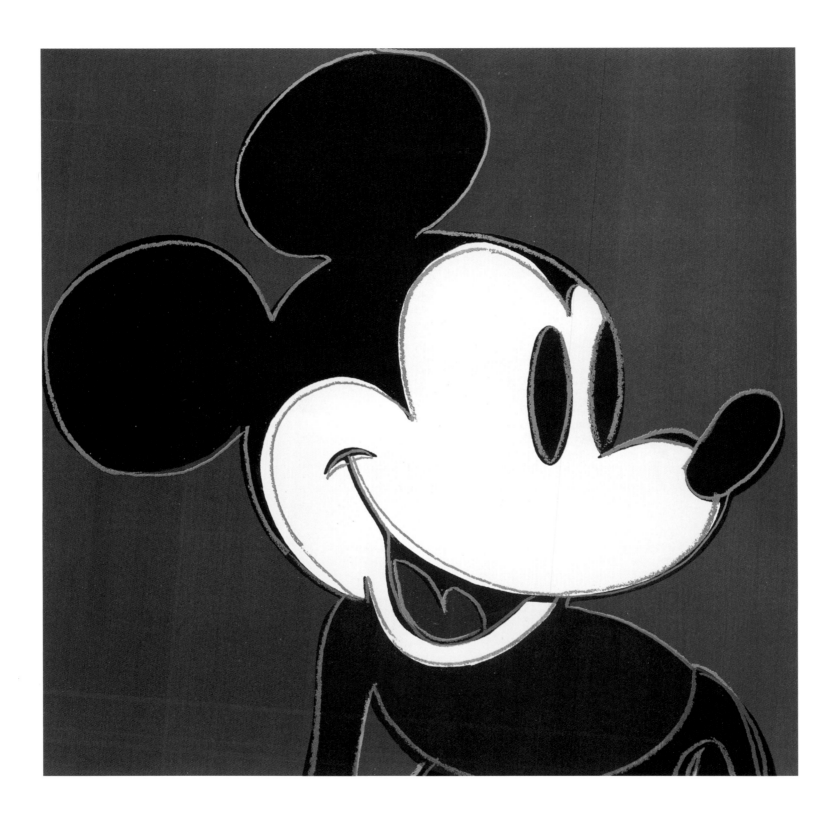

Early in January 1987 an exhibition of his stitched and sewn photographs opened to excellent reviews in New York, and soon afterwards he flew to Milan, Italy, for an exhibition of his *Last Supper* paintings. Back in New York he created images of Rado Watches and of Ludwig van Beethoven, whilst planning the creation of yet another grandiose series of pictures, this time relating to the history of American television. But it was not to be.

On 20 February, Warhol checked into New York Hospital for a routine gallbladder operation the following day. Although the operation itself was successful, the post-operative care was very poor and early on the morning of Sunday 22 February 1987 the painter died. He was just fifty-nine years old.

His body was taken back to Pittsburgh where he was buried on 26 February. In his will Warhol named Fred Hughes his executor and bequeathed him a quarter of a million dollars, the same sum that he left to each of his two brothers. The rest of his estate, valued at between $75 million and $100 million, went to create an arts charity, the Andy Warhol Foundation for the Visual Arts, which is now one of the richest such organisations ever established in the United States.

By the end of his life Andy Warhol had become one of the leading mass-media personalities of his day and a touchstone of superficial contemporary social mores. But this should not blind us to his earlier seriousness and creative achievements. Certainly his career as a fine artist after the mid-1960s was uneven, but that seems inevitable, for between 1961 and 1966 the painter had explored most major aspects of modern experience and consequently had not left himself much else to add.

After that time he painted more uncertainly and unevenly. And after 1968 Warhol seems understandably to have felt that he was living on borrowed time, so the nihilism and resulting shallowness of his latter days are surely explained by that realisation. Yet despite all his apparent cynicism and his outward refusals to seem serious, Andy Warhol was far more than just a superficial pop artist, for unlike many of his creative contemporaries his finest work is not simply about having fun in a mass-culture: it confronts us with some of the underlying and most uncomfortable truths of our age, such as the inhumanity, exploitation, banality, trivialisation and destructiveness of modern culture, as well as our loss of faith in God, art and life itself. Warhol may have wanted to appear to be a machine but under his apparent and assumed *sang-froid*, pretended intellectual vacancy and desire for fame there lay an artist who did experience the pain of things considerably and expressed it subtly and cleverly in much of his work. Pain is expressible not only in tortured mouthings; it can be articulated by a detached voice, or even a hollow one.

53. *Myths (Mickey Mouse)*, 1981. Synthetic polymer paint and silkscreen, 152.4 x 152.4 cm, Mugrabi collection.

In Warhol's pictures the pain lies just below the bright surfaces of the images and waits passively to engage us. If and when we take it seriously, the art of Andy Warhol has much to warn us about the perils that confront us as we now move into an increasingly manipulative and teeming new millenium.

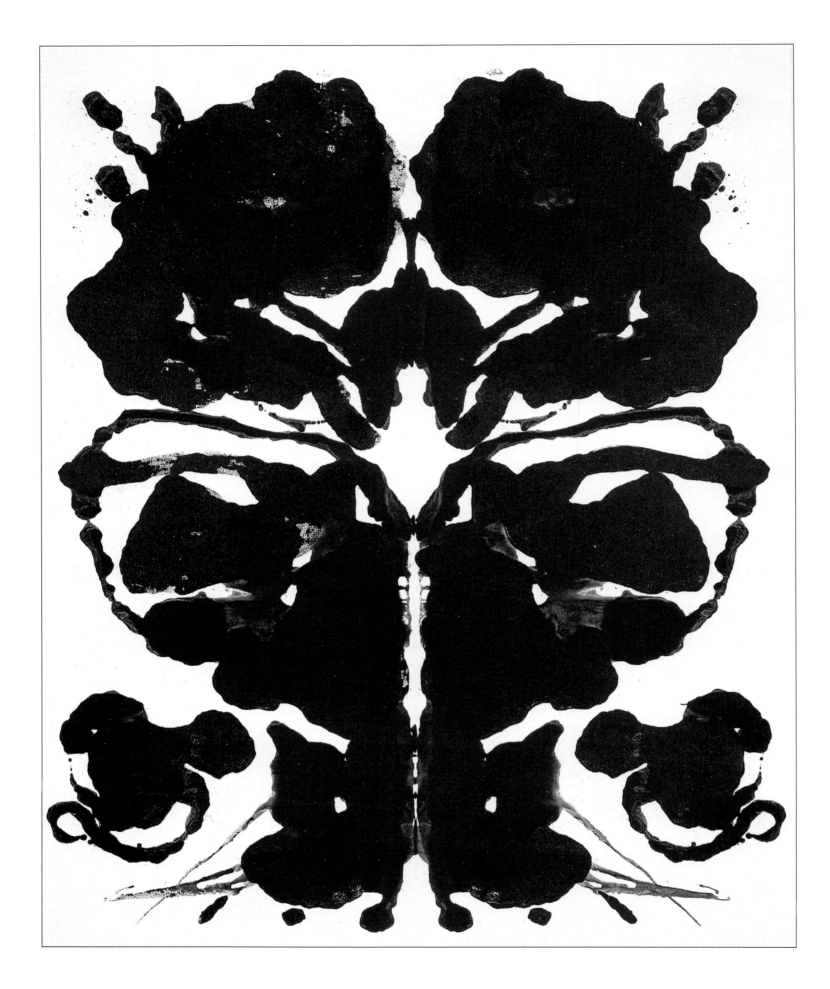

54. *Rorschach*, 1984. Synthetic polymer paint and silkscreen, 304.8 x 243.8 cm, Gagosian Gallery, New York.

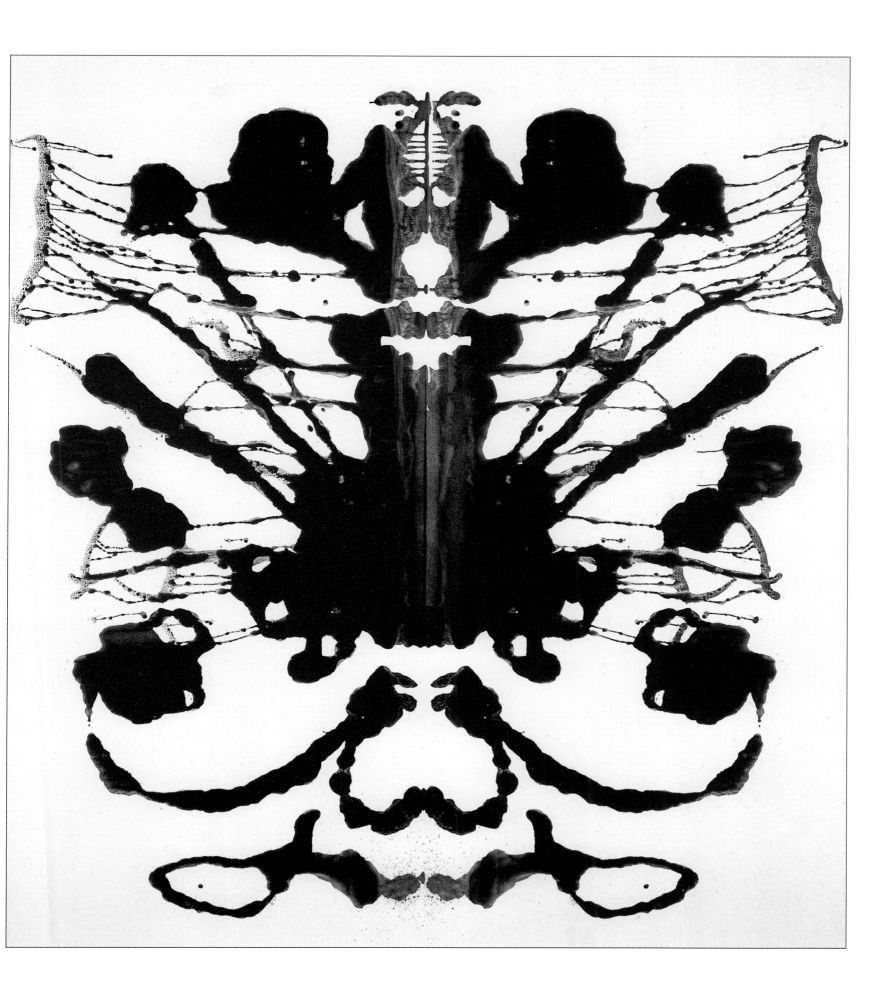

55. *Rorschach*, 1984. Synthetic
polymer paint and silkscreen,
279.4 x 254 cm,
Gagosian Gallery, New York.

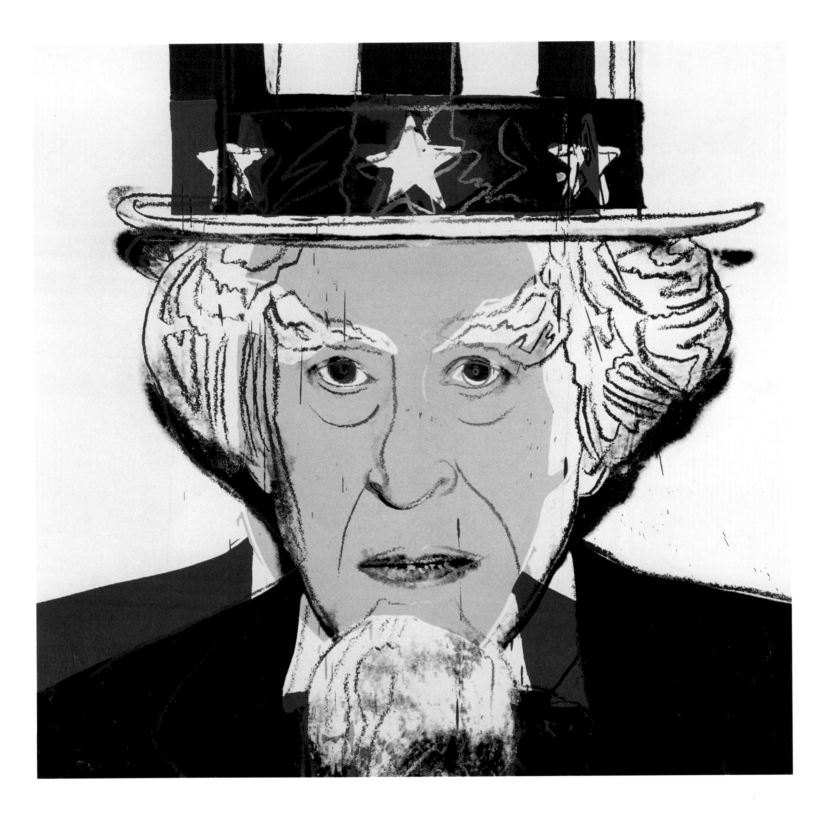

56. *Myths (Uncle Sam)*, 1981.
Acrylic paint on canvas,
152.4 x 152.4 cm,
Ronald Feldman Fine Arts,
New York.

His Work

Peach Halves	77
Saturday's Popeye	79
Do It Yourself (Landscape)	81
100 Cans	83
192 One-Dollar Bills	85
Green Coca-Cola Bottles	87
Big Torn Campbell's Soup Can	89
Red Elvis	91
Triple Elvis	93
Marilyn Diptych	95
Gold Marilyn	97
Marilyn Monroe's Lips	99
Optical Car Crash	101
Red Race Riot	103
Suicide	105
Five Deaths Seventeen Times in Black and White	107
Orange Car Crash Ten Times	109
Ethel Scull 36 Times	111
Mona Lisa	113
Blue Electric Chair	115
Atomic Bomb	117
Elvis I and II	119
The American Man – Watson Powell	121
Most Wanted Men	123
Brillo Boxes	125
Flowers	127
Jackie	129
Cow Wallpaper	131
Marilyn	133
Julia Warhola	135
Skull	137
Hammer and Sickle	139
shadows	141
Truman Capote	143
Diamond Dust Joseph Beuys	145
Gun	147
Goethe	149
Sixty Last Suppers	151
Camouflage Self-Portrait	153

PEACH HALVES

1960
Synthetic polymer paint on canvas
177.5 x 137.5 cm
Staatsgalerie, Stuttgart

Here the painter was working at the interface between cultural and artistic statement by combining a subject-matter taken from popular culture with an abstract expressionist looseness of paint handling, very much in the conceptual wake of Jasper Johns and Robert Rauschenberg, if not necessarily in their manner. The result is neither one thing nor the other, offering only a limited statement about the cultural implications of a can of fruit, along with a rather flabby pictorial structure that does not enjoy to the full the courage of its visual convictions.

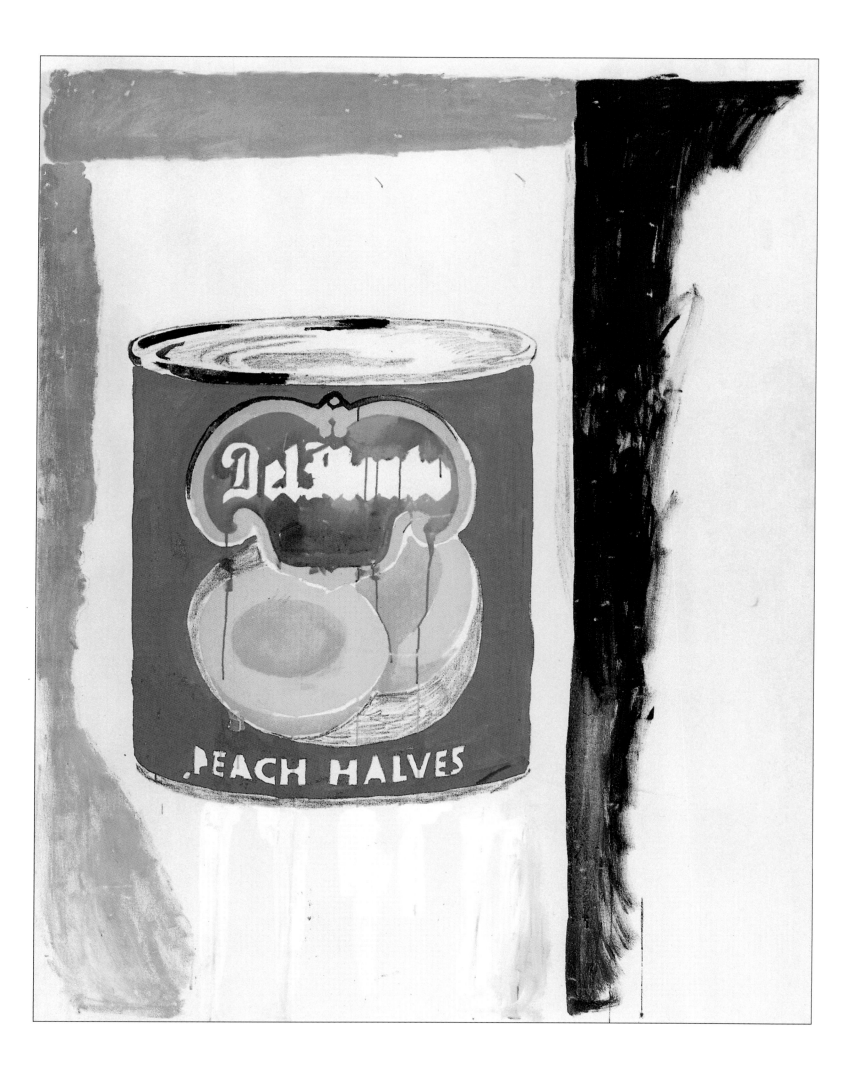

SATURDAY'S POPEYE

1960
Acrylic paint on canvas, 108.5 x 98.7 cm
Ludwig Forum für Internationale Kunst,
Aachen

This is one of the works that Warhol displayed in April 1961 in a 57th street window of the Bonwit Teller department store in New York where it received little if any attention.

Along with the crudely drawn representationalism that Warhol appropriated from cheap advertisements in works like *Peach Halves*, comic strip imagery was another obvious visual source with which he tried to find some new way forward for his art in 1960. In this picture the artist again combined popular imagery with a quasi-expressionist paint handling that lacks conviction: the drips look too artificial to be witty, and they certainly do not signify painterly commitment, as they might have done in works by the more serious abstract painters of the New York school of the preceding generation. Here Warhol greatly simplified his source material so as to bring it nearer to abstraction, and indeed, it was his responsiveness to the inherent abstract qualities of form that would greatly strengthen his mature pictures as well. But although this work enjoys some formal impact, it offers little cultural comment. Certainly it says nothing about the production values of mass-communications media imagery that, unbeknown to Warhol when he made the work, his contemporary Roy Lichtenstein was beginning to explore more forcibly at the time through his adoption of Ben Day dot stencils in order to emulate the dot patternings of mechanically printed newspaper reproductions. Only when Warhol learned of Lichtenstein's exploration of comic strips did he abandon such subject-matter.

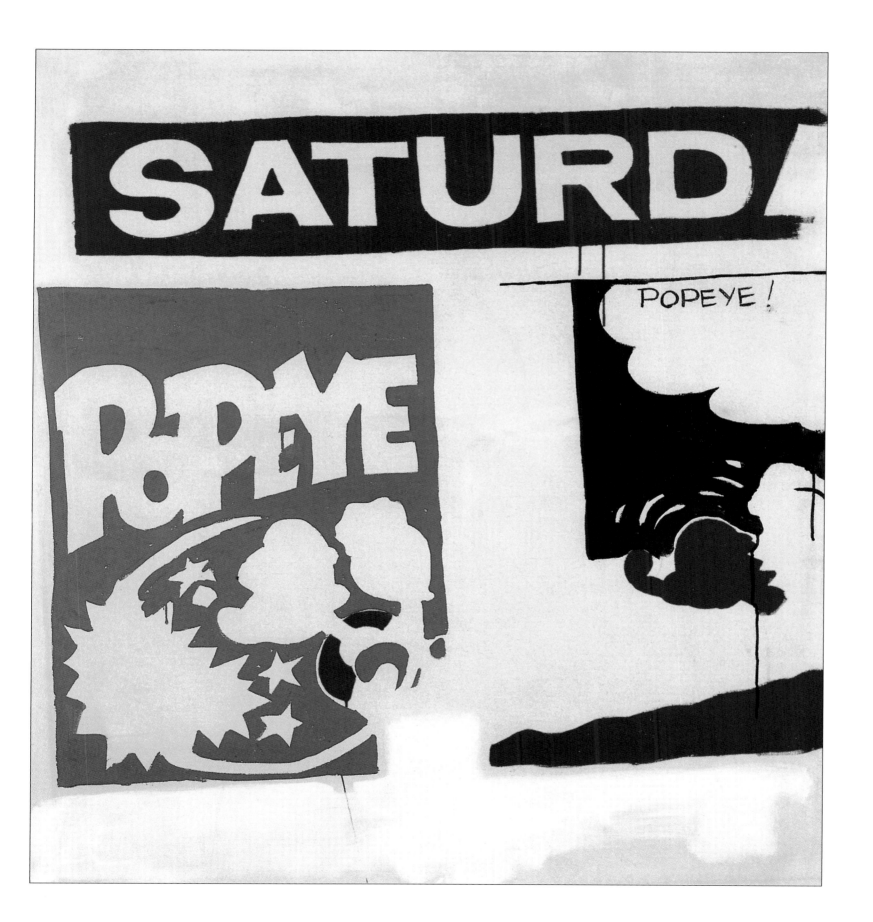

DO IT YOURSELF
(LANDSCAPE)

1962
Acrylic paint and pencil on canvas
177.2 x 137.5 cm
Museum Ludwig, Cologne

Here Warhol again tackled the related themes of art and kitsch. Do-it-yourself, or paint-by-numbers kits, afford the means whereby anyone can create a passable painting by simply matching the colours in numbered tubes or pots of paint with the corresponding numbers appearing. However, in this and similar works, where commercial transfer type was employed for the numbers throughout, Warhol turned the whole do-it-yourself art concept on its head.

By inventing his own paint-by-numbers pictures, Warhol satirised cheap amateurism, the commercial and mechanistic production of 'art', and the notion of inspiration. Paint-by-numbers kits mean that anybody, however untalented, can mechanically produce a coherent picture without having to think about the process at all. And simultaneously the work also sends up the cosily familiar, if not even banal, subject-matter of do-it-yourself pictures, such as neat farmyard scenes or seascapes and beach panoramas, subjects that Warhol equally dealt with in his other *Do It Yourself* paintings. And ultimately this series of works raises highly witty but fundamental questions about art and how it is made, while simultaneously proclaiming its superiority over amateur paintings quite simply because few amateur painters using do-it-yourself kits could ever produce their pictures on the comparatively huge scale of Warhol's offerings. By blowing up such objects, the artist takes paint-by-numbers pictures out of their normal sphere and thus greatly emphasises their fatuousness.

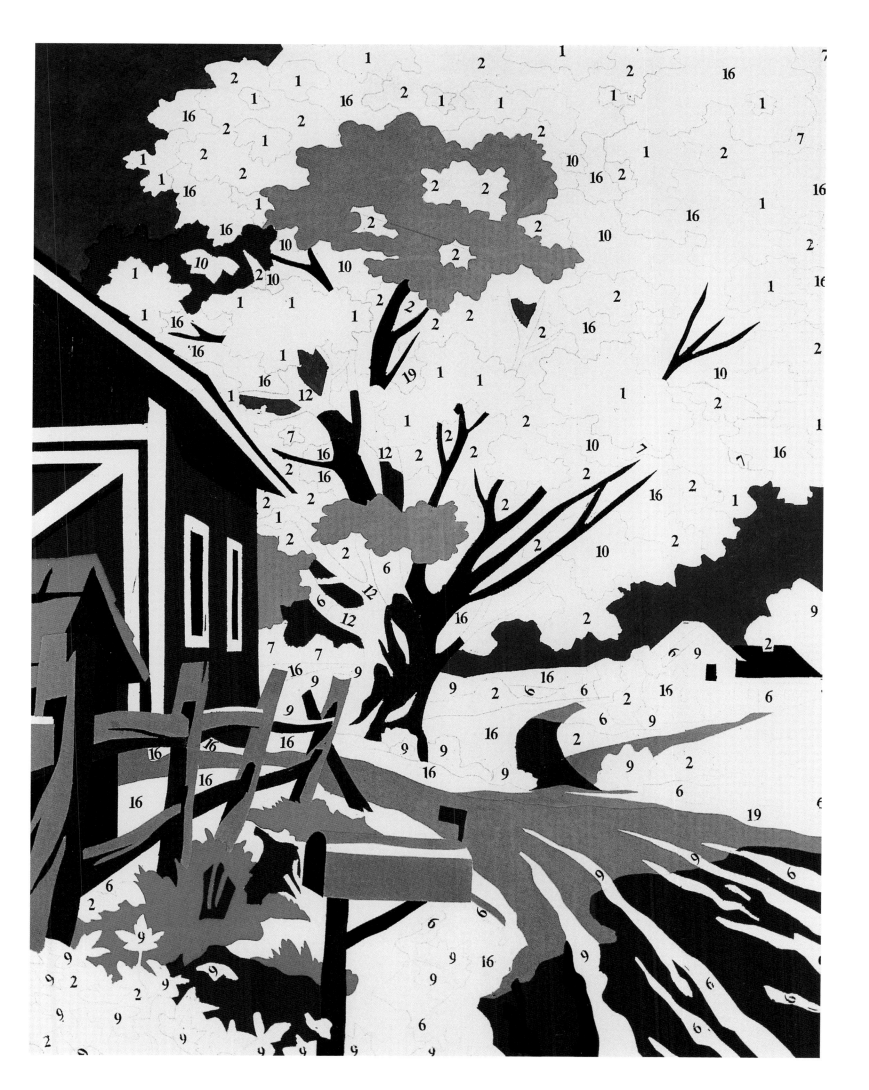

100 CANS

1961-1962
Oil on canvas
182.8 x 132 cm
Albright-Knox Art Gallery, Buffalo

This is the seminal work in Warhol's oeuvre. It was developed from an idea sold to the painter for fifty dollars by Muriel Latow in December 1961. The group of canvases formed the artist's first one-man exhibition, held at Irving Blum's Ferus Gallery in Los Angeles in July 1962. The original display maximised the repetition of the imagery through being so spatially extended, and given that it filled the gallery, and that any art exhibition necessarily creates a finite world of its own, the show must therefore have ultimately projected the fearsome notion that the entire visible universe was filled with Campbell's soup.

This work was equally the first of Warhol's largescale iconic projections. The painter developed the notion of taking an image familiar to millions and presenting it frontally, without painterly qualities, and with a flat surround (as though it were some kind of holy icon), from the Flags paintings of Jasper Johns which were well known to him. However, Warhol went much further than Johns in the degree of objectivity with which he projected his icons, for by now an alliance between quasi-abstract expressionist paint-handling and popular cultural imagery in the manner of Johns no longer interested him. Instead, he isolated each of the 32 varieties of Campbell's soup so as to emphasise the sterile appearances of mechanically produced objects, and the different varieties of soup, as stated on the labels, force us to look hard at the images in order to perceive those slight variations, thus making us self-aware of how we look (or should look) closely at a work of art. And in their subject-matter these images both fly in the face of traditional notions of 'art' and simultaneously enforce the recognition that no objects are inaccessible to artistic treatment simply because they are familiar or banal.

192 ONE-DOLLAR BILLS

1962
Silkscreen ink on canvas
242 x 189 cm
Hamburger Bahnhof – Museum
für Gegenwart, Berlin

As Muriel Latow also recognised in 1961, money was Warhol's very favourite subject, and he bought the idea of using it for the selfsame fifty dollars with which he purchased the Campbell's soup cans concept from her. This is one of the most minimalist of the many pictures of money that Warhol produced, and it demonstrates why the painter influenced minimalist art in the 1960s through obtaining the maximum conceptual mileage for the least visual effort. By extending all over the canvas, the dollar bills mimic the all-over visual effect of much American abstract painting, and simultaneously suggest that money fills the cosmos.

Because these are not real money bills but artistic representations of them, he was reminding us that works of art denote monetary value, while by painting money he was cutting out the intermediate stage that other subject-matter usually represents. The filling of every corner of the canvas with the dollar bills, and their presentation in a purely frontal manner, emphasises their iconic nature, and thus takes further, and in a much more rigorously detached manner, the type of implied comment about idolatry that Jasper Johns had earlier made in his paintings of the American flag.

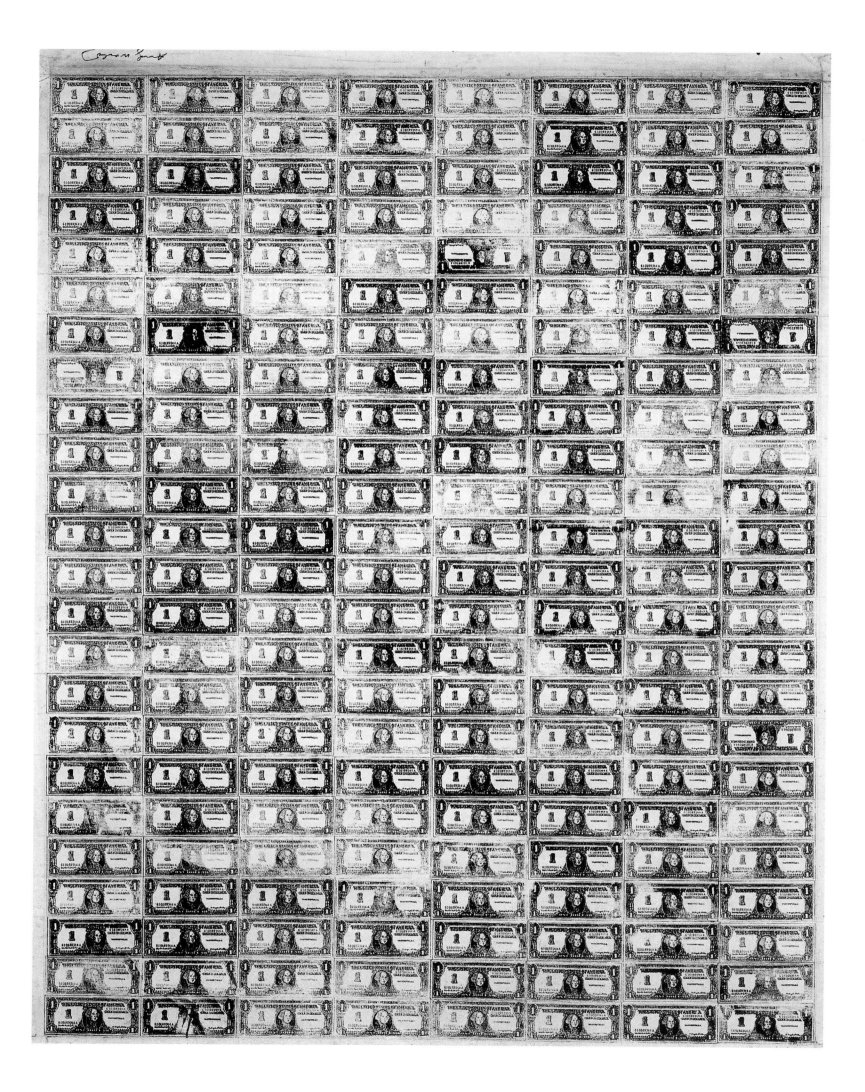

GREEN COCA-COLA BOTTLES

1962
Silkscreen ink, acrylic paint and
pencil on canvas, 209.5 x 144.7 cm
Whitney Museum of American Art, New York

This represents yet another of the cornerstones of modern consumerism and of American culture in particular, painted iconically but entirely dispassionately and in strict ranks so as to emphasize a repetition that exactly mirrors the industrial process that had brought the bottles into existence in the first place. And that Warhol thought about the social implications of such imagery is made evident by his statement in *The Philosophy of Andy Warhol*, published in 1975, that

> … America started the tradition where the richest consumers buy essentially the same things as the poorest. A Coke is a Coke and no amount of money can get you a better Coke than the one the bum on the corner is drinking. All the Cokes are the same and all the Cokes are good.

Indirectly, such egalitarianism may also be expressed through the equal ranking of the bottles.

In many of Warhol's Coke bottle pictures, areas of dark colour were underpainted beneath each bottle, so as to denote the drink within, before the Coke bottle design was then overprinted in an even darker tone. Here the underpainted flat pale green areas match the colouring of empty Coke bottle glassware and they often enjoy subtle formal differences from one another that suggest various light sources for the empty bottles.

Both bottles and the Coca-Cola logo were hand-drawn rather than being reproduced photographically, and the drawing of the bottle displays the type of visual shorthand that is customarily found in graphic design. Such a shorthand adds a subtle sense of personality to the imagery and offsets the effect of sterile mechanisation that is induced by so much repetition. Similarly, the variations in inking bring about the same compensation whilst equally creating a subtle but necessary visual rhythm.

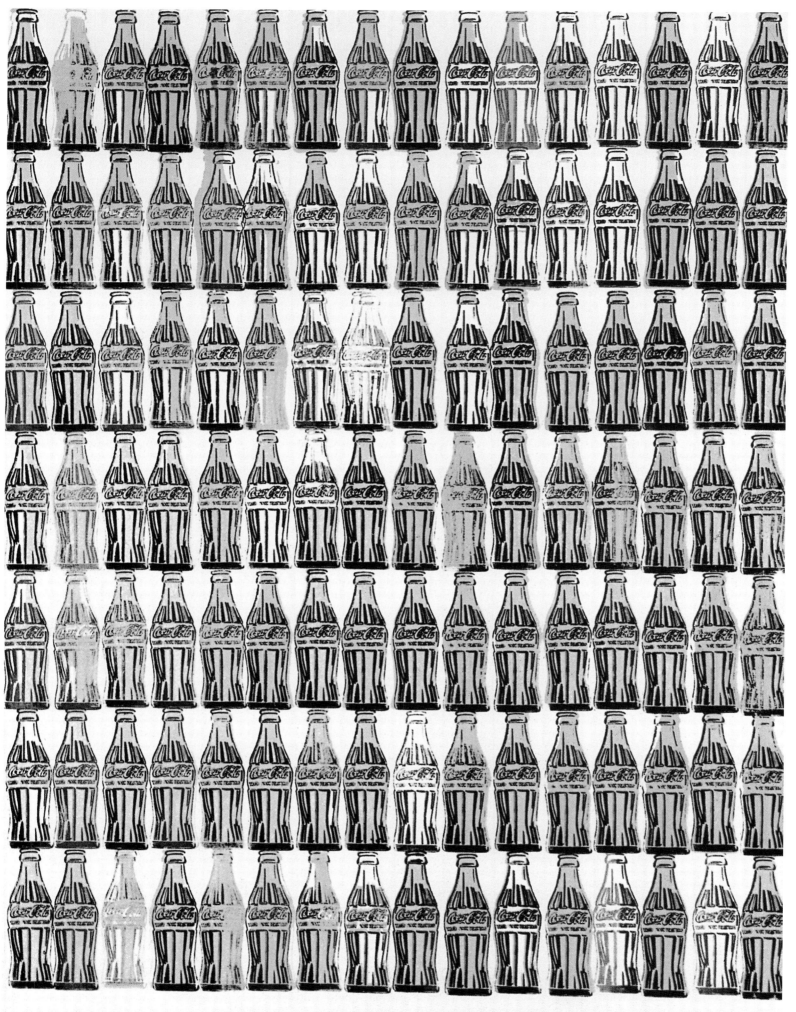

63.

BIG TORN CAMPBELL'S SOUP CAN

1962
Silkscreen ink on synthetic polymer
paint on canvas, 182.9 x 136 cm
Kunsthaus, Zurich

As well as painting ranks of Campbell's Soup cans and large representations of individual cans, Warhol also produced a number of pictures of damaged cans, the types of objects that are regularly thrown out by supermarkets as being unsaleable. Naturally, such 'damage' does not make Warhol's pictures of these types of cans unsaleable, and therein resides their irony, for whereas on the supermarket shelf most of us would undoubtedly steer clear of purchasing any can that differed from its peers, in art individuality makes wholly for attractiveness and economic value. And because damaged goods depart from a norm, ultimately these damaged soup can paintings are therefore statements about individuality versus conformism.

Once again the huge enlargement of a common consumer object takes what we see far beyond the realm of realism by investing it with humour. Warhol's graphic skill is further in evidence in the deft visual shorthand with which the tin can is represented: in order to obtain the speckled effect on the naked part of the can, the artist mixed ordinary household washing-up detergent with his paint.

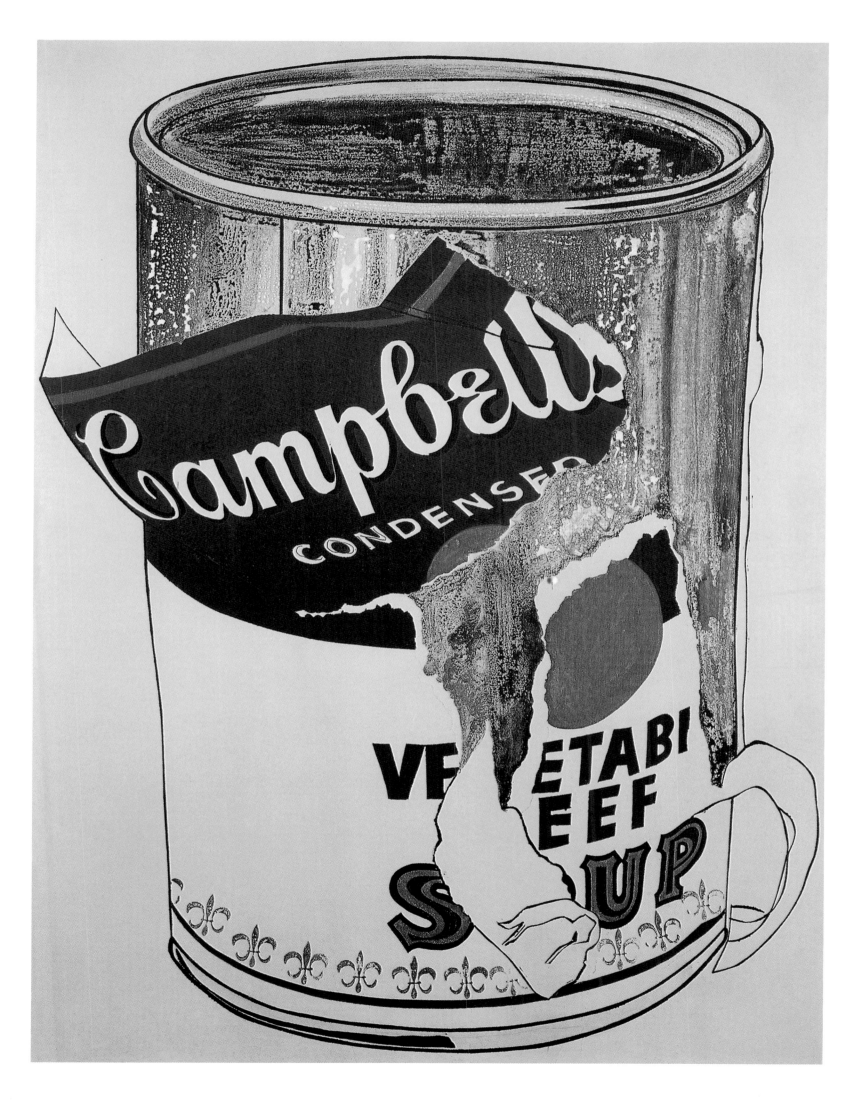

RED ELVIS

1962
Silkscreen ink on synthetic polymer
paint on canvas, 175 x 132 cm
Private Collection

We live in a culture that idolises both consumer objects and people, and Warhol shared in that worship. Yet equally he was aware of the cultural manipulations and distortions that stimulate our regard for such idols, and he employed visual repetition to parallel those cultural processes.

Repetition forms a central physical and psychological dynamic of all industrial societies: consumer objects are mass-produced by repetitious means, their costs are minimised through standardisation, and they are marketed through selling techniques that are highly repetitive. Similarly, the entertainment, leisure and advertising industries employ repetition to drum home the attractiveness of their products, often by using film stars, television personalities and the like. Warhol's genius was to perceive the cultural centrality of repetition and to make it the dominant subject of his art.

This painting was exhibited in Warhol's first New York exhibition at the Stable Gallery in 1962. As Warhol was well aware, our perceptions of individual images are usually altered when those images are frequently repeated, for their inherent formal properties are subtly stressed by the repetitiousness, and in *Red Elvis* the repeatedly curved outline of the top of the singer's head creates a pronounced curvilinear visual rhythm. The uneven inking lends variety to the repetition, and the lurid colouring certainly seems apt, for it points up the crude but striking colours by which the mass-media habitually assault the eye and mind.

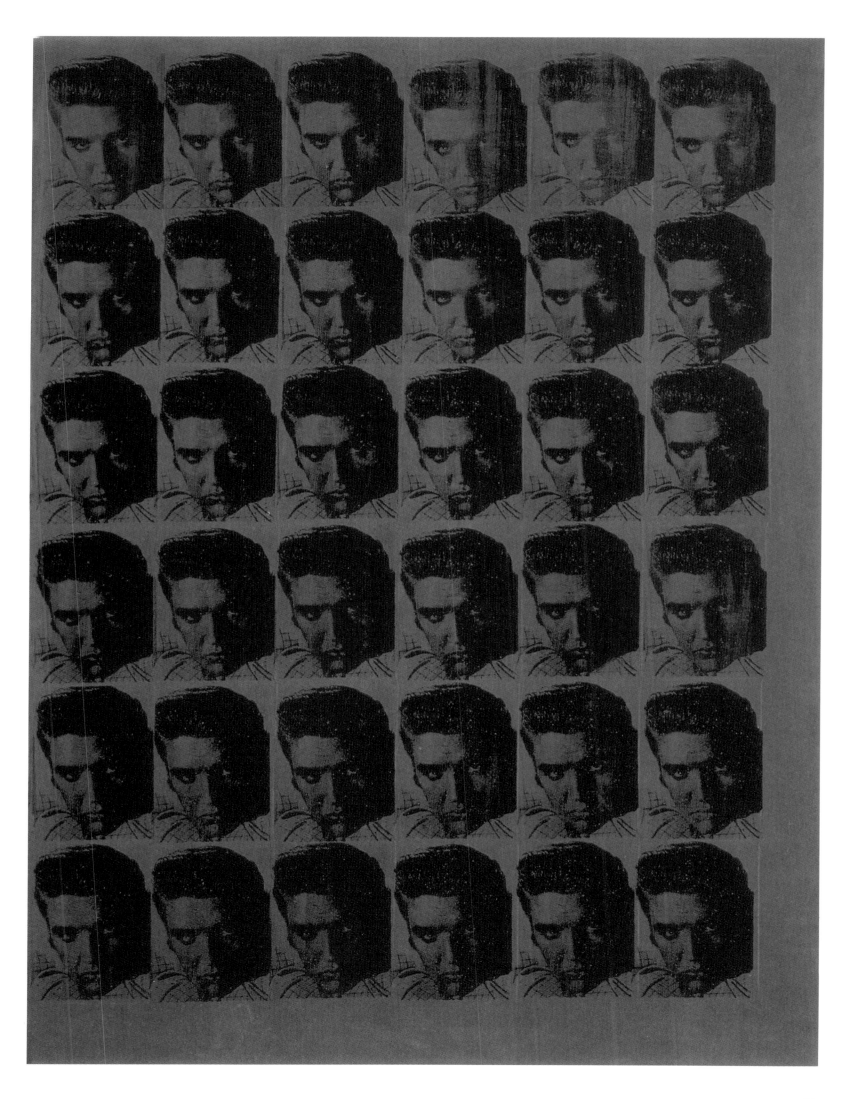

91.

TRIPLE ELVIS

1962
Silkscreen ink on aluminium paint on canvas
208.3 x 152.4 cm
Virginia Museum of Fine Arts,
Richmond, Virginia

This image of Elvis Presley derived from a publicity still made for the 1960 film *Flaming Star*. Originally Warhol created a large number of the Elvises on a single roll of canvas which he took with him to Los Angeles in September 1963 for his second one-man show at the Ferus Gallery.

On his arrival he asked the gallery director, Irving Blum, to cut the roll into conventional-format paintings mounted on wooden stretchers, and told him 'The only thing I really want is that they should be hung edge to edge, densely — around the gallery. So long as you can manage that, do the best you can'. In the event Blum left space around each painting, although the hang still looked fairly dense. It was complemented by twelve pictures of Liz Taylor hung in an adjacent room.

According to Gerard Malanga who was Warhol's painting assistant when the Elvises were created, it was he rather than the artist who was responsible for the overlapping multiple imaging in these paintings, saying that he 'deliberately moved the image over to create a jump affect' which Warhol liked. Again through heightening the inherent abstraction of the forms, such multiplicity forces the imagery away from merely operating on an informational level. Naturally it also calls forth associations of the repetition of cinematic motion. Moreover, the aluminium paint background looks silvery and thus introduces highly appropriate reminders of the silver screen.

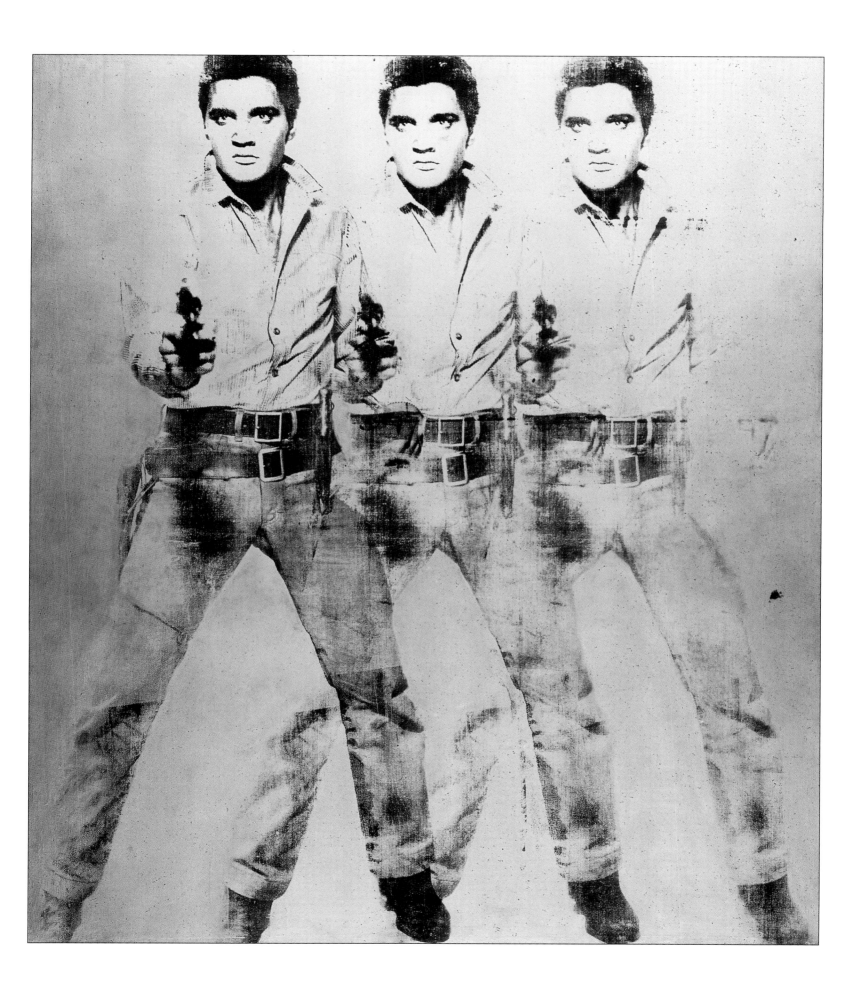

66.

MARILYN DIPTYCH

1962
Acrylic paint on canvas
205.4 x 144.8 cm
Tate Modern, London

Warhol was prompted to embark upon his series of paintings of Marilyn Monroe by news of the actress's suicide on 4 August 1962. This is perhaps the most commemorative of all the Marilyns and it was exhibited in Warhol's New York debut exhibition in 1962.

The photograph of Marilyn Monroe that Warhol used in his paintings and prints of the actress was taken in 1953 by Gene Kornman to publicise the film *Niagara*. When producing coloured portraits such as those, Warhol would actually build up the picture in reverse: first he would underpaint the background and individual colour areas constituting, say, the golden hair, the pink face, the red lips, and the green eyelids and collar, before finally overprinting the silkscreened photographic image of the person being portrayed. The areas of garish colour do not merely act as visual accents but serve brilliantly to stress the garishness of Marilyn Monroe's media personality. The slight variations in the underpaintings lend variety to the coloured images of Marilyn, without diminishing the sense of a repetitiveness that bears its usual implications of mass-communications media repetitiveness.

However, it is in the contrast between the cleanly painted coloured elements in the lefthand canvas and the messily painted monochromatic elements on the right, that the dramatic and commemorative level to this painting clearly resides. On the right the tonally disparate over-inking and under-inking, as well as the smeariness, introduce associations of physical obliteration and extinction that are entirely appropriate to a portrait of the dead Marilyn. By such means Warhol brilliantly juxtaposed the actress's entirely kempt and colourfully garish public personality, on the left, with her psychologically messy, uncolourful and gradually disintegrating, unhappy private self on the right.

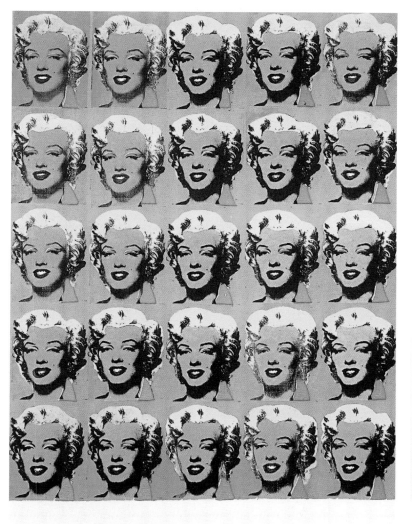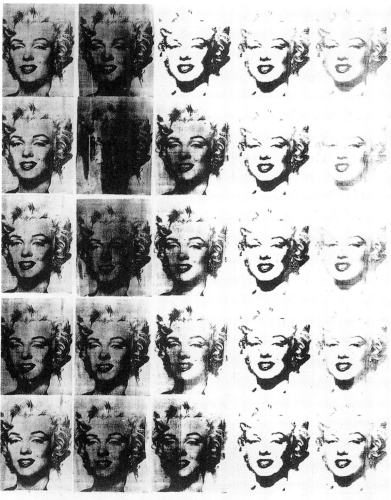

GOLD MARILYN

1962
Silkscreen ink on synthetic polymer
paint on canvas, 211.4 x 144.7 cm
Museum of Modern Art, New York

This is another of the paintings shown in Warhol's first New York exhibition in 1962. If in recent times Marilyn Monroe perhaps represented the supreme symbol of Western male notions of womanhood and sexuality, then Andy Warhol's *Gold Marilyn* is surely the supreme artistic icon of that mythicality, for because of its golden background, this picture comes closer to looking like a religious icon than most of the painter's other iconic images. Ultimately Warhol developed the work from the Flags paintings of Jasper Johns, although that does not in any way detract from his achievement in engaging a rather different set of ideas and associations in the work. Some of the major components of Marilyn's glamour – her peroxide hairdo, coloured eyelids and lips, as well as her facial skin area and shirtcollar – are luridly heightened in colour so as to stress the garishness of glamour. And the surrounding of the actress's head by a vast sea of gold paint introduces unmistakeable associations of wealth and economic value that remind us that Marilyn Monroe was at the cutting edge of a vast and highly exploitative financial operation, as are all successful media superstars.

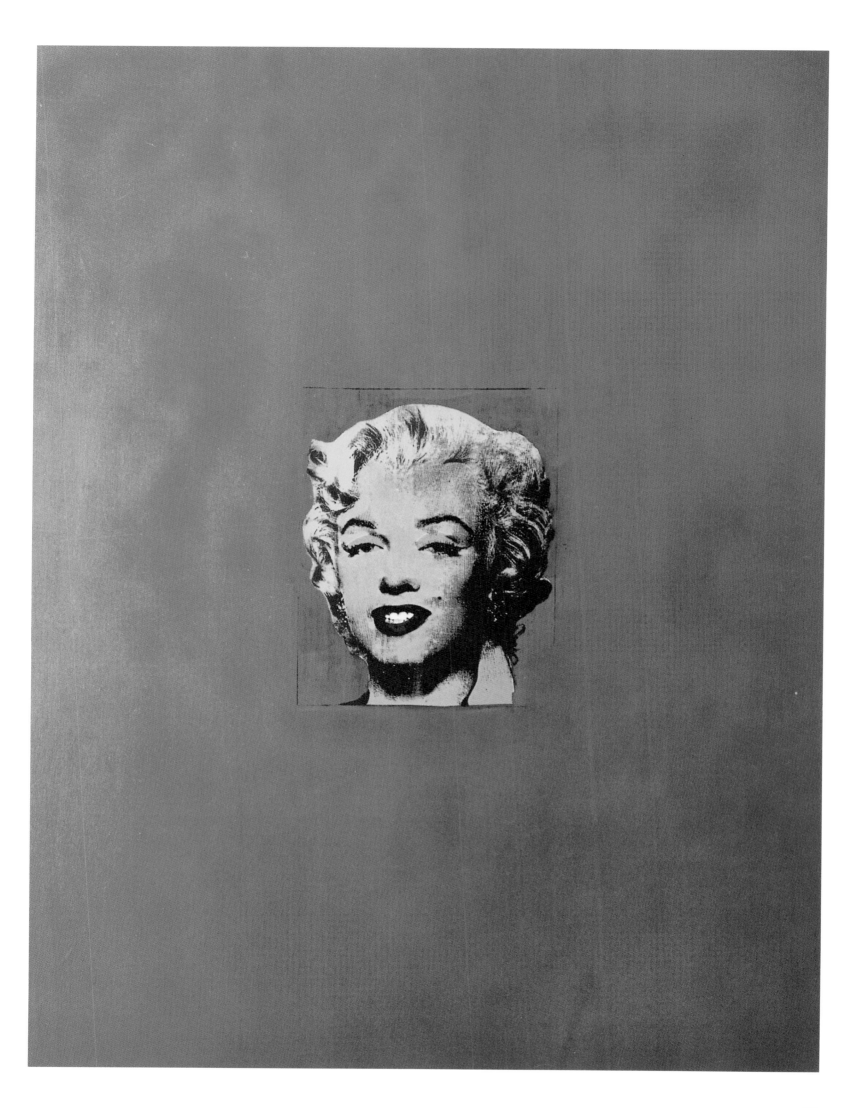

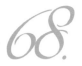

MARILYN MONROE'S LIPS

1962
Silkscreen ink on synthetic polymer
paint and pencil on two canvases
210.2 x 205.1 and 211.8 x 210.8 cm
Hirshhorn Museum and Sculpture Garden,
Smithsonian Institute, Washington, DC

This is perhaps Warhol's wittiest work. Ultimately it may have derived from the sofa that Salvador Dalí created of Mae West's lips around 1936, although the repetition makes these lips into something very different.

In the public appreciation of any glamorous mass-media personality, the isolation of certain physiognomical and anatomical details – eyes, lips, breasts, buttocks, legs – plays an important pyscho-sexual role. By filling this work entirely with Marilyn's mouth, Warhol not only stressed such psycho-sexual detailing but also turned a physiognomical feature that was very glamorous in the full context of the face into something rather repulsive. The endless repetitiveness makes Warhol's customary point about mass-communications media repetition, whilst simultaneously pushing the imagery to the verge of abstraction.

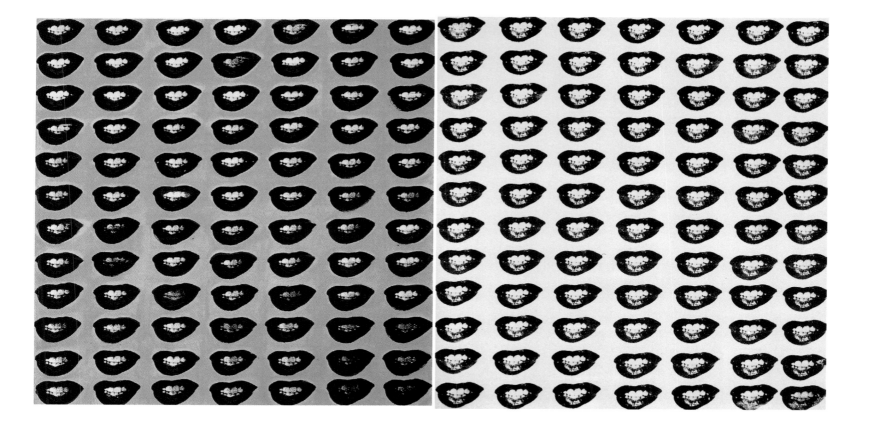

OPTICAL CAR CRASH

1962
Silkscreen ink on synthetic polymer
paint on canvas, 208 x 208.3 cm
Kunstmuseum, Basel

Here Warhol's tendency to push his imagery towards abstraction took over almost completely, for the painting walks a fine line between representationalism and the type of investigation into perceptual qualities that was being explored contemporaneously by pop artists during the early 1960s. Yet simultaneously the massive overlaps and blurred inkings, and the vibrancy of the strident green and hot orange colours, enforce a wholly appropriate dramatic level to the work, for the visual confusions and clashings of form naturally parallel the confusions and clashings of the crashed vehicles. The sharply contrasting colours also project the dynamic physical tensions of their impact.

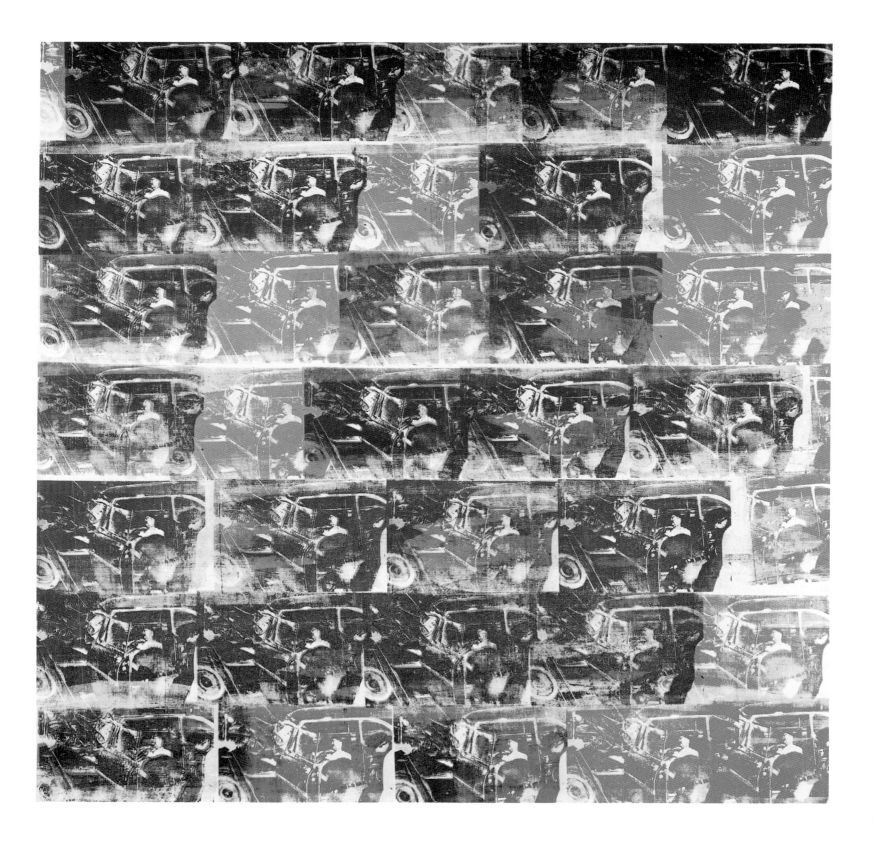

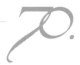

RED RACE RIOT

1963
Silkscreen ink on synthetic polymer
paint on canvas, 350 x 210 cm
Museum Ludwig, Cologne

Although Warhol's attention was drawn to the ugly side of American life in 1962, when he painted *129 Die in Jet!*, it was not until the following year – by which time he had mastered silkscreen printing and painting techniques – that he really began to grapple with tragic subject-matter.

For this painting Warhol used three photographs of police dogs being unleashed on civil rights protestors in Birmingham, Alabama, pictures by Charles Moore that had originally appeared in the 17 May 1963 edition of *Life* magazine. Warhol was never politically committed, so it would be wrong to see any particular position regarding the Civil Rights struggle here, but nonetheless the imagery does speak frighteningly for itself. Warhol's arrangement of the component images forces us to look carefully in order to distinguish one photo from another, and the internal diagonals enforced by legs, batons, dogs and torn trousers create a number of powerful linear cross-rhythms that offset the rectilinearity of the individual images. The graininess of the photos is counterpoised by the smeariness of the background colour, thus further pushing the imagery towards abstraction, while that very smeariness, plus its colour, introduces appropriate associations of blood.

103.

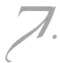

SUICIDE

1963
Silkscreen ink on synthetic polymer
paint on canvas, 313 x 211 cm
Sammlung Nordrhein-Westfalen, Düsseldorf

When it comes to death and disaster we are most of us voyeurs: bad news and tragedy sells newspapers and/or forces us repeatedly to our television sets and radios. Certainly such matters were frequently dealt with in post-Renaissance art, as in the hordes of pictures of shipwrecks, avalanches, volcanic eruptions, murders by banditti and other natural or manmade catastrophes. Yet Warhol's Death and Disaster pictures subtly differ from all their predecessors, for he does not take pleasure in morbidity, he simply confronts us with the fact of death dispassionately and with a heightened sense of emotional and pictorial abstraction (the one heightening the other). It is as if he asks 'here is the clinical reality of death, but what are you looking at, and are you deriving pleasure from it? If so, why?'

Through Warhol's conscious ignoral of precise matchings of tone and form, the variations and overlappings of inking in this image boost both the sense of movement of the falling suicide and the feeling of impersonality that the picture projects.

Moreover, the tonal variety augments the inherent pictorial abstraction, but again that forces us to question how we can concern ourselves with such aesthetic matters when confronted by the death of others. Surely some subject-matter is located beyond the reach of art, and thus the aesthetic pleasures it affords? And naturally the repetition of the images reinforces our awareness of how repetitiveness is constantly employed to communicate tragedy in the real world around us.

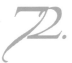

FIVE DEATHS SEVENTEEN TIMES IN BLACK AND WHITE

1963
Silkscreen ink on synthetic polymer
paint on two canvases, each 262 x 209 cm
Kunstmuseum, Basel

Warhol may first have obtained the idea of specifically dealing with smashed cars from a sculpture entitled *Jackpot* by the American, John Chamberlain, for he had purchased the piece in 1961. It comprises of the crushed body of an automobile painted in factory colours. Because of that work Warhol cannot have been unaware of the physical damage wrought by smashing a car body. The painter gleaned the photographs he used for the car crash pictures from police and press files that respectively were not released for use to the press or were unpublishable, being deemed too horrific.

Through its monochromatic starkness, this is one of the most visually powerful of all of Warhol's car crash pictures. Yet again visual repetition confuses the eye, and thus augments the inherent abstraction of the imagery, while equally that repetitiveness reminds us that death is everywhere. The uneven inking enforces subtle differences between the individual images, thus lending visual variety to the work. Warhol attached identically-sized and coloured but wholly blank canvases to many of the paintings he produced during the early 1960s. He furnished a number of different explanations for having done this. One was that the coupling gave purchasers twice as much art for their money; another was that conversely they were paying good money in part for empty canvases. A further reason had to do with Warhol's admiration for the flat-patterned, abstract paintings of Ellsworth Kelly (one of which he owned), for as he stated, 'I always liked Ellsworth's work, and that's why I always painted a blank canvas.' But in the final analysis it also seems possible that the blank canvases were intended to heighten the meaning of the pictures they complemented.

Blankness is not necessarily without meaning, for it can easily signify vacancy. Thus in the paired disaster paintings the large, complementary flat, blank areas of colour or tone heighten the sense that the horrific events represented adjacently have created nothingness. In the light of Warhol's stated emotional neutrality and *anomie*, that blankness could well have been intended to stand for something larger, namely a cosmic emptiness or indifference. In the present work the utterly bare blackness of the right-hand canvas certainly does project the finality and endless blackness of annihilation, as experienced by the deceased victims of the crash on the left.

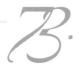

ORANGE CAR
CRASH TEN TIMES

1963
Silkscreen ink on synthetic polymer
paint on canvas, 269.24 x 208.2 cm
Museum Moderner Kunst Stiftung
Ludwig, Vienna

Here the sensual pleasurability of the orange background and overprinted maroon colouring is surely at odds with the horrific nature of the imagery. Once again, a purely aesthetic approach to what Warhol gives us seems utterly inappropriate, just as he knew it would be. The seemingly random, off-centre placing of the car-crash images projects a more universal arbitrariness, whilst the overwhelming blankness of an adjacent canvas once again heightens our sense of the cosmic meaninglessness of the tragedy laid out before us.

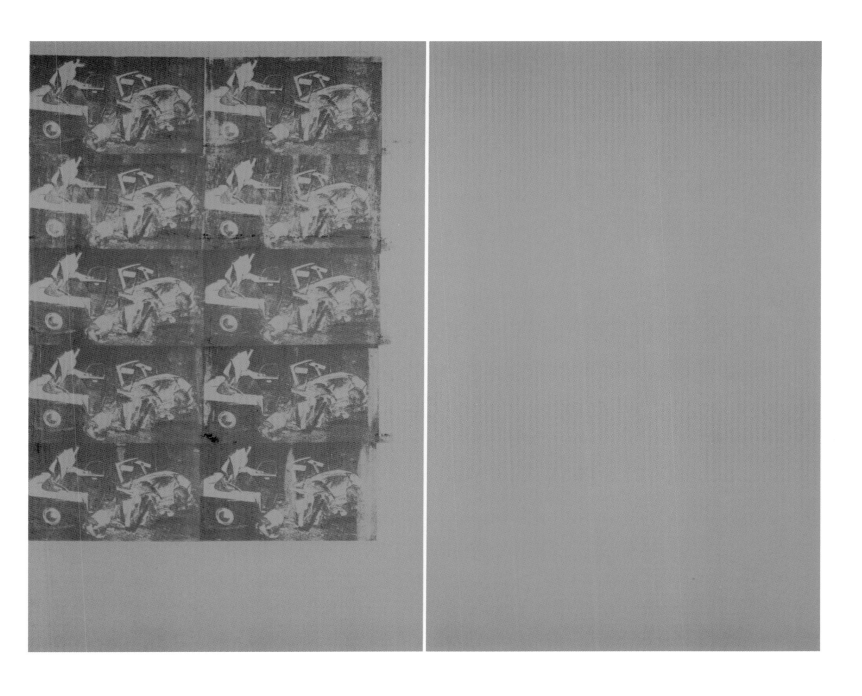

ETHEL SCULL 36 TIMES

1963
Silkscreen ink on synthetic polymer paint on
36 canvases, 202.6 x 363.2 cm overall
Whitney Museum of American Art, New York

This was Warhol's first commissioned silkscreen portrait, and it was ordered and paid for by Robert Scull, a New York taxi-fleet owner who was amongst the most prominent collectors of new art in the early 1960s.

Warhol's customary habit of dealing directly with reality paid off handsomely here. Knowing that the painter wanted to use photographs of her for the portrait, Ethel Scull imagined that he would get someone like Richard Avedon to take the pictures. Accordingly she dolled herself up in an Yves St Laurent suit for the photographic session. However, Warhol instead took her to a group of 42nd Street photobooth machines that he fed with small change; as the sitter later told Emile de Antonio:

He said, "Just watch the red light," and I froze. I watched the red light and never did anything. So Andy would come in and poke me and make me do all kinds of things, and I relaxed finally. I think the whole place...thought they had two nuts there. We were running from one booth to another, and he took all these pictures, and they were drying all over the place.

Warhol subsequently selected seventeen of the photographs for the portrait, some of which appear several times. He then photo-silkscreened them onto the individual panels which he finally brought together to form one work in the Scull's Fifth Avenue apartment.

The novel result of Warhol's approach was that in effect Ethel Scull portrayed herself, for by posing both selfconsciously and uninhibitedly, she thus revealed facets of her personality that would normally be hidden by more conventional portrait methods. She herself liked the work, for as she told Emile de Antonio, '...it was a portrait of being alive and not like those candy box things, which I detest, and never ever wanted as a portrait of myself'.

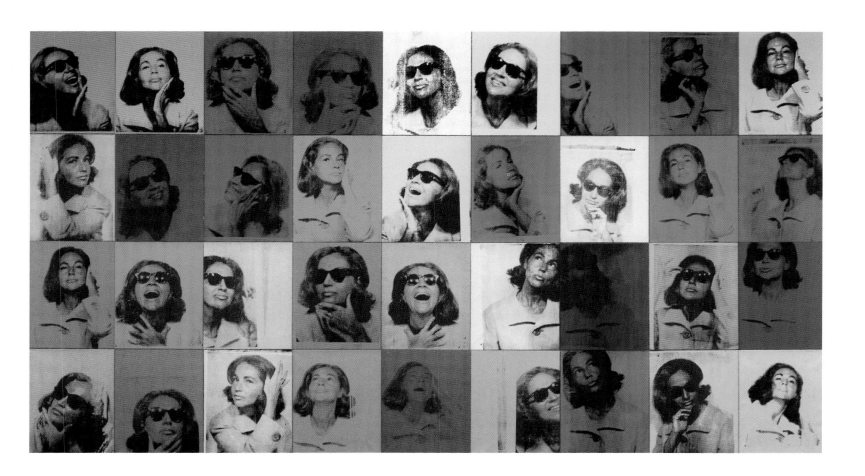

MONA LISA

1963
Silkscreen ink on synthetic polymer
paint on canvas, 319.4 x 208.6 cm
Blum Helman Gallery, New York

Leonardo da Vinci's *Mona Lisa* is without doubt the most famous artistic icon in the world. It has therefore long acted as a potent symbol for those who wish to attack the traditional cultural values it represents. Perhaps the best known such attack is Marcel Duchamp's *L.H.O.O.Q* of 1919 in which a moustache and goatee were pencilled on a reproduction of the painting, with the ribald, phonetically punning abbreviation that doubles as the title of the work added below the image.

The *Mona Lisa* was lent to the Metropolitan Museum of Art, New York, in February 1963 for a month, and the tremendous media hullabaloo it caused motivated Warhol to produce a number of largescale paintings which recycle the image. As a means of mirroring the endlessly repetitive cultural treatment that was being meted out to the *Mona Lisa*, Warhol emphasized replication in these works, and even entitled one of them *Thirty Are Better Than One*, a wry comment on the popular equation of value with multiplicity. In the version reproduced here Warhol dealt instead with the reproduction of a work of art by the print media, and specifically by colour printing.

All colour reproductions break images down into three primary colours: cyan (a sharp sky blue); magenta (a deep red); and yellow, plus black. From combinations of these, all other colours and tones are obtained. It is exactly those three colours and black that Warhol has employed here. Moreover, the array of component images makes the overall image look exactly like a colour printer's rough proof sheet, with seemingly arbitrary overprintings of the type that come about when colour printers run off preliminary colour proofs and do not want to use up endless sheets of paper whilst doing so – usually they will just overprint on a single sheet of paper. And that is exactly what Warhol has duplicated here, for he must have seen such rough proofs many times during his commercial art career.

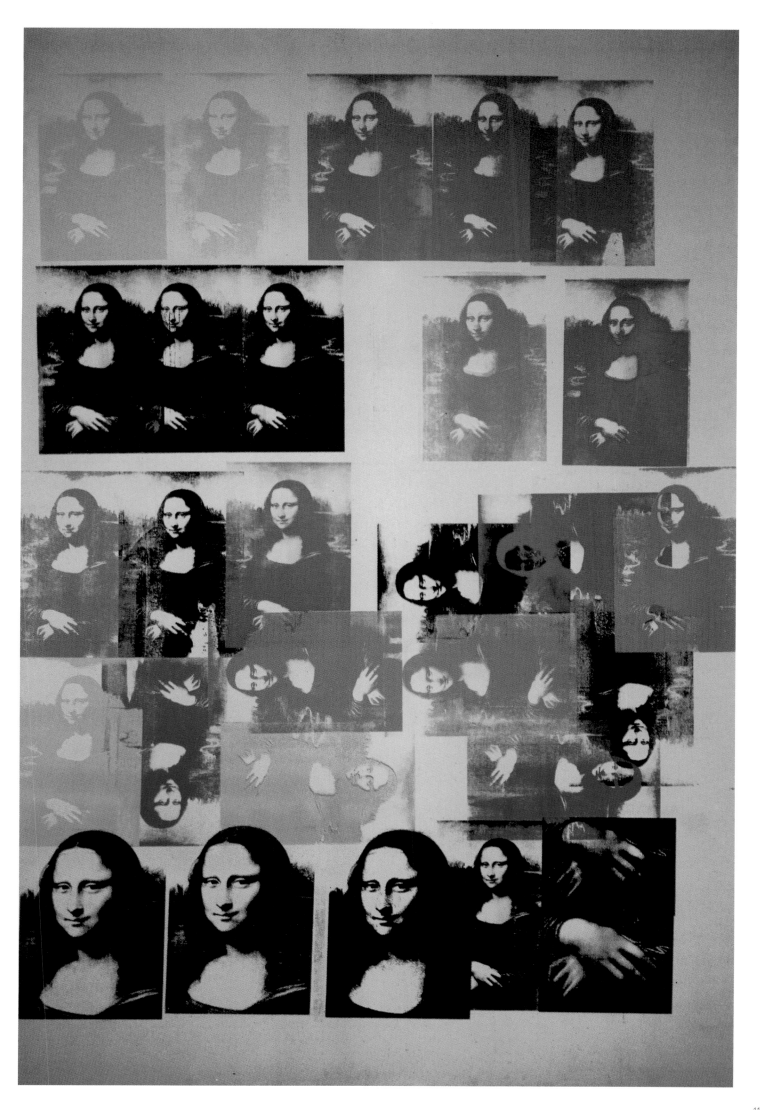

BLUE ELECTRIC CHAIR

1963
Silkscreen ink on synthetic polymer paint on
two canvases, each 266.7 x 203.8 cm
Saatchi Collection, London

Death by electrocution was widely discussed in New York State in 1963. Warhol was clearly inspired by news of that debate to make a set of electric chair images. In some of them he superimposed the silkscreened image of the chairs in black ink over areas of attractive colour, thereby creating an ironic juxtaposition of horror and prettiness, a linkage he may have seen as a metaphor for life itself. Such analogues encourage interpretation of the vivid blue colour of the present work as similarly denoting something beyond what we actually see, namely a powerful electrical discharge.

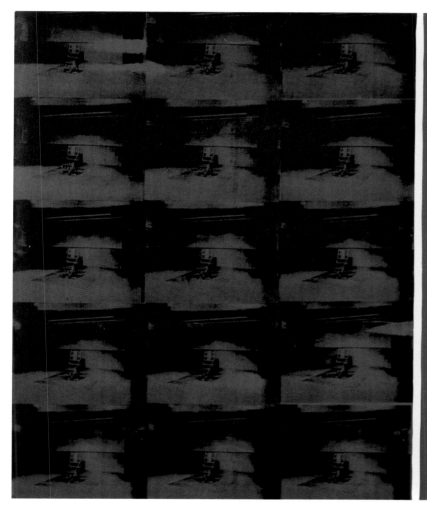

ATOMIC BOMB

1965
Silkscreen ink on synthetic polymer
paint on canvas, 264.1 x 204.5 cm
Daros Collection, Zurich

The painting has usually been dated to 1965, but it seems likely it was created earlier. As Warhol celebrated his birthdays on 6 August, he had every reason to be aware of atomic explosions, for it was on his seventeenth birthday in 1945 that the first atomic bomb was dropped on Hiroshima. Despite Warhol's disclaimers to have expressed any meanings in his works, this painting indubitably demonstrates that he *did* want his imagery to say something about the world. The garish red colour (which bears connotations of fire) and the gradual blackening of the image so that it totally closes up in darkness towards the lower right, create an outstandingly inventive metaphor for the utter fiery annihilation that is rapidly brought about by an atomic explosion.

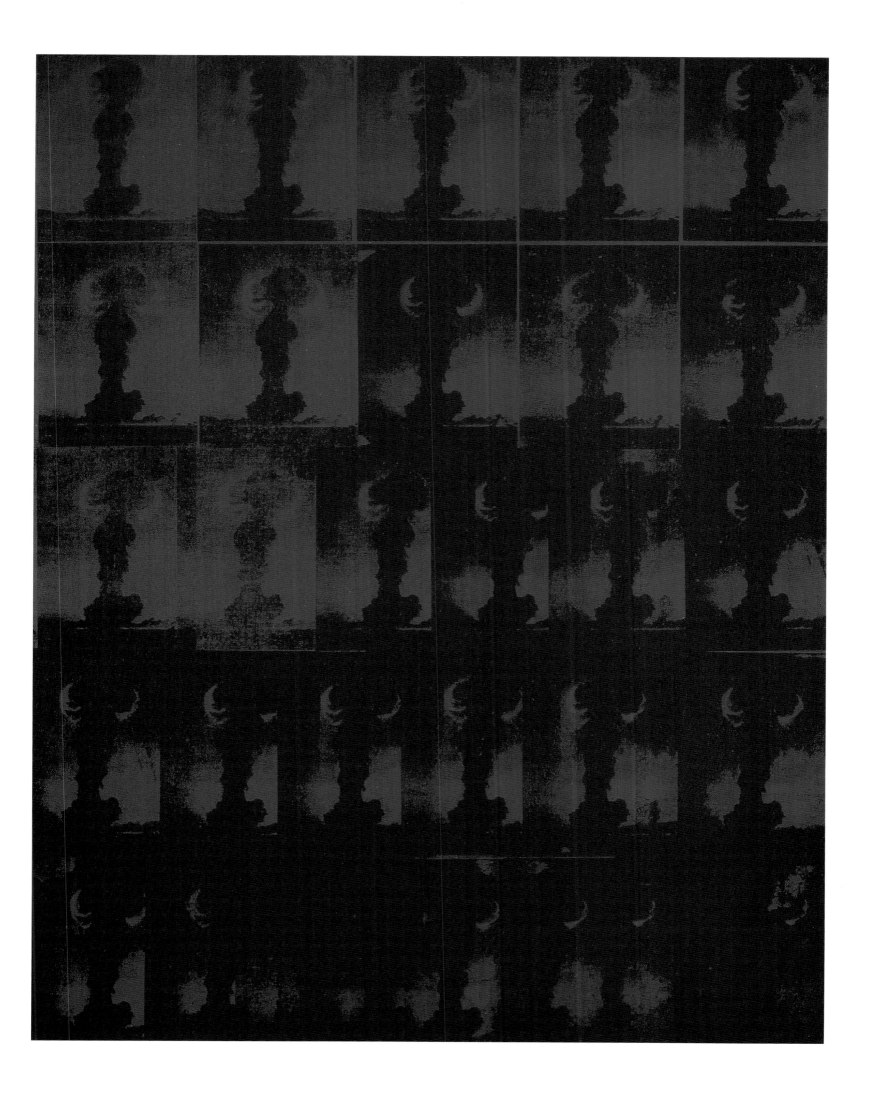

ELVIS I AND II

1964
Silkscreen ink on synthetic polymer paint on
two canvas, each 208.3 x 208.3 cm
Art Gallery of Ontario, Toronto

Not the least of Warhol's talents was his ability to select images judiciously. By using a publicity photo of Elvis Presley as a cowboy pointing a gun, the painter both appropriated a major American area of myth and touched upon the violence that stands at the heart of that myth. Yet in its coloured form the image does triple duty, for through the garish simplification of the colour it projects cultural banality. This seems highly appropriate, for Elvis Presley looks extremely unconvincing and kitsch dressed as a cowboy. The images on the right are silkscreened over aluminium paint, the metallic sheen of which introduces unmistakeable associations of the silver screen. Equally, the cloning of the images projects the cloning of cultural images by the mass-media. Towards the right the tonality of Elvis lightens, which may have been accidental but which nevertheless could imply that even superstars fade.

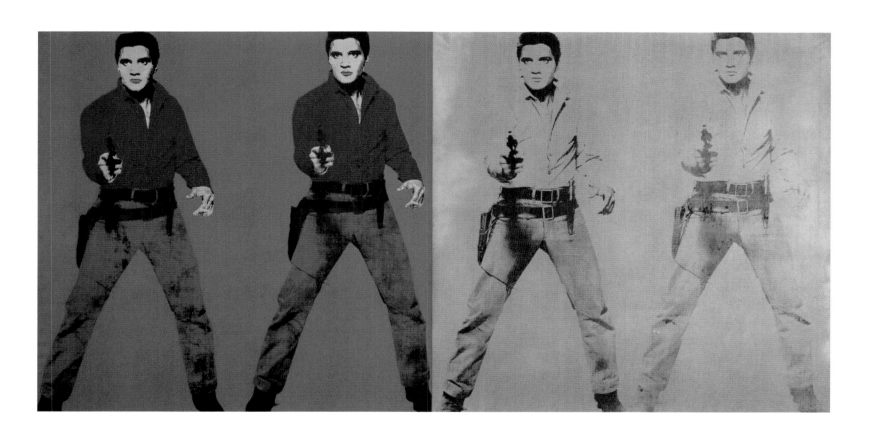

THE AMERICAN MAN – WATSON POWELL

1964
Silkscreen ink on synthetic polymer
paint on canvas, 326.4 x 163.8 cm
American Republic Insurance Company,
Des Moines, Iowa

It seems apt that Warhol created this archetypically bland but multitudinous businessman's portrait, for he dealt with almost every other aspect of contemporary life. The portrait was commissioned by the insurance organisation that still owns it, and it represents the then-President of the company. The photograph of Watson Powell that Warhol used was one frequently handed out by the executive, so the replication of the image was therefore extremely apt. Warhol gave the work its present title, presumably because he saw Watson Powell as the archetypal American male. However, in private he always referred to him as 'Mr Nobody'. The English painter and art critic Mark Lancaster visited Warhol when he was mixing and testing the colours for this portrait, and the latter complained of having to do such work instead of making movies. Yet Lancaster gained the impression 'that [Warhol] was absorbed and happy in this activity'. The varied tones of beige, white and black create a subtle visual rhythm that offsets the repetition of the imagery, while the colours themselves effectively project the requisite emotional neutrality of an official, corporate image.

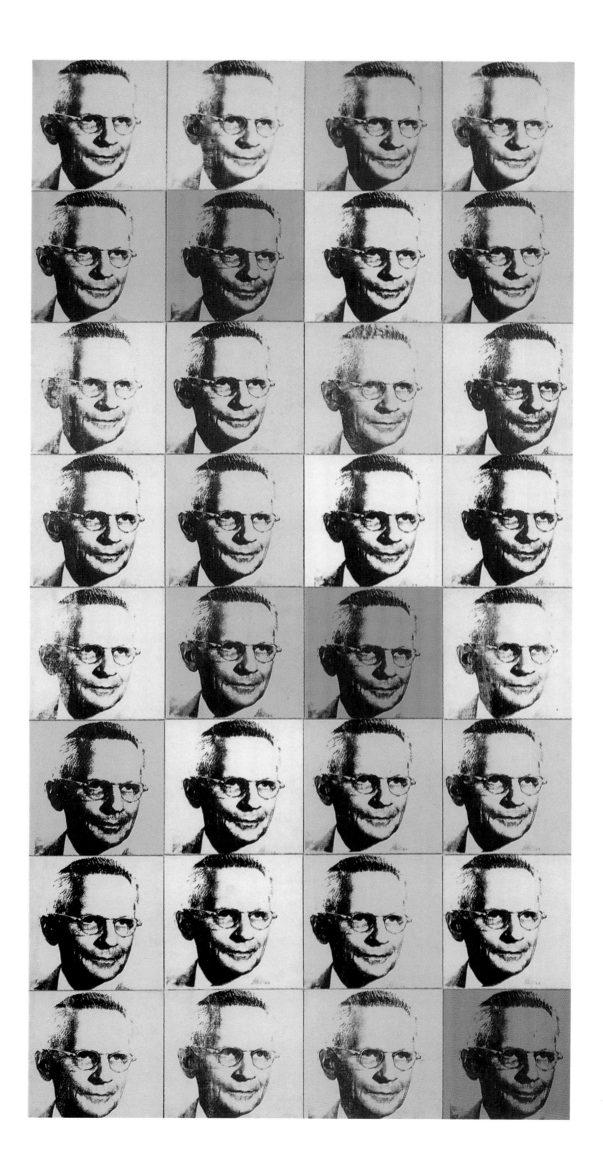

MOST WANTED MEN

1964
Top: *Most Wanted Men No. 10: Louis Joseph M.*
Silkscreen ink on two canvases
each 122 x 101.5 cm
Städtisches Museum Abteiberg,
Mönchengladbach

Below: *Most Wanted Men No. 11: John Joseph H.*
Silkscreen ink on two canvases
each 122 x 101.5 cm
Saatchi Collection, London

In April 1964 Warhol was invited by the architect Philip Johnson to adorn the outside of the New York State Pavilion at the New York World's Fair. Initially he planned to make a work using Heinz brand pickles in order to allude to the pickles that had been handed out at the previous New York World's Fair in 1939. Yet perhaps because he remembered a poster by Marcel Duchamp seen in Los Angeles the previous year as he changed tack. (The Duchamp poster reproduced one of the French artist's works dating from 1923, namely a photo of himself with the words 'WANTED $2000 REWARD' printed in bold type around it). Instead, Warhol created a vast mural comprising 22 canvases reproducing mug-shot photographs of some thirteen alleged criminals taken from the FBI's 'Most Wanted Men' posters openly displayed in U.S. Post Offices; the work was entitled *Thirteen Most Wanted Men.* The notion of using criminals or suspects as subjects for art wittily ties in with the subversive tactics of Dadaism, which again points to Warhol's strong affinity with that anti-artistic movement. Naturally, by employing criminal imagery in the first place, he was also taking his art into yet another major area of human experience.

Unfortunately for Warhol, however, only a few of the men represented in the mural were still wanted by the police, and predominantly they were of American-Italian extraction, so both of these factors led to complaints. Under pressure from the New York State Governor Nelson Rockefeller, the director of the World's Fair, City Commissioner Robert Moses, ordered the removal of the mural. Warhol then proposed that he replace the images with pictures of Commissioner Moses himself, and even went ahead and made the Robert Moses paintings in his studio.

However, they never saw the light of day, for Philip Johnson refused to countenance such a substitution. As a result, Warhol simply obliterated the mural by having it painted over with aluminium paint. That effacement ties in with the artist's usual attitude towards negation, and it was an act that was certainly worthy of the Dadaists at their height.

Who are these men and what have they done, or stand accused of? Because we are not told of their supposed or real offences, they surely intrigue us all the more. We can only attempt to deduce their alleged or actual crimes from their physiognomies. Once again Warhol brilliantly confronted us with basic problems of rationale, both artistic or otherwise, for our possible interest raises disturbing questions about the motivation of being drawn to such imagery.

BRILLO BOXES

1964
Silkscreen ink on synthetic polymer paint on
wood each box 51 x 51 x 43 cm
The Andy Warhol Foundation for the
Visual Arts, Inc., New York

This is a colour photograph of part of Warhol's packing carton sculptures exhibition held at the Stable Gallery, New York, in April 1964. Warhol probably derived the idea for the display from the exhibitions held by Claes Oldenburg in 1961 under the title of *Store*. These were made up of sculptures representing everyday consumer goods. Warhol is known to have visited one of the *Store* shows and been taken aback by it. Here, however, he gave us a somewhat more subversive and relentless project than Oldenburg's witty celebrations of consumerism.

For these works Warhol and Gerard Malanga silkscreened the designs of the cardboard outer packing cartons of Campbell's Tomato Juices, Del Monte Peach Halves, Mott's Apple Juices, Brillo Soap Pads, Heinz Ketchups and Kellogg's Cornflakes on all six sides of over 400 wooden boxes that had been made to order by a team of

carpenters. By being created and displayed *en masse*, Warhol's boxes raise pointed questions about the nature of appearance and reality, and about the commercial value of a work of art versus the object it represents. And by almost filling the Stable Gallery with these sculptures Warhol was thereby converting the space into a glorified supermarket stockroom, thus reminding us that art galleries are usually only glorified supermarket stockrooms anyway.

The carton sculptures caused further cultural ructions early in 1965 when a Toronto art dealer attempted to import eighty of them for a show. He was prevented from doing so by Canadian Customs officials who attempted to levy a hefty import duty on the objects as 'merchandise'. When the dealer appealed to the Director of the National Gallery of Canada to mediate on his behalf he was told that such artefacts were certainly not works of art.

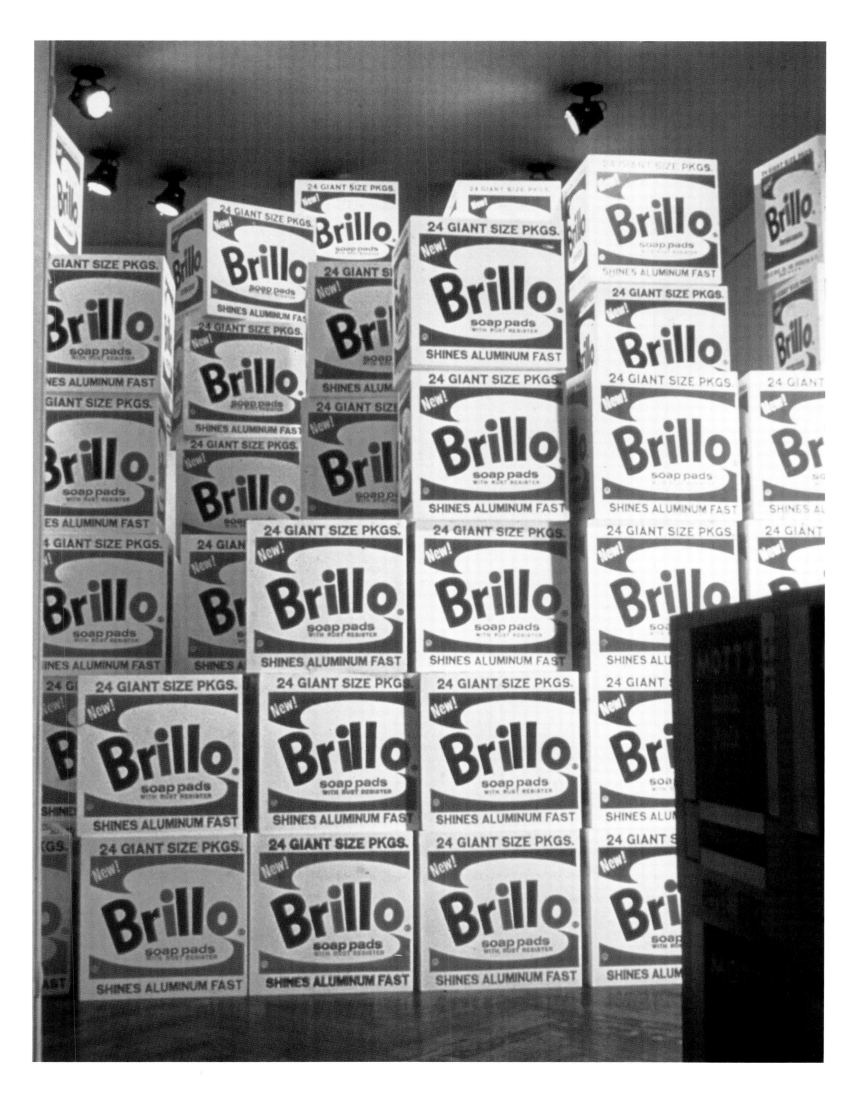

FLOWERS

1964
Silkscreen on two canvases, 12.7 x 12.7 cm
Sonnabend Collection

In his *Flowers* paintings Warhol covered yet another major area of life and art, for flowers form a principal component of the natural world, and there is a long and hallowed tradition of depicting such blooms in Western art. The series came about at the suggestion of Henry Geldzahler who met Warhol in April 1964 at the New York World's Fair and suggested that instead of producing yet more death and disaster pictures, he should instead paint flowers. Warhol thereupon had sets of silkscreens made up from a photograph of some hibiscus flowers that he cropped and rearranged from the June 1964 edition of *Modern Photography* magazine. Assisted by Gerard Malanga, he made over 900 flower paintings that summer (although he forgot to obtain permission to reproduce the original flower photograph before doing so, and was successfully sued for breach of copyright by the photographer, Patricia Caulfield). The vast replication of the images surely makes the point that the natural world has become prettified, commodified and marketed on a mass scale during the present era. Naturally, this prettification, commodification and marketing were paralleled by Warhol himself, for the first exhibition of the Flowers paintings at the Leo Castelli Gallery in November 1964 was a complete sellout.

The original photograph in *Modern Photography* magazine adorned an article on variations in colour printing, so Warhol's many colour variations of flowers are very apt. Because of the formal repetitiveness and colour variation, the works almost function simultaneously as investigations into the ways that such stresses and changes alter our perceptions of form, which could conceivably have been one of Warhol's intentions, given his highly developed visual sensibility.

In addition, as usual, the painter's alertness to the intrinsic properties of forms made him push the shapes of the flowers to the interface with abstraction. That effect is heightened by the repetition, crowding and colour variation of the flowers when they are seen *en masse*, as they were in the Castelli Gallery show, and again at the Ileana Sonnabend Gallery in Paris in May 1965. Warhol chose to display these pictures in Paris at that time because, as he commented in *POPism: The Warhol '60s*:

> In France they weren't interested in new art; they'd gone back to liking the Impressionists mostly. That's what made me decide to send them the Flowers; I figured they'd like that.

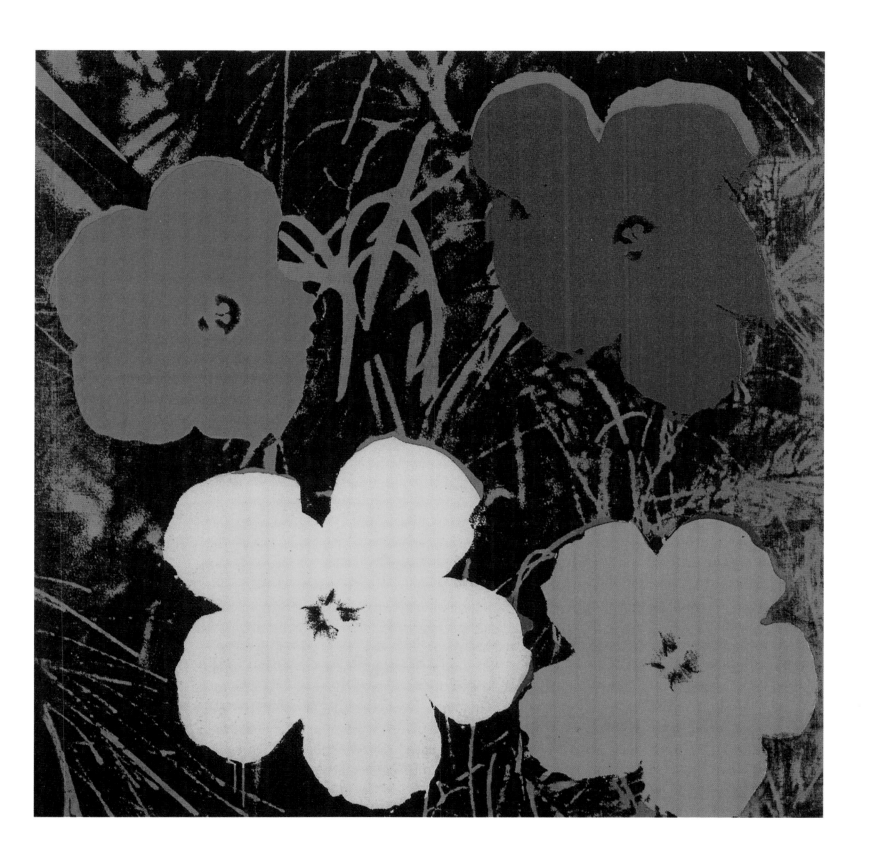

JACKIE

1964
Silkscreen ink on synthetic polymer
paint on 35 canvases, 40.6 x 50.8 cm each
Museum für Moderne Kunst,
Frankfurt-am-Main

Rhythm is the keynote of this most formally cohesive of all the portraits of Jacqueline Kennedy. Warhol embarked upon it shortly after the assassination of John F. Kennedy in November 1963.

The original photograph that provided the image was taken aboard the presidential airplane on the evening after the shooting, when Kennedy's shocked widow stood beside Lyndon B. Johnson and his wife as the Vice-President was being sworn in as President on the flight back to Washington. Warhol refused to grieve overly for the dead president, however, for as he commented in *POPism: The Warhol '60s*:

I'd been thrilled having Kennedy as president; he was handsome, young, smart – but it didn't bother me that much that he was dead. What bothered me was the way the television and radio were programming everybody to feel so sad.

That programming is indirectly suggested by the use of a repetition which simultaneously reminds us of the way that the mass-communications media originally sent Jackie Kennedy's pained likeness through a multitude of electric and printed conduits to the world. And once again on show is Warhol's propensity to enjoy two pictorial worlds, for through the use of visual rhythm the imagery approaches the condition of abstraction.

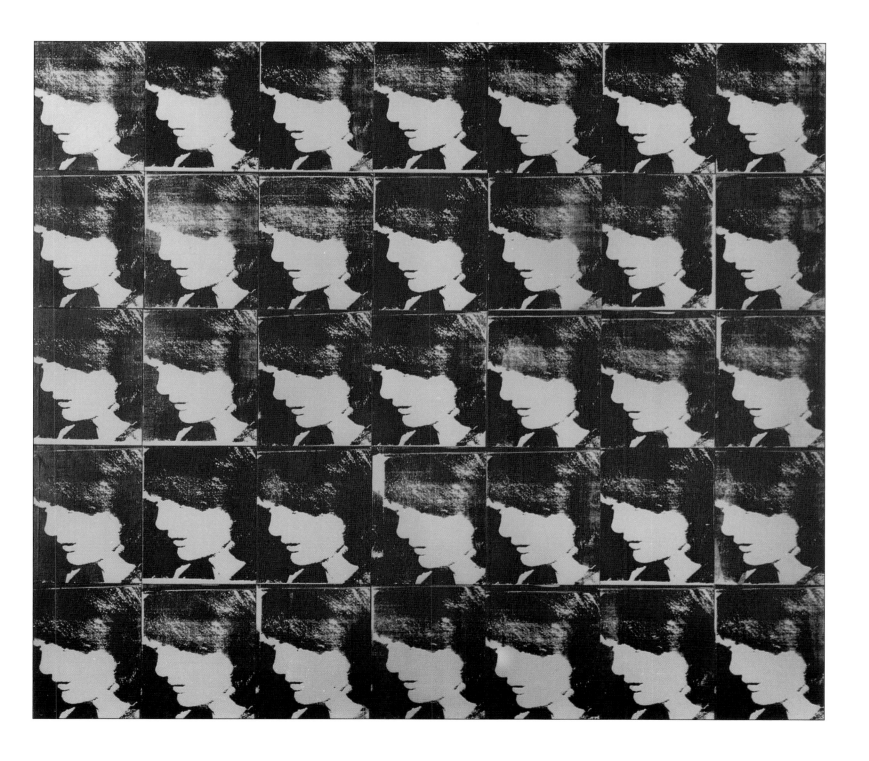

129.

COW WALLPAPER

1966
Silkscreen on paper, 115.5 x 75.5 cm
The Andy Warhol Foundation for the Visual
Arts, Inc., New York

Here we see just one section of a printed design that was originally repeated vertically in strips as a wallpaper. That wallpaper developed logically from the wallpaper effect that the Flowers paintings had created when shown *en masse* in New York in 1964 and Paris in 1965. The wallpaper was used to cover one of two rooms in the exhibition Warhol held in the Leo Castelli Gallery in April 1966.

Unfortunately only a few of the rolls of wallpaper were sold, thus bringing about a break between artist and dealer (and also now making the few surviving rolls very rare and thus pricey indeed). But the wallpaper could never have functioned as a proper wallpaper anyway, for as Charles F. Stuckey has pointed out, 'Its left side does not interlock graphically with its right side as repeat patterns must. Instead, Warhol's *Cow Wallpaper* is like a printed film strip of a close-up shot for one of his motionless movies'.

As narrated above, Warhol derived the notion of making images of cows from Ivan Karp, who felt that nobody dealt with pastoral imagery any more. And like the Flowers paintings, the *Cow Wallpaper* operates on a variety of levels: it links with – and perhaps sums up – the pastoral tradition in Western art; it points up the repetition through which generally we now experience nature 'in the comfort of our own homes'; it makes the point that in the modern world, painting has usually become just so much cultural wallpaper (and often rather dumb wallpaper at that); and it connects very strongly with the Dada tradition of subverting our notion of what constitutes a work of art, let alone the validity of art itself.

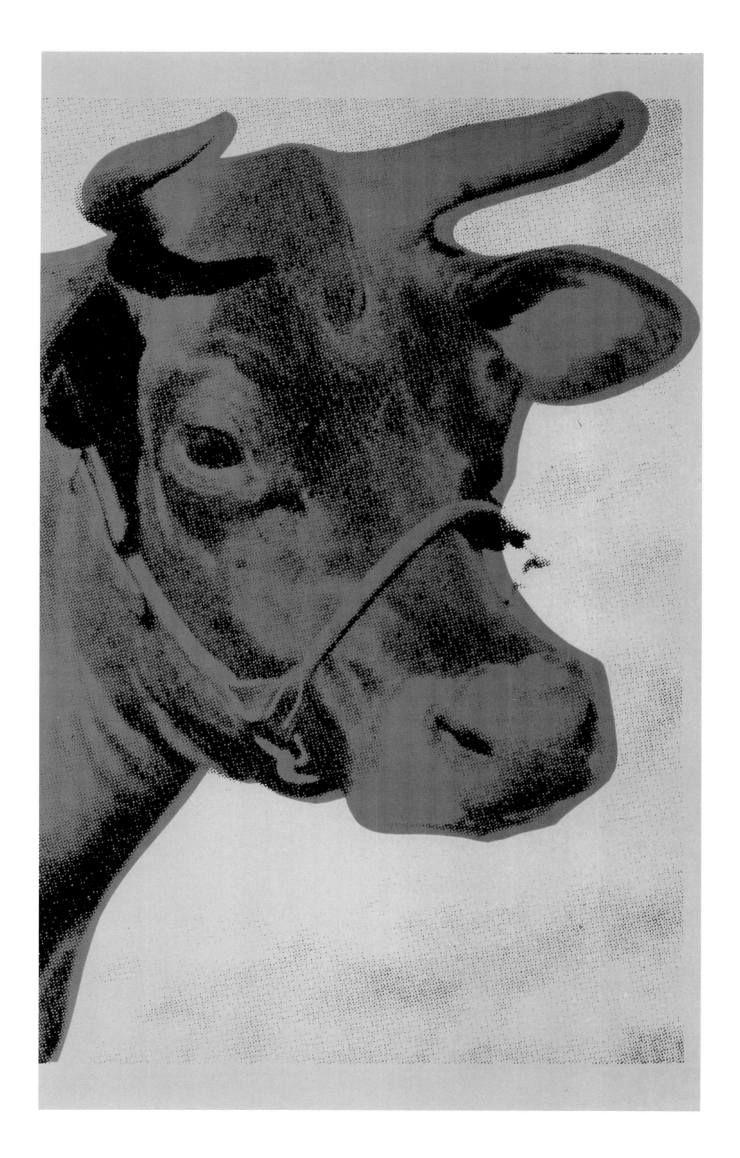

MARILYN

1967
Portfolio containing nine silkcreens
each 91.5 x 91.5 cm
The Andy Warhol Foundation for the
Visual Arts, Inc., New York

Although Warhol had made a number of individual screenprints on paper before 1967, it was logical for him eventually to exploit the medium more fully by creating series of prints devoted to a single theme. This enabled him to open up a much wider and more financially accessible market than the one enjoyed by his paintings. And given the popularity of the Marilyn pictures, those images were an obvious choice for the painter's first series of prints.

Once again Warhol's characteristic tendency to stress the innate abstraction of things is apparent, for the prints function efficiently as a series of investigations into the nature of colour relationships. They also double as comments upon the occasional deformations of colour printing. And in addition to the breakdown into yellow hair, green eyelids, ruby lips and pink skin that is familiar from many of the Marilyn paintings, a number of unusual colour arrangements impart a wholly different and even unfamiliar slant to the image, if not even deform or mask it. A good example of this is the green, pink and red polarised version which renders the face difficult to see. Such perceptual difficulties prefigure the camouflaging that Warhol would explore near the end of his life.

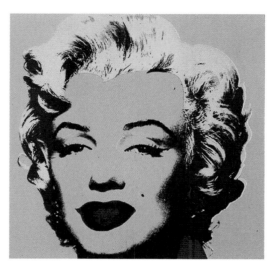
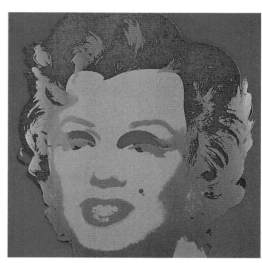
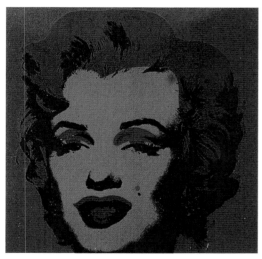
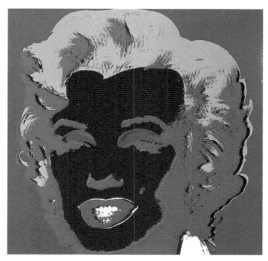
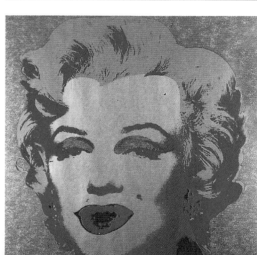

JULIA WARHOLA

1974
Synthetic polymer silkscreened on canvas
101.5 x 101.5 cm
The Andy Warhol Foundation
for the Visual Arts, Inc., New York

It may be that Warhol had some commemorative purpose in painting a number of pictures of his dead mother shortly after her decease in 1972. However, other than rememberance it is difficult to discern what that purpose could have been, for despite the apparent dynamism of their surfaces, the works lack dramatic point. This is because the dynamism has nothing much to do; the thick paint simply swirls around or under the images of Julia Warhola without deepening our insight into her personality, or even the painter's reaction to her. When Warhol used portraiture to make telling cultural points, as he had done in the highly ironic Chairman Mao images, the failure to relate painterly means to dramatic ends does not really matter, for the implications of the imagery carry the flaccid underlying painterliness with them. But when any such larger dramatic purpose is apparently absent (as here), the painterliness merely appears turgid rather than expressive, if not even emptily rhetorical and messy. In pictures like these, Warhol had returned full circle to the unconvincing, affected painterliness evident in his art around 1960-61 when he had married popular imagery with a synthetic expressionism.

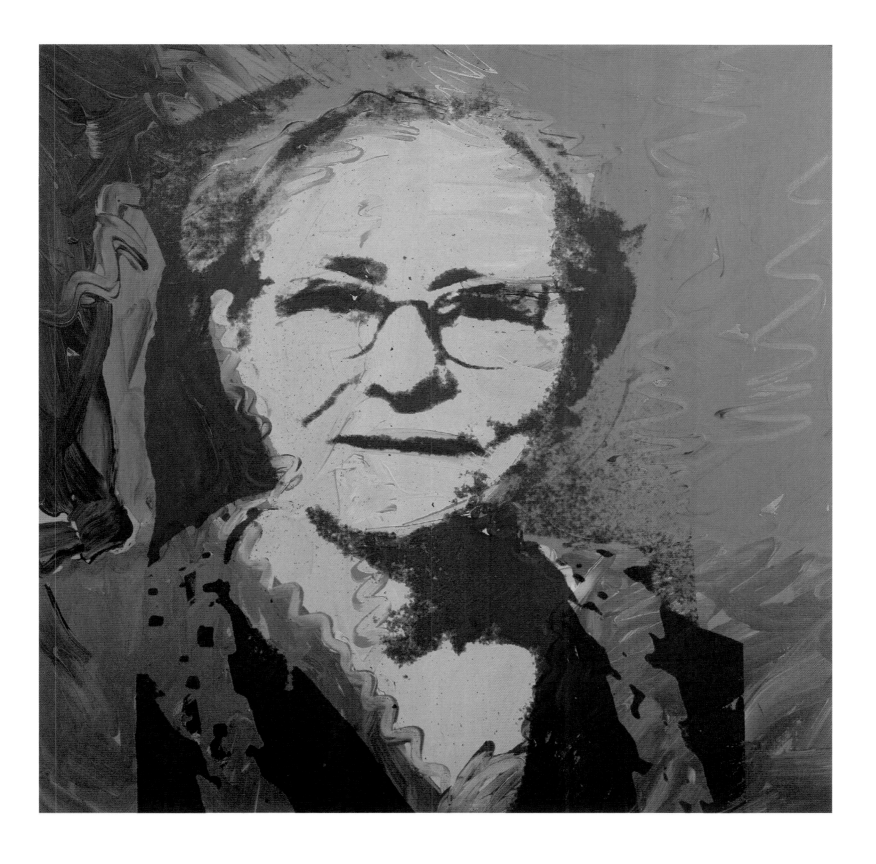

SKULL

1976
Silkscreen ink on synthetic polymer
paint on canvas, 38.1 x 48.3 cm
The Andy Warhol Foundation
for the Visual Arts, Inc., New York

Despite Warhol's customary declaration that there were no meanings behind the surfaces of his works, the Skulls series of paintings again demonstrate his underlying seriousness of purpose. The images were made from photographs of a skull that the painter had bought in a Paris flea market around 1975. He was encouraged to develop the series by Fred Hughes who reminded him that artists such as Zurbarán and Picasso had used the objects to great expressive effect.

Moreover, Warhol's studio assistant, Ronnie Cutrone (who became his professional helper in 1974), also encouraged him to use the skull by remarking that it would be 'like doing the portrait of everybody in the world'. At Warhol's behest, Cutrone took a great many monochrome photographs of the skull from a number of different angles. He lit it harshly and from the side so as to obtain the most dramatic visual effects through maximising its light and dark contrasts, plus the shadows thrown by the object. In most of the Skulls images (as here), the use of vivid colours tends to glamourise the object.

That glamourisation is highly ironic, given the way that the leering skull points up the superficiality of glamour: in the midst of life we are in death indeed, as Andy Warhol the media Superstar was only too painfully aware after 1968.

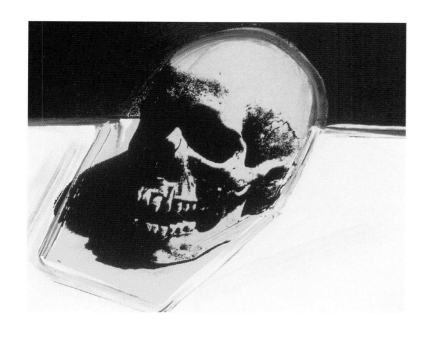
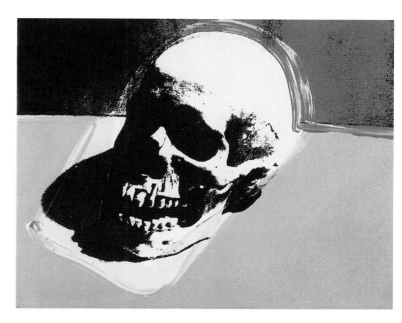
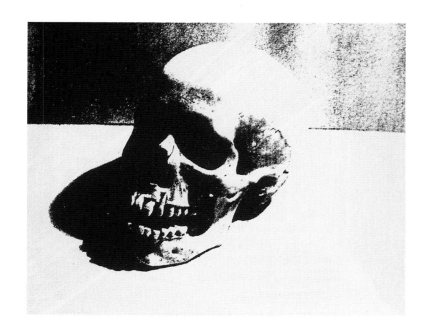
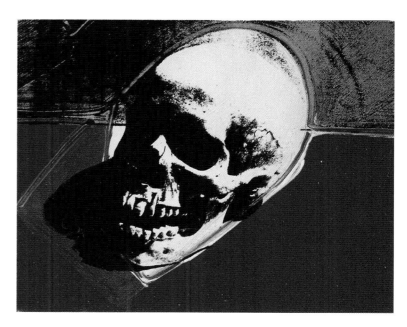
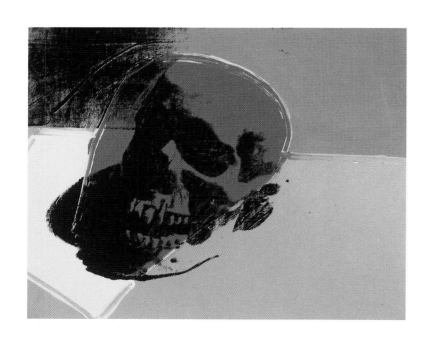
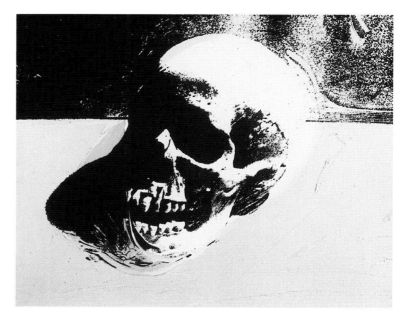

HAMMER AND SICKLE

1977
watercolor on paper
71.1 x 102.9 cm
The Andy Warhol Foundation for the
Visual Arts, Inc., New York

More irony in the vein of the Chairman Mao images assails us here, as Warhol presented the capitalist art market with communist symbols for its delectation. These images had their origins in a 1976 visit to Italy, where the painter frequently saw the symbols of industrial and agrarian power scribbled on walls; as he later told Ronnie Cutrone:

"Gee, when you walk around Italy, all over the walls no matter where you go, there in chalk or paint, there's all these images scribbled on everything with hammers and sickles..."

Back in New York Warhol had Cutrone fruitlessly scour left-wing stores in search of three dimensional hammer and sickle symbols for subsequent use in pictures; in the end Cutrone simply bought brand new hammers and sickles from a hardware store, and then photographed them many times. From those photos, Warhol subsequently made both watercoloured and silk-screened images, as here. In them he stressed the contrast between the objects and the shadows they cast, a pointer to the Shadows series of wholly abstract images that was soon to follow.

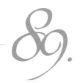

SHADOWS

1978
Silkscreen ink on synthetic polymer paint on
canvas, 102 canvases, each 193 x 132.1 cm
Dia Art Foundation, New York

This photograph shows the installation of the Shadows paintings at 393 West Broadway, New York, in January 1979. The pictures were made using photographs that Ronnie Cutrone had taken of fragments of cardboard; like the Skulls, these were dramatically lit so as to cast long shadows and be sharply divided between light and shade.

Warhol claimed that the Shadows paintings were simply 'disco decor', for disco music was played at the party held for the opening of the 1979 New York exhibition. However, there are a number of reasons to take the works a little more seriously than that. As we have already seen, Warhol always felt an affinity with abstract painting, even if such an attraction usually found expression through pushing representational imagery to the interface with abstraction, rather than crossing that frontier. But rather than working purely as abstract paintings - and not very good ones at that, for there is little if any correspondence here between form and emotional expression, which is surely the point of gestural abstract painting like this - the very abstraction itself is surely its own point. This seems especially the case if we consider both the artistic context and scale on which the

paintings were first shown, for they may represent a comment upon the limitations of abstract art.

One of the ways that many non-representational painters project a sense of visual identity is through creating series of repetitious forms. Here Warhol may have been taking to its logical conclusion that tendency of abstract works to look uniform. It is also possible that he was paying homage to Robert Rauschenberg when doing so, for surely he saw the latter artist's *White Paintings* dating from around 1949 when they toured various American museums between 1976 and 1978; those works are simply blank images designed to allow shadows to play across them. In his Shadows paintings Warhol was instead fixing such transient shapes. And ultimately the fact that Warhol called these works 'Shadows' rather than, say, 'abstract paintings', perhaps makes a dramatic point, for shadows are by their very nature fleeting and have long been employed metaphorically in both painting and literature to denote the transience of life. By giving these images such a collective title Warhol was surely projecting that awareness also. This reading is certainly supported by the many addressals of nihilism and death encountered elsewhere in his oeuvre.

TRUMAN CAPOTE

1979
Silkscreen ink on synthetic polymer paint
101.5 x 101.5 cm
The Andy Warhol Foundation
for the Visual Arts, Inc., New York

On his very first visit to New York in 1948 Warhol formed a crush on Truman Capote after seeing the author's photograph on the back of his first book, *Other Voices, Other Rooms*. When Warhol settled in New York soon afterwards he pestered his way into acquaintanceship with the writer. Capote never regarded him highly in return and did little to encourage the relationship. However, Warhol persisted in his adulation and it was with a group of '15 Drawings Based on the Writings of Truman Capote' that he held his first exhibition in June 1952. Capote eventually visited that show.

In 1956 Warhol also made a shoe portrait of Capote which he exhibited in the *Crazy Golden Slippers* show at the Bodley Gallery. Later, when Warhol had achieved worldwide fame, he enjoyed a more equal relationship with the writer. Eventually he employed Capote on *Interview* magazine when the writer's career was on the wane due to his failing literary powers and related alcoholism.

In other contemporaneous portraits of Capote using the same photo-silkscreened image, Warhol tonally emphasised the flat areas of supporting colour so as to make the staring eyes the focal point of the design and thereby increase their haunted, fixed look. Here, however, the flesh areas of cool blue set off the stridency of the yellow hat by contrast, thus making a somewhat more fashion-conscious and glamorous statement about the author.

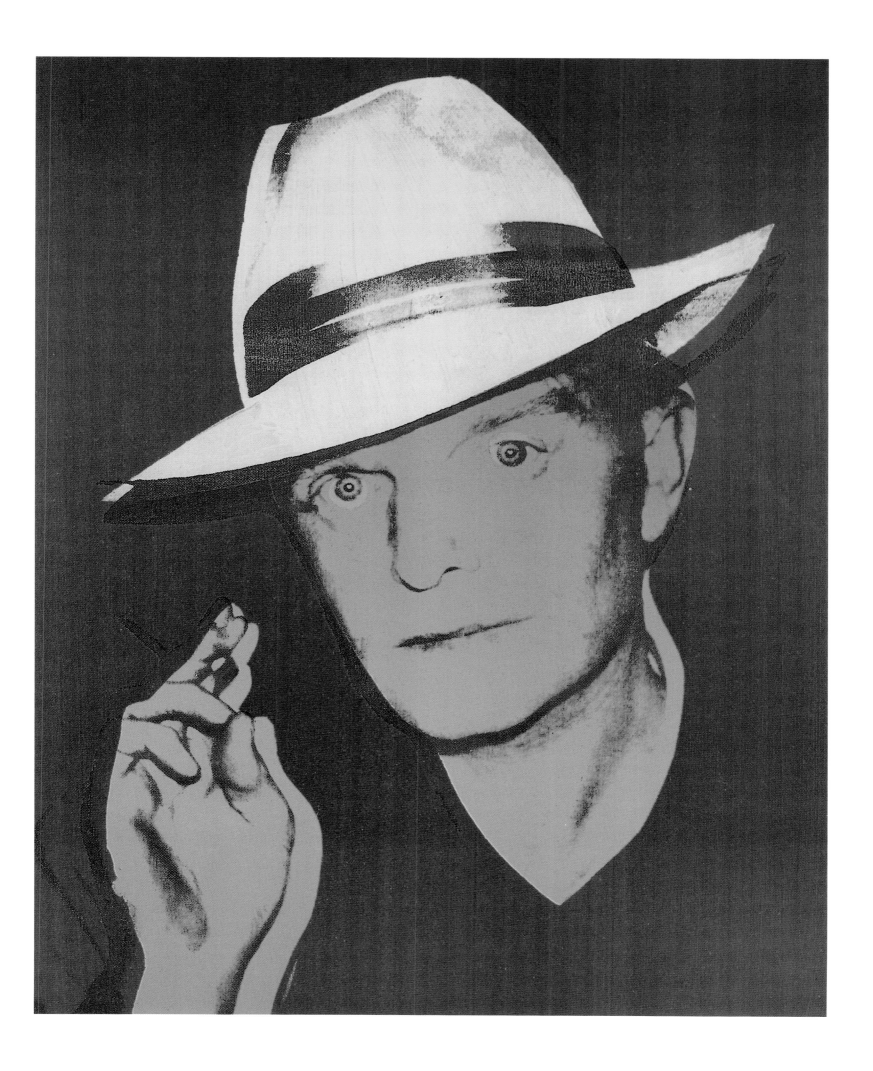

DIAMOND DUST
JOSEPH BEUYS

1980
Silkscreen ink and diamond dust
on synthetic polymer paint on canvas
254 x 203.2 cm
Hamburger Bahnhof - Museum
für Gegenwart, Berlin

Joseph Beuys (1921-86) was perhaps the most influential of post-war German sculptors and conceptual artists. By the time of his death he was also the most financially highly valued artist in the world, something that certainly appealed to Warhol (who was not far behind him in the league table of artistic top earners). Beuys was one of the founders of the German Green movement, and was especially brilliant at communicating through the mass media. He first met Warhol in New York in 1979. The American artist was commissioned to paint his portrait the following year. Later he went on to create further images of Beuys, including sets of silkscreen prints, published between 1980 and 1983. And a portrait entitled *Joseph Beuys in Memoriam* created after the sculptor's death overlays a positive image of the head with camouflaged patternings. Warhol had a low opinion of Beuys's work, but the German sculptor esteemed Warhol highly for the conceptual complexity of his art.

This is yet another of Warhol's reversals images. The fusion of negativism and glamour noted elsewhere in the Skulls and Reversals series pictures was effected here not by means of an underpainting of garish colours. Instead, Warhol sprinkled synthetic diamond dust over the image whilst the silkscreen ink was still wet, thus bonding the two together. Although unfortunately it is difficult to see in reproduction, in reality the diamond dust gives off a brilliant glitter that introduces potent associations of a showbiz glitziness which is entirely and wittily appropriate to Beuys's role as an art-world superstar.

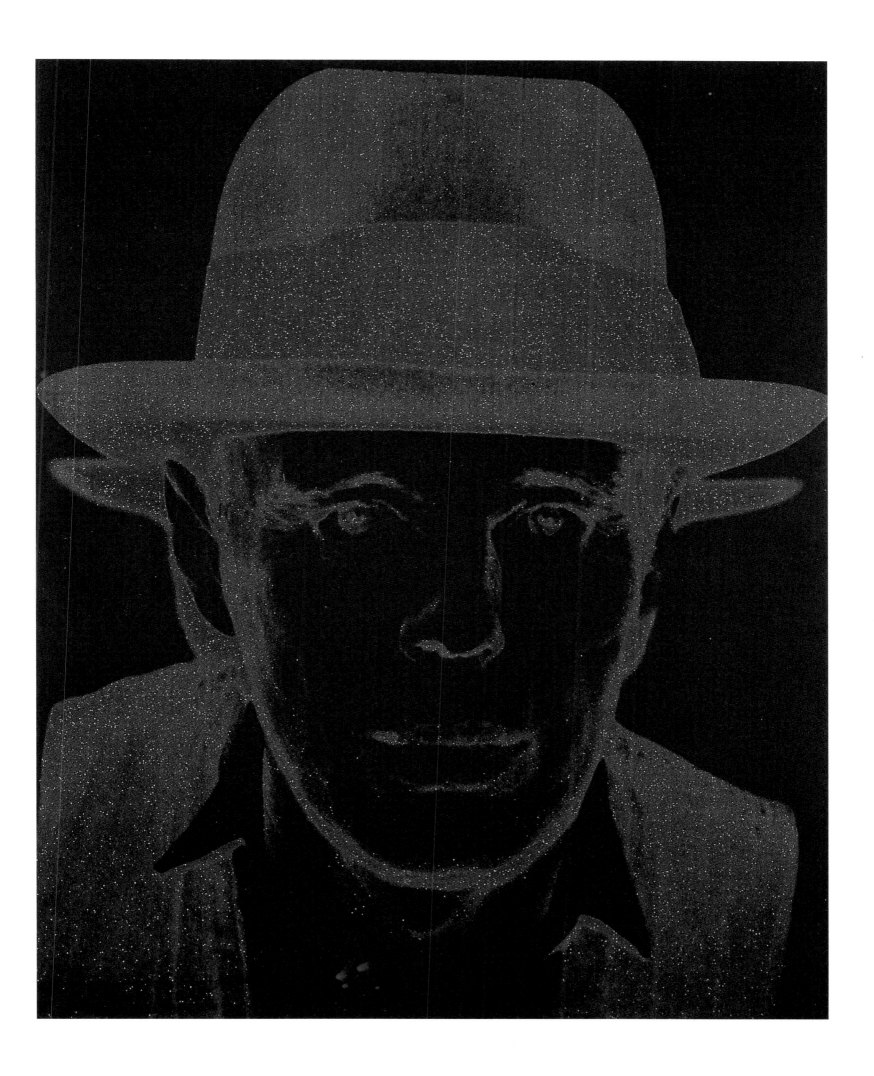

GUN

1981
Silkscreen ink, acrylic paint on canvas
177.8 x 228.6 cm
Anthony d'Offay Gallery, London

Given the personal suffering inflicted upon Warhol by means of a gun, it seems natural, if somewhat masochistic, that he should have represented such objects as cultural icons, which of course they are to a great many Americans. And the personal significance of the image is heightened by the fact that Warhol did not just represent any old gun here, for this is a 32 snub-nosed pistol, one of which Valerie Solanas had used when attempting to kill him in 1968.

The chilling associations of the subject-matter are heightened by the fact that the portrayal of the gun is so impersonal. That impersonality accurately mirrors reality of course, for a gun is merely a tool in the hand of the person who wields it. The visual detachment goes back to the impersonality of much of Warhol's art from the 1960s, where by identical means the painter had projected the utter emptiness of modern life, as represented by its artefacts.

93.

GOETHE

1982
Silkscreen print, 96.5 x 96.5 cm
The Andy Warhol Foundation for the Visual
Arts, Inc., New York

Warhol took this image of the great German poet, playwright and philosopher Johann Wolfgang Goethe (1749-1832) directly from the famous portrait entitled *Goethe in the Campagna* by Wilhelm Tischbein (1750-1812) which hangs in the Stadlisches Kunstinstitut, Frankfurt-am-Main, a portrait painted when Goethe visited Italy in 1786.

The *Goethe* series of prints was published in a hundred numbered sets of four prints each. Warhol unashamedly created these portraits as a way of appealing directly to the highly profitable German market (for exactly the same reasons a set of Beethoven portraits was created after 1987 by the artist's executors from designs supplied by Warhol). By the addition of 'glamorous' colours, Warhol reminds us that Goethe was a media superstar of the Romantic era, even if the images themselves do not seem to differ very much visually from the types of glamourised portraits that are commonly encountered on the covers of record albums, book jackets and the like.

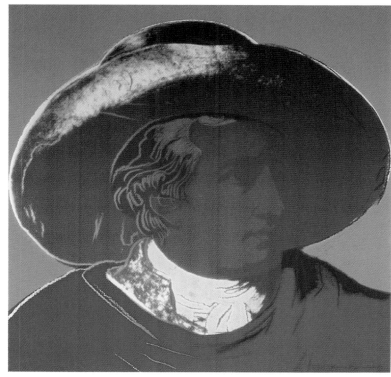
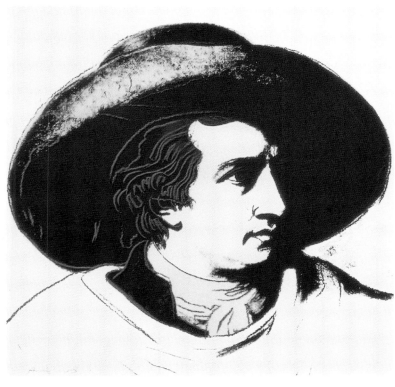
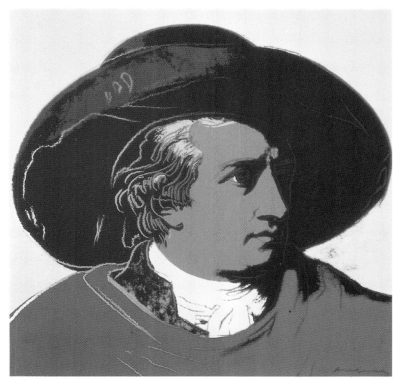

SIXTY LAST SUPPERS

1986
Silkscreen ink on canvas
294.6 x 998.2 cm
Leo Castelli Gallery, New York

Warhol was invited to rework Leonardo da Vinci's image of the *Last Supper* by his first New York dealer, Alexandre Iolas. The latter wanted to show the resulting paintings in a gallery that stood opposite the refectory of the Church of Santa Maria della Grazie in Milan, Italy, the very building in which Leonardo's original mural is located. However, Warhol did not use reproductions of the Leonardo for his pictures. Instead, he employed photographs of two kitsch sculptural reproductions of Leonardo's painting (one in white plastic, the other in Capo-di-Monte clay), as well as a published line drawing that greatly simplified the Leonardo. Warhol's images are therefore twice removed from the original, and act both as comments upon simplified reproductions of religious works of art, and upon the way that such reworkings can easily degenerate into utter kitsch.

Warhol explored two approaches in the *Last Supper* pictures. In one he took the line drawing reproduction of the Leonardo as the starting point for a series of hand-drawn variations. In the other approach, Warhol reproduced photographs of the two kitsch sculptures by means of silkscreen printing over paint on canvas, as here. In several of these latter images Warhol coupled his statement about religious art and kitsch with his current interest in camouflage patternings, perhaps to suggest that true religiosity is obscured by such artefacts, rather than revealed by them.

In this work Warhol used the replication of the kitsch Leonardo sculptures to make familiar but still valid points about the replication of both religious icons and religious kitsch. It matters little whether or not we can see the individual details clearly in reproduction: the repetition of a familiar icon is the point here.

The opening of Warhol's *Last Supper* exhibition in Milan in late January 1987, which the artist attended, was his last important public appearance as a media superstar.

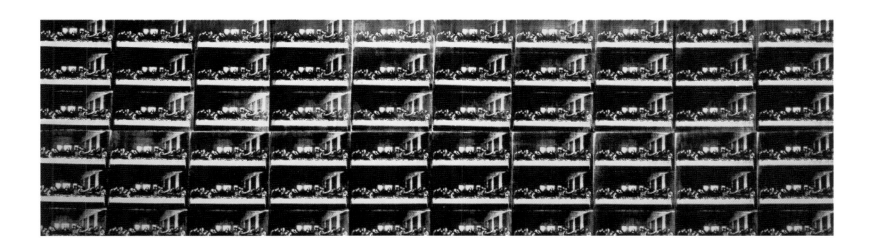

95.

CAMOUFLAGE
SELF-PORTRAIT

1986
Silkscreen ink on synthetic polymer
paint on canvas, 208.3 x 208.3 cm
The Metropolitan Museum of Art, New York

The camouflage patternings seen here derived from some standard United States military camouflage. Initially he used the camouflage to create a group of abstract paintings, but eventually he put it to much more fruitful employment in conjunction with representational imagery, as here.

Warhol was a master at masking his real self from public gaze. To art critics, art historians and media questioners he usually went out of his way to appear naive, mentally slow, emotionally detached and even. Yet this was pure disingenuousness, for in private Warhol was very worldly, mentally quick, frequently emotional, always manipulative and anything but robotic. The late series of camouflaged self-portraits therefore project the real Andy Warhol in a very direct fashion indeed, for camouflage is a means of masking true appearances.

Naturally, the camouflage in these late self-portraits forces the images to the interface with abstraction, that frontier the painter had explored so often in previous works. The spikiness of the hair contrasts strongly with the swirling, curvilinear shapes of the camouflage, and together they imbue the image with a startling visual impact.

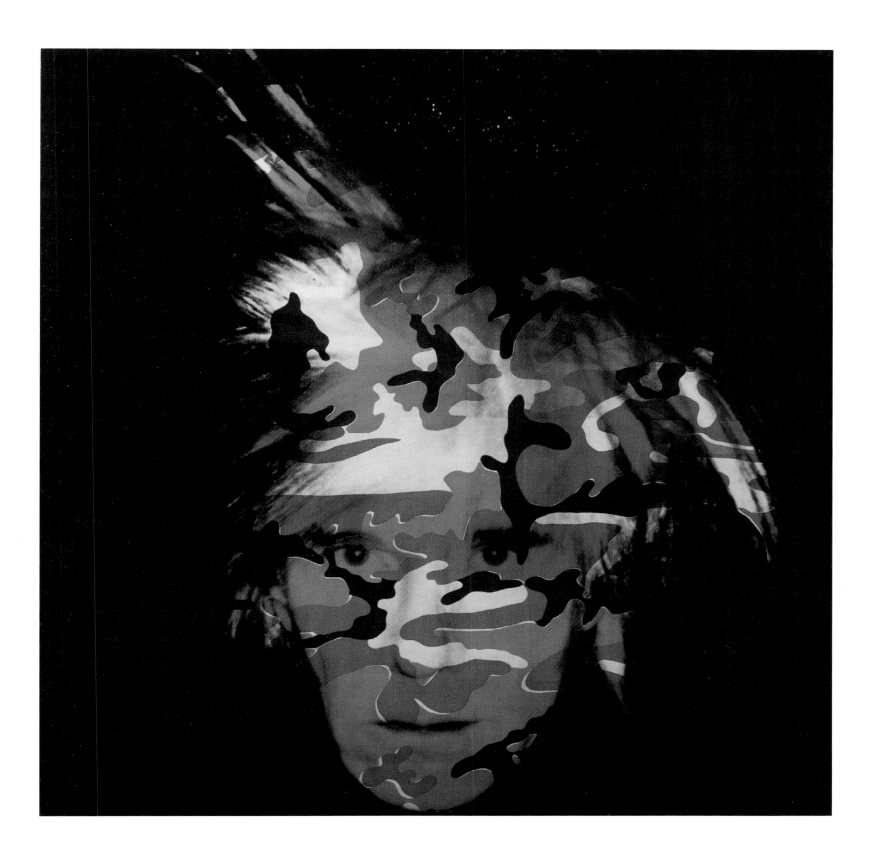

1928

Born Andrew Warhola 6 August in Pittsburgh, Pennsylvania, the third son of Ondrej and Julia Warhola.

1934

Enters Holmes Elementary School, Pittsburgh.

1941

September, enters Schenley High School, Pittsburgh.

1945

Graduates from Schenley High School. Enters Carnegie Institute of Technology to study art.

1948

Spring, works part-time in the display department of the Joseph Horne department store in Pittsburgh

1949

June, graduates with a Batchelor of Fine Arts degree; July, moves to New York with fellow student Philip Pearlstein. First illustrations published in leading fashion magazines under the name of Andy Warhol.

1950

Career as commercial artist begins to take off.

1951

Makes first drawings for television, as well as advertisement design that two years later wins him first Art Director's Club Gold Medal.

1952

Holds first exhibition at Hugo Gallery, New York but sells nothing. With Fred McCarroll and Mary Suzuki illustrates *Amy Vanderbilt's Complete Book of Etiquette*.

1954

Holds three shows of work at the Loft Gallery on East 45th Street, publishes *Twenty-five Cats Name [sic] Sam and One Blue Pussy*, sells books and drawings through *Serendipity* shop on 58th Street, active in designing for the *Theater 12* group.

Hires first studio assistant, Vito Giallo, begins relationship with Charles Lisanby.

1955

Obtains commission to make series of weekly shoe advertisement newspaper designs on behalf of fashionable I. Miller shoe store. Publishes *A la Recherche du Shoe Perdu* and exhibits portfolio of *Drawings for a Boy Book*.

1956

February, exhibits at Bodley Gallery but only sells small number of drawings. April, exhibits some drawings in the *Recent Drawings U.S.A.* show at the Museum of Modern Art, New York. Receives 35th Annual Art Directors Club Award for Distinctive Merit for I. Miller shoe advertisement.

1957

Wins 36th Annual Art Directors Club Medal, as well as Award for Distinctive Merit for I. Miller shoe advertisement. Holds another successful show at the Bodley Gallery.

1959

Loses I. Miller shoe account, although has plenty of other advertising work and receives Certificate of Excellence from American Institue of Graphic Arts for previous year's work. Autumn, publishes joke cookbook, *Wild Raspberries* with Suzie Frankfurt and holds exhibition of drawings made for the book at Bodley Gallery in December.

1960

Takes up painting seriously, drawing imagery from advertisements and comic strips, and painting popular culture objects such as Coca-Cola bottles.

1961

April, exhibits Pop paintings in 57th Street window of Bonwit Teller department store. Begins selling paintings directly to collectors, often at knock-down prices. December, purchases idea for Campbell's Soup Can paintings from gallery owner and interior decorator Muriel Latow.

1962

Makes Campbell's Soup Cans and Dollar Bills paintings. July, discovers potentialities of silk screen technique, and also exhibits Soup Can series of paintings at Irving Blum's Ferus Gallery in Los Angeles. Summer, makes first silkscreen paintings of baseball, movie and pop music stars, and begins Marilyns series. October, exhibits in group Pop Art show at Sidney Janis Gallery. November, makes New York breakthrough with one-man show at influential Stable Gallery. Show almost complete sell-out.

1963

May, makes first Race Riot pictures; June, embarks upon first silkscreened Disaster pictures. November, moves studio to loft at 231 East 47th Street, henceforth known as 'The Factory'. December, begins Jackie series using photos of Jackie Kennedy at presidential funeral. Begins *Kiss* film.

1964

January, exhibits Disaster paintings at Ileana Sonnabend Gallery in Paris under title of 'Death in America'. Creates 400 wood sculptures of Campbell's Soup Cans, Brillo Pads, Del Monte Peach Halves and similar cardboard grocery boxes which are exhibited at Stable Gallery in April. Also in April exhibits *Thirteen Most Wanted Men* monochrome mural on New York State Pavilion at New York World's Fair. Has four Marilyn canvases holed in studio by visitor with gun. December, receives sixth annual award of *Film Culture* magazine.

1965

March, involved in Canadian customs dispute over artistic status of grocery box sculptures. Summer, begins collaboration with Paul Morrissey. October, holds first solo museum retrospective exhibition at Institute of Contemporary Art, Philadelphia, opening turns into near-riot. December, creates music group *The Velvet Underground*.

1966

April, opens multimedia and music show the Exploding Plastic Inevitable at Polish Cultural Center (the 'Dom') on St Mark's Place, featuring *The Velvet Underground*. Also in April holds exhibition of cow wallpaper and helium-filled silver balloons at Leo Castelli Gallery. Summer, makes *Chelsea Girls*, his first commercially successful film.

1967

May, visits Cannes, France for planned film festival showing of Chelsea Girls but film is not shown. Summer, makes further films, *I, a Man* and *Bikeboy*. Shows six self portraits in U.S. pavilion at Montreal Expo '67. Autumn, takes on Fred Hughes as business manager.

1968

3 June, is shot by Valerie Solanas in assassination attempt, and hospitalized until 28 July. Recuperates during remainder of year and paints multiple portrait of Happy Rockefeller in August. Autumn, supervises production of *Flesh* (directed by Paul Morrissey), and produces film *Blue Movie*.

1969

Publishes first issue of Andy Warhol's *Interview* magazine in autumn. 25 June to 5 August shows homosexual pornographic films in regular cinema to raise money. December, makes most successful film, *Trash*.

1970

May, travels to California for opening of large retrospective exhibition in Pasadena; show later travels to Chicago, Eindhoven (Holland), Paris, London and New York. 13 May, one of Soup Can paintings fetches highest price ever received at auction until then by living American artist. September, visits Paris to make movie, *L'Amour*.

1971

February, Warhol visits London for opening of four shows of his works, later travels to Cologne and Munich. April, retrospective opens in New York at Whitney Museum of American Art. June, makes film, Heat, in Los Angeles with Paul Morrissey.

1972

Winter 1971-72, makes over 2000 paintings of Chairman Mao. September, flies to Italy for showing of Heat at Venice Film Festival. 22 November, mother dies in Pittsburgh aged eighty; Warhol does not attend funeral.

1974

December, receives award from Popular Culture Association for services to understanding of homosexuality.

1975

Begins portfolio of Mick Jagger portrait prints and Ladies and Gentlemen series of prints of drag queens. September, book *The Philosophy of Andy Warhol* is published.

1976

Spring, makes last movie, *Bad*. August, makes portrait of Jimmy Carter for cover of *New York Times* magazine, later turns it into print to raise funds for presidential campaign.

1977

Makes Athletes, Torsos and American Indian series of images, as well as Oxidation series using urine interaction with wet copper paint on canvas. October, visits Paris and Geneva.

1978

Makes Sex Parts pictures, as well as Shadows paintings. Produces own television programme, Andy Warhol's TV on cable television; show broadcasts weekly for about two years but is commercially unsuccessful.

1979

Begins Reversals and Retrospectives series of pictures. October, publishes book of photographs, *Exposures*, for which undertakes U.S and European promotional tour over next few months. November, Portraits of the Seventies exhibition of portraits held at Whitney Museum, New York.

1980

Makes series of Portraits of Jews of the Twentieth Century, as well as portraits of German artist Joseph Beuys. April, publishes book, *POPism*, written with Pat Hackett.

1981

Makes Dollar Signs, Knives, Guns and Myths series of images. Befgins relationship with Jon Gould. November, exhibits with LeRoy Neiman at the Institute of Contemporary Art in Los Angeles.

1982

Makes German Monuments, Goethe and De Chirico Replicas series

1984

Makes Rorschach Test, Edvard Munch and Renaissance Paintings series. Begins artistic collaboration with Jean-Michel Basquiat.

1985

Makes Advertisements series of images, while series of pictures of Queens of England, Denmark, Holland and Swaziland is created entirely by studio assistants following Warhol's instructions. Publishes book, *America*. September, show of paintings made in collaboration with Jean-Claude Basquiat opens at Tony Shafrazi Gallery.

1986

Makes Camouflaged Self Portraits, as well as Frederick the Great, Lenin, Leonardo Last Supper, Cars, Flowers and Campbell's Soup Boxes series of paintings and prints. Is sued for damages by City of Oslo, Norway, for appropriation of Edvard Munch images in paintings. Suffering increasingly from gallstones.

1987

January, exhibition of stitched and sewn photographs opens to excellent reviews in New York. Makes Rado Watches, Beethoven pictures, begins work on The History of American TV series. 22 February, dies in New York Hospital after routine gallbladder operation.

Warhol 1928-1987: Bibliography

ANTONIO, Emile De and TUCHMAN, Mitch
Painters Painting, New York, 1984.

BLINDERMAN, Barry
'Modern "Myths": An Interview with Andy Warhol', *Arts Magazine*, October 1981.

BOCKRIS, Victor
Warhol, New York and London, 1989.

BOURDON, David
— *Warhol*, New York, 1989.
— 'Warhol as Filmmaker', *Art in America*, May 1988.

CROW, Thomas
'Saturday Disasters: Trace and Reference in Early Warhol', *Art in America*, May 1987.

FELDMAN, Frayda and SCHELLMANN, Jorg
Andy Warhol Prints, New York, 1989.

FREI, George and PRINTZ, Neil (editors)
The Andy Warhol Catalogue Raisonné, Volume 1 *Paintings and Sculpture 1961-1963*, New York and London, 2002.

FRANCIS, Mark and KING, Margery (editors)
The Warhol Look: Glamour, Style, Fashion, Exhibition catalogue, The Whitney Museum of American Art, New York, 1997.

GARRELS, Gary (editor)
The Work of Andy Warhol, Seattle, 1989 (collection of essays by Charles F. Stuckey, Nan Rosenthal, Benjamin H.D. Buchloh, Rainer Crone, Trevor Fairbrother and Simon Watney).

GELDZAHLER, Henry
'Andy Warhol', *Art International*, April 1964.

HUGHES, Robert
'The Rise of Andy Warhol', in *Art after Modernism: Rethinking Representation*, ed. Brian Wallis, New York and Boston, 1984.

KATZ, Jonathan
Andy Warhol, New York, 1993.

LANCASTER, Mark
'Andy Warhol Remembered', *The Burlington Magazine*, March 1989.

McSHINE, Kynaston (editor)
Andy Warhol, A Retrospective, New York, 1989.

RATCLIFF, Carter
Warhol, New York, 1983.

SMITH, Patrick S.
Warhol, Conversations about the Artist, Ann Arbor and London, 1988.

STUCKEY, Charles F.
'Andy Warhol's Painted Faces', *Art in America*, May 1980.

SWENSON, Gene
'What is Pop Art?', *Artnews*, November 1963.

TRÉTIACK, Philippe, *Warhol's America*, London, 1997.

WARHOL, Andy
— *The Philosophy of Andy Warhol (From A to B and Back Again)*, New York and London, 1975.
— (with Pat Hackett), *POPism, The Warhol '60s*, New York and London, 1980.
— (Edited by Pat Hackett), *The Andy Warhol Diaries*, New York and London, 1989.

WARHOL MUSEUM, PITTSBURGH
The Andy Warhol Museum, Pittsburgh, New York, 1994.

WOLF, Reva
Andy Warhol, Poetry and Gossip in the 1960s, Chicago, 1997

YAU, John
In the Realm of Appearances, The Art of Andy Warhol, Hope, New Jersey, 1993.

There are also numerous other catalogues pertaining to general exhibitions of Warhol's work.

Index of Works

100 Cans — p. 83

129 Die in Jet (Plane Crash) — p. 59

16 Jackies — p. 43

192 One-Dollar Bills — p. 85

A

A la Recherche du Shoe Perdu — p. 10

Andy Warhol and Jean-Michel Basquiat,

Monster Meat — p. 52

Andy Warhol, Jean-Michel Basquiat, Stoves — p. 53

Atomic Bomb — p. 117

B

Big Torn Campbell's Soup Can — p. 89

Black on Black Retrospective — p. 34

Blue Electric Chair — p. 115

Brillo Boxes — p. 125

Brooke Hayward — p. 39

C

Cagney — p. 13

Camouflage Self-Portrait — p. 153

Campbell's Soup Can (Turkey Noodle) — p. 18

Campbell's Tomato Juice — p. 19

Capricorn Sloe Whiskey Fizz — p. 22

Chanel — p. 54

Close Cover Before Striking — p. 27

Coca-Cola — p. 26

Cow Wallpaper — p. 131

D

Dance Diagram (Fox Trot) — p. 9

Diamond Dust Joseph Beuys — p. 145

Dick Tracy — p. 4

Do It Yourself (Landscape) — p. 81

Do It Yourself (Sailboats) — p. 21

Dollar Sign — p. 67

Double Self-Portraits — p. 16

E

Elvis I and II — p. 119

Ethel Scull 36 Times — p. 111

Ethel Scull Triptych — p. 35

F

Five Deaths Seventeen Times

in Black and White — p. 107

Flag on Orange Field II — p. 7

Flowers — p. 127

Four Marilyns — p. 28

G

Gangster Funeral — p. 24

Goethe — p. 149

Gold Marilyn — p. 97

Green Coca-Cola Bottles — p. 87

Gun — p. 147

Guns — p. 69

H

Hammer and Sickle — p. 139

Horoscopes for the cocktail hour — p. 23

J/K

Jackie — p. 129

Jean-Michel Basquiat — p. 17

Julia Warhola — p. 135

Knives — p. 68

L

Ladies and Gentlemen	p. 40
Ladies and Gentlemen	p. 41

M

Man Ray	p. 46
Marella Agnelli	p. 38
Marilyn	p. 133
Marilyn Diptych	p. 95
Marilyn Monroe's Lips	p. 99
Mona Lisa	p. 113
Monument for 16 Soldiers	p. 65
Most Wanted Men	p. 123
Myths (Mickey Mouse)	p. 70
Myths (Uncle Sam)	p. 74

O

Optical Car Crash	p. 101
Orange Car Crash Ten Times	p. 109

P

Peach Halves	p. 77
Photo of Andy Warhol with Jasper Johns	p. 12
Photo of the exterior of the New York State Pavilion at New York World's Fair	p. 56
Photo of the installation of Cow Wallpaper at Leo Castelli Gallery	p. 57

R

Red Elvis	p. 91
Red Race Riot	p. 103
Reigning Queens, Ntombi Twala of Swaziland	p. 61
Reigning Queens, Queen Elizabeth II	p. 60
Roll of Bills	p. 14

Rorschach

Rorschach	p. 72
Rorschach	p. 73

S

Saturday's Popeye	p. 79
Self-Portrait	p. 32
Self-Portrait	p. 62
Self-Portrait with Skull	p. 31
Shadows	p. 141
Shoe Advertisement for I. Miller	p. 11
Shot Blue Marilyn	p. 29
Silver Liz	p. 36
Sixty Last Suppers	p. 151
Skull	p. 137
Statue of Liberty	p. 6
Suicide	p. 105

T

Ten Portraits of Jews of the Twentieth Century (Albert Einstein)	p. 48
Ten Portraits of Jews of the Twentieth Century (The Marx Brothers)	p. 49
The American Man – Watson Powell	p. 121
The Last Supper	p. 64
Thirty Are Better Than One	p. 44
Triple Elvis	p. 93
Truman Capote	p. 143

V

Vote McGovern	p. 33

W

Walking Torso	p. 51
White on White Mona Lisa	p. 45